ART AND POLITICS

CONTRIBUTIONS IN AMERICAN STUDIES

Series Editor: ROBERT H. WALKER

ART and POLITICS

Cartoonists of the *Masses* and *Liberator*

by Richard Fitzgerald

Contributions in American Studies, Number 8

GREENWOOD PRESS
Westport, Connecticut ● London, England

Library of Congress Cataloging in Publication Data

Fitzgerald, Richard.
 Art and politics.

 (Contributions in American studies, no. 8)
 CONTENTS: The Masses and The Liberator.—Art
Young.—Robert Minor. [etc.]
 1. Cartoonists—United States. 2. American
wit and humor, Pictorial. 3. The Masses. 4. The
Liberator. I. Title.
NC1305.F57 741.5'973 72-609
ISBN 0-8371-6006-5

Copyright © 1973 by Richard Fitzgerald

Library of Congress Catalog Card Number: 72-609

ISBN: 0-8371-6006-5

First published in 1973

Greenwood Press, a division of Williamhouse-Regency Inc.
51 Riverside Avenue, Westport, Connecticut 06880

Manufactured in the United States of America

*To the bunch at Ryan's Tavern who still
quite justifiably blame the boss rather than themselves.*

Contents

List of Illustrations

Acknowledgments

I wish to thank Maurice Becker and K. R. Chamberlain for
patiently providing correspondence and interviews; Helen Farr
Sloan for correspondence, interviews, and notes; and Gil Wilson
for his correspondence with Robert Minor and Art Young.

At various stages this manuscript benefited from the criticisms
of Earl Weaver of California State University at Fullerton;
Robert Hine of the University of California at Riverside; and
Ronald Grele of the Ford Foundation. Jon McKenney, a gradu-
ate student at Columbia University, offered helpful stylistic
corrections; Jeanne Harvey, typing and proofreading. Most
helpful were the staffs of the Bancroft Library and of the Laney
College Library; the Interlibrary Loan Service of the University
of California at Riverside; the Readers' Services of the Hoover
Institution of Stanford University; the Manuscripts Divisions
of the Butler Library, Library of Congress, and Lilly Library;
and particularly the Rare Books Collection of the Bancroft
Library and the Newspaper Division of the General Library
of the University of California at Berkeley. The illustrations
were provided by the Library Photographic Services of Colum-
bia University (Figures 16-17), the University of Washington
(Figures 1, 52), the Stanford University Photo-Reproduction
Service (Figures 11-12, 15, 51), and the Library Photographic
Service of the University of California at Berkeley (all other
figures). Of all the services, the Berkeley service produced the

best prints from magazines and newspapers. Unfortunately, the prints provided by the other institutions are of somewhat inferior quality; however, the University of California was able to improve them greatly.

A special word of appreciation is due Helen Farr Sloan, not only for furnishing information about her late husband, but also for a perceptive and most helpful reading of the finished manuscript, particularly chapter 4.

My greatest debt is to Anatole Anton of the University of Colorado. Drawing on his own family background of artistic rebellion, he clarified many difficult questions relating to this general subject.

Art and Politics

Introduction

This discussion of art and radical politics will rest upon two closely related questions: what is the relationship between artistic form on one hand and political theories and practices on the other, and can this artistic form be both esthetically satisfying and politically instructive?

To explore this general problem, I have chosen for analysis the works of five artists whose works appeared in the two best illustrated radical publications in the United States—the *Masses* (1911-1917) and its successor, the *Liberator* (1918-1924). This analysis will attempt to illuminate the various problems and questions raised by art in the service of ideology. It will also seek to measure the extent to which artists can remain true to deeply held artistic values when they identify themselves and their art with political and social movements.

Thus, I am concerned with these cartoonists not simply as artists, but also as successes or failures in shaping their art as an instrument of political consciousness. The concern is not simply with artistic techniques but with the *use* of these techniques, and the way in which these techniques served certain professed ends which were partly political.

These five men were chosen from the many cartoonists of the *Masses* and the *Liberator* because they seemed to exemplify most clearly the tendencies then inherent in the tensions between art and politics. The fact that they were, for the most

3

part, well known, successful, and politically within this larger
group of cartoonists was also a consideration in choosing them.
While any such selection is partially arbitrary, few who examine
the work of these five artists would question their abilities or
their relevance to esthetic developments and political com-
mentary.

The careers of these artists raise more than academic ques-
tions about the validity of political movements. If such move-
ments cannot attract and hold, and have as advocates, the most
talented artists of the day, we may entertain serious doubts
about the life of the mind and the meaning of art within such
movements. Any serious political movement must integrate the
interests of the artist, which may or may not be primarily politi-
cal, and the interests of the movement, which may or may not
be culturally alluring. The varying careers of these five car-
toonists may suggest some of the responses to this early and
continuing failure of the American left to integrate culture and
politics.

These five had to deal with the reality of an institutionalized
art market, and their careers individually embodied the radical
artist's possible response to that market. Art Young (1866-1943)
refused to compromise, choosing to remain a socialist and a
political cartoonist. Robert Minor (1884-1952) gave up art for a
political profession. John Sloan (1871-1951) quit politics and
continued painting but, like Art Young, refused to yield to the
market. Unlike Young, Sloan gave up socialism for a different
form of independence, and lived from teaching. K. R. Chamber-
lain (1891—) compromised completely with the market and
even saw value in it. Maurice Becker (1889—) lived in an other-
worldly limbo; he did radical work and, when he had to, he drew
political cartoons which he disliked, but he refused to admit the
conflict between radical politics and commercial art.

In the nineteenth century most free lance illustrators could
assume the role of businessmen and could sell their products
freely to such clients as book publishers, magazines, and news-
papers. But with the growth of the giant corporation and with
the acceleration of the sales effort through advertising, graphic

artists became increasingly "proletarianized"—that is, it was no longer a material product but rather their labor power which they sold.[1] In other words, they "alienated" their ability to create art. For the politically rebellious artist, this proletarianization almost instinctively led to his emotional identification with the working "slob."

Although this identification was the result of the artists' own situations, they never regarded themselves as workers or identified their own interests with those of the working class. They saw industrial working-class struggles as real, but they did not consider them their own. They never regarded themselves simultaneously as both artists and workers. Thus, they saw their career options as open in a way no industrial worker could, and they responded in different ways to the situation which they confronted.

These artists, in alienating their artistic ability, threw the whole question of artistic standards up in the air. Because they did not produce a certain commodity with a fixed market but provided their abilities and talents to others who produced for many markets, standards had to be fluid, relative, and unfixed. This situation is characteristic of twentieth century art in general: that is, there are no fixed and established standards of good and bad in art, and artists are subject to such fluctuations. This is not to say that there are no longer any standards; rather, there are a number of different competitive standards, and trends and fashions sweep over the art world much more swiftly. What this means to the artist is that he has to determine which set of preassigned standards—which of the various "schools" of art available—he is going to adhere to.

We do not know exactly why there are no fixed standards in twentieth century art, but there is no question that there are none. One obvious factor is that, before the nineteenth century, conditions in the art market were generally determined by wealthy nobility or wealthy merchants to whom the artist sold his goods. This is not to deny that Hogarth and others made prints for a narrow, literate audience. But the nature of their work was clearly free of the characteristics imposed on twentieth

century artists by large-scale industrialization and mass society.
Like all historical transitions from one phase to another, change
did not occur in a perfect, steplike fashion. Yet at some point,
perhaps with the later Goya, art became primarily an instru-
ment of self-expression, and not an expression of religious feel-
ing or social convention. By the nineteenth century, too, many
artists attached themselves to various social movements, and
often they were not aiming at the old aristocratic clients and
buyers but at other people. As the art and politics of the culture
became more democratic, the old elitist character of their art
collapsed. With the advent of the twentieth century, this situa-
tion culminated in a wave of trends—Cubism, Expressionism,
Dadaism, Surrealism, Futurism—each competing with the other
for the hegemony of the artistic market place. At the same time
the artist, if he was to maintain his place in the market, was
forced into the avant-garde (or willingly went into it), and thus
in terms of his own work revolutionized art as a medium of
expression.

With the new mass audience of the twentieth century, our
five artists were able to capture certain artistic values which
previously had eluded them. A primary value was the simplicity
of cartoons produced with relatively few lines and with a spon-
taneous quality which mass audiences could apprehend—cartoons
which, at their best, had artistic merit.

The style of the mass artists was one of conscious simplifica-
tion suitable for the news media and the printing press. Art
in the early twentieth century predominantly tended to create a
form more and more inaccessible to any but the cognoscenti. And
insofar as Cézanne and others attempted to develop simplicity,
it was an abstract simplicity that only a sophisticated art viewer
could immediately appreciate.

Topicality was also a value the mass artists held dear. By
topicality is meant the attempt to create an art that comments
on the events of the day and on the times. In general, twentieth
century art is more topical than that of the midnineteenth.
Newer printing techniques which came into common usage in
the late nineteenth century made the mass-circulation daily

press possible. Thus, while cartooning was forced to be ever
fresh and the news truly new, and as both grew more topical,
cartooning in particular became a mass medium.

And so the effectiveness of illustration in the *Masses* was
partly due to newer printing techniques which allowed more
freedom of style than the old techniques which, until the
1880s, had limited Thomas Nast to stiff wood engravings.
Midnineteenth century illustrations in American periodicals
were usually done on wood blocks. By the late 1820s stereo-
typing had been perfected. Type metal casts, made from wood
blocks, allowed printing from durable casts. Then in the late
1830s, electrotyping resulted in high-quality facsimiles of the
blocks. By the 1850s magazines and newspapers used economi-
cal, fast, wood engravings for a mass audience. The original pen
lines were cut on a hard wood block. The engraver could achieve
gradations, but not a third dimension, by criss-crossing or "cross-
hatching" fine lines with his tool. For large printings, a metal
cast was made from the block. In the same period, the develop-
ment of smooth wove paper allowed the printing of detailed
designs. Meanwhile, printing was speeded up with new equip-
ment. In the 1820s the steam-driven cylinder press was developed
and later improved. In the 1860s stereotyping plates were
adapted to newspaper printing, and by the 1880s automatic
typesetting was in use.[2]

Over a long period, photography gradually replaced engraving.
Starting with the daguerreotype in 1839, it was common by the
1870s to photograph onto wood blocks. This allowed drawings on
a larger scale, as a result of which, in the late 1870s, American
magazine engraving featured subtle tone gradations. The first
photomechanical graphic reproduction was made in France in
the 1860s. The artist's design was photographed onto a zinc
plate, the plate was given an acid bath, and then a mold was
made, from which an electrotype cast was taken. However, the
"zinc-cut" printed only lines. Around 1860 a variation of this,
the "chalk plate," was invented in the United States. The artist
drew on hard chalk which covered a steel plate, and cut his trace
with a steel stylus. Then a mold and cast were made. This was

simple, fast, and widely used in the 1890s.[3]

It took almost forty years to perfect photomechanical grada-
tions of tone for photographs and drawings. The first relief-
printed halftones of 1853 were, in a few years, adapted to litho-
graphic stones. A variation of the "photo-litho" halftone, relying
on cross-lined screens, was used in the first halftone periodical
illustration in 1869. In the 1870s the *New York Daily Graphic*
adapted the halftone to the letterpress. This was impossible
without the halftone screen, which was adapted to the large
perfecting presses in the late 1890s and is still in use. The image
was photographed through lines, reducing it to dots on a metal
plate; the dots were widely spaced for darkness, closely for
lightness. From the etched plate a mold and electrotype cast
were taken. The halftone was common to American newspapers
by the mid-1890s. By 1905 the halftone process had almost re-
placed wood engraving.[4]

In time the "final triumph of the photo-mechanical processes
eliminated both the wood engraver and many newspaper illus-
trators, particularly the artist-reporter." The sketch artist was
needed with the rise of the American illustrated press in the
1840s. By the early 1890s every large newspaper had an art
department. In the same decade a number of inexpensive month-
ly magazines, such as the *Saturday Evening Post,* appeared. Using
a good halftone screen, the cost of a halftone was one-tenth that
of a wood engraving. This, plus linotype and faster presses, meant
cheaper magazines. But the 1890s, when many *Masses* artists
such as John Sloan were trained as sketch artists and cartoonists,
saw the last and "rather rich flowering" of newspaper illustra-
tion in the United States before the victory of photography in
the twentieth century.[5]

By the 1900s few illustrators worked with chalk plate or
wood block etching. Drawings were done in black crayon pencil,
pen and ink, sometimes with water color, and with sable brush
"for ready distribution of blacks," or they were rubbed in with
cloth or thumb. Pen and crayon were still zinc-etched, the most
common method of engraving, known as "direct process"; the
halftone reproduced subtle gradations and colors. It was Sloan's

idea to feature full-page cartoons and one-line captions in the
Masses and to reproduce the illustrations by linecut rather than
halftone. Linecut provides sharper, more graphic reproductions
than halftone. With Sloan on the *Masses,* illustrations were larger,
often independent of the text, and pages were uncluttered by
decorative headings.[6]

The increasing reliance of the press on the photographer, and
the technical obsolescence of the newspaper illustrator, explain
why numerous talented cartoonists joined the *Masses* in New
York in the 1910s. They gravitated to New York to contact
magazine editors for free lance work; finding their talent in-
creasingly superfluous and knowing that photography might
even supersede the magazine illustration from which they lived,
they were predisposed to join the *Masses* revolt.[7]

It can be argued that photography partly replaced the political
cartoon because of photography's "one-dimensional" character,
as Herbert Marcuse would call it, as opposed to the potency of
the political cartoon.[8] The political cartoon was driven off the
feature pages because photographs were easier and cheaper to
produce, and could be supplied in great quantity. The photo-
graph, by and large, captured the structure of daily life as it
occurred. In that sense it was one-dimensional—it simply
replicated the surface structure of life; it did not normally give
it a "depth" of interpretation or meaning. The political cartoon
on the other hand sought to disrupt daily life, to make jokes and
stage whispers and asides at the process of everyday life. For just
this reason—the suitability of photography for replicating daily
life (the political cartoon was by its nature more subversive)—
it brought ideas into the news and the political realm. Theoreti-
cally, the whole effect of a newspaper and the consciousness it
promoted was to deluge one with a high proportion of facts and
information, with very few editorial ideas focused in any particu-
lar political direction. That is, the newspaper tended to minimize
the extent of political content.

Although our five artists are judged as political artists, it
would be a mistake to judge them *solely* as such, for none of
them consciously tried to create a political art in the manner

attempted by the Russian poet Maiakovski after the Bolshevik
Revolution. In general, the artists on the *Masses* and *Liberator*
made no conscious attempt to create a purely political art; they
did attempt, however, to synthesize their artistic and political
rebelliousness, and it is this effort which made these magazines
so graphically exciting.

While their greatest successes were in capturing the ferment
of artistic and political dissent, their most significant failure was
their continual inability to provide a deeper analysis of the role
of art and politics in the culture. In the twentieth century,
graphic artists were changing from old craft forms of organiza-
tion to proletarian forms. But the artists were not really aware
of this change—they were fighting to perpetuate art as a craft
(this was particularly true of John Sloan), when in fact art had
been assimilated into the industrial order. They failed to see
themselves and the communications media as intrinsic to the
functioning of the political-economic system. And thus they
did not have a sense of their social worth as artists to society.

NOTES

1. Proletarianization is not necessarily connected to increasing misery,
or to socialist or even to trade union consciousness. It refers to the fact
that the artist, instead of marketing his art, markets his *ability* to produce
a certain kind of art for an employer. By the 1890s the free professional
illustrator, who was closer to the artist and artisan than to the wage
worker, had virtually disappeared. Most cartoonists worked steadily for
chains, newspapers, or magazines. They were no longer entrepreneurs
selling their property. A publisher, editor, or advertising agency was selling
it instead; the cartoonist therefore belonged to a propertyless class, the
proletariat. To be sure, some artists at an earlier time faced similar condi-
tions in the marketplace. The point here is that by the 1890s these condi-
tions had become so general and endemic that artists began responding
collectively to them.
2. Morton Keller, *The Art and Politcs of Thomas Nast* (New York:
Oxford University Press, 1968), p. 8. This discussion of printing techniques
is based on Frank Luther Mott, *A History of American Magazines* (Cam-

bridge: Harvard University Press, 1938), II, pp. 43-45, 192-193, *American Journalism: A History, 1690-1960* 3rd ed. (New York: Macmillan Company, 1962) pp. 321, 400, and especially on the survey of changes in printing conventions in Edgar John Bullard III, "John Sloan and the Philadelphia Realists as Illustrators, 1890-1920," Master's thesis, University of California, Los Angeles, 1968, pp. 3-7.

 3. Bullard, "Illustrators," pp. 8-11. Mott, *Journalism*, p. 501.

 4. Bullard, "Illustrators," pp. 11-12. Mott, *Journalism*, pp. 501-502.

 5. Bullard, "Illustrators," pp. 13-14, 70. Quote 1 from p. 13. Quote 2 from Milton W. Brown, "The Two John Sloans," *Art News* 50 (January 1952):26. Bullard, "Illustrators," p. 80, dated the peak period of American illustration as 1880-1910.

 6. Art Young, "Theory of Design, Technique, and Materials," under "Cartoon," *Encyclopaedia Britannica: A New Survey of Universal Knowledge*, vol. 4 (London, 1929), 14th ed., p. 951. According to Lloyd Goodrich, "halftone dulls a drawing, putting a film over it; whereas linecut is the nearest equivalent in ordinary photomechanical reproduction to the artist's original drawing." "Draft #2," p. 9 [manuscript], John Sloan File, Whitney Museum Records, Archives of American Art, Detroit. Charcoal required a halftone screen, so no *Masses* drawings, despite first appearances, were done with charcoal. An artist could, however, use graphite on pebbled paper, and achieve an effect similar to that of charcoal. Interview with Helen Farr Sloan [John Sloan's widow], December 16, 1970. Bullard, "Illustrators," p. 106.

 7. Van Wyck Brooks, *John Sloan: A Painter's Life* (New York: E. P. Dutton & Co., 1955), pp. 39-40, note. Charles H. Morgan, *George Bellows: Painter of America* (New York: Reynal, 1965), p. 45.

 8. Herbert Marcuse, *One-Dimensional Man: Studies in the Ideology of Advanced Industrial Society* (Boston: Beacon Press, 1964).

1
The *Masses* and the *Liberator*

Irving Howe, writing in what must have been one of his more expansive moods, said that "there has never been, and probably never will again be, another radical magazine in the U. S. quite like the *Masses,* with its slapdash gathering of energy, youth, hope." The *Masses* was founded by Piet Vlag and was financed by Rufus W. Weeks, vice-president of New York Life Insurance Company, as a magazine devoted to consumer cooperatives, socialism, art, and literature. After a year and a half it was still not self-supporting, and "Vlag's cooperative stores were suffering from too much individualism." Vlag wanted to merge the *Masses* with a Chicago socialist women's magazine, but the artists rejected his plan. The artists, including Charles and Alice Beach Winter, John and Dolly Sloan, Louis Untermeyer, Eugene Wood, Maurice Becker, Glenn O. Coleman, William Washburn Nutting, H. J. Turner, and Art Young, met to keep the magazine going. Young suggested Max Eastman, a student of John Dewey and a philosophy instructor at Columbia, as editor. All signed the letter to Eastman: "You are elected editor of the *Masses,* no pay." Though "not keen about taking a no-pay editorship," recalls Art Young, Eastman accepted. In December 1912 the *Masses* was out again with a colored cover, a new layout, "and a fresh note of hope." Their policy statement proclaimed that "our appeal will be to the masses, both Socialist and non-Socialist, with entertainment, education, and the livelier kinds of propa-

13

ganda." They frankly hoped that the magazine, as a "meeting
ground for revolutionary labor and the radical intelligentsia,"
would bring together art and politics.[1]

In mid-1913 editor Eastman moved the *Masses* from Nassau
Street on the edge of the downtown jewelry district to 91
Greenwich Avenue in the center of Greenwich Village. Under
Eastman the *Masses* was financed by a number of patricians,
notably Mrs. August Belmont and Amos Pinchot, and by
E. W. Scripps and Eastman's fees from lectures.[2]

Although Eastman later founded the *Liberator* with the same
intention of providing a radical but humorous journal of politics
and art, the *Liberator* was in many ways a different magazine.[3]
World War I and the Russian Revolution had changed the
American radical movement by markedly altering the nature and
setting of the bohemian-socialist rebellion which fed the *Masses*
and the *Liberator*.

In the decade of the 1910s there existed a large, mass-based
socialist movement in the United States, organized in the Social-
ist party of America (SPA), which reached a peak membership
of 118,000 in 1912. In 1910 most members were native born,
but by 1919 a majority of the party were foreign born, mostly
in Eastern European language federations. In this decade, the
SPA's center of gravity shifted from a concentration among
miners, lumber workers, and farm laborers west of the Mississippi
River to industrial workers in the larger midwestern and eastern
cities. The Socialist party had real influence in the trade union
movement, particularly among garment and brewery workers,
machinists, and miners. In all these respects—except for its
increasingly foreign-born ethnic composition—the SPA differed
from the communist parties of the 1920s and 1930s.[4]

There were factional tensions within the Socialist party. On
the left were the industrial-unionist Industrial Workers of the
World (IWWs) under Bill Haywood, and on the right, the "con-
structive" municipal socialists such as Victor Berger. Questions
such as union organization, parliamentarism, and immigration
restriction were never resolved. The IWWs left the party after
Haywood was expelled from its National Executive Committee

in early 1913 over the question of industrial sabotage. But
generally latitudinarianism characterized American socialism and
the SPA until 1919. Factional differences were fought out within
the party, and losers were not expected to confess error or be
purged. That is, the Socialist party of America in this decade had
no party line, although members did share a general outlook.[5]
Such latitudinarianism permitted an easy alliance between artists,
journalists, the bohemian intelligentsia, and the socialist move-
ment. To a great extent, the *Masses* exemplified this latitudi-
narianism in its colorful and high-spirited pages.

But prominent Progressive Amos Pinchot also asserted that

> the Masses is a big stunt. It is fiercely militant, of course, but
> it combines a lot of fine thinking with its fierceness, and as
> an artistic and literary production it is in a class by itself. It
> is kind of harrowing to many people, but I think that it does
> much good. Old gentlemen who totter around the University
> Club library read it and tear it up in a rage. I think that when
> the rage passes, they are probably a lot more human and alive
> than they were before.[6]

Perhaps as a big stunt, too, John D. Rockefeller contributed a
dollar to the Masses Publishing Company. Max Eastman (though
he later renounced socialism entirely in *Reflections on the Failure
of Socialism* [1962] and other essays) referred to the *Masses*
with great fondness in his memoirs:

> The *Masses* was not ill-humored and bitter, it was lusty and
> gay. I doubt if socialism was ever advocated in a more life-
> affirming spirit. We did shock the American mores with some
> gloomy-grim and cruel writing, and with saber-toothed cartoons
> that set a new style in both art and satire. And we spoke our
> minds with unprecedented candor on both sex and religion.[7]

The *Masses* was a cooperative and its staff shareholders; its
successor, the *Liberator*, was not. At *Masses* meetings in the
Village, the staff voted on writings and illustrations for publica-
tion in the forthcoming issue, although Floyd Dell and Eastman
still exercised disproportionate influence. "At the monthly pre-
publication meetings of *The Masses*," Maurice Becker explained,

"there were always a group of subscriber visitors. They were always welcome."[8]

Dell, as a *Masses* and *Liberator* editor, devoted much attention to the Village and what it meant to its denizens, pointing out how radically its composition and character changed during and after World War I. Dell arrived in New York from the Midwest in late 1913, when Greenwich Village was still "a picturesque twentieth century slum," before the West Side subway and the traffic of Seventh Avenue cut through its twisted streets. Rents were low, and it was quiet and secluded. The Village and its artists existed before the 1900s, but "in tiny cliques and groups . . . mutually indifferent or secretly suspicious of each other."[9]

But when Dell arrived, the Liberal Club gave the Village a new character by being the center for loud, inciting ideas. The setting, then, for prewar radicalism was "the atmosphere of the salon, the informal 'club,' the *Masses* editorial conference. . . . These intellectuals entertained radical proposals in much the same way that they entertained views on other matters. Political issues and economic questions were—like birth control, woman's suffrage, psychoanalysis, and vegetarianism—subjects of debate."[10]

But during World War I the Village became commercialized. "The little basement and garret restaurants," Floyd Dell remembered, "decorated according to our own taste, proved a lure to up-towners, who came into the Village with . . . a pathetic eagerness to participate in the celebrated joys of Bohemian life." New restaurants along with higher prices sprang up, and old residents left the Village as a "show-place, where there was no longer any privacy from the vulgar stares of an up-town rabble." As old Villagers departed for the suburbs, there "appeared a kind of professional 'Villager,' playing his antics in public for pay."[11]

As if to underscore the general cultural decline of the Village, Irving Howe, a noncommunist socialist, lamented that after World War I, "as our radicalism took a disastrous plunge into a peculiarly sterile form of communism, the spirit of *The Masses* would be dead." It was not to be revived, felt Howe, by the *Liberator,* which "took a hand in stirring up the infantile disorders of communism," nor by the *New Masses* (1926-1948),

which manipulated artists "cynically in behalf of Stalinism."[12]

In contrast to the *New Masses* and the *Masses,* the *Liberator* reflected the process of transition between the latitudinarian, ideologically vague, pre-Russian Revolution American socialism and the hard-line communism of the depression. But despite this contrast, the *Liberator* was tied much more closely to the *Masses* and the 1910s than to the *New Masses* and the 1930s. The *New Masses* was a more "political" magazine than either the *Masses* or *Liberator.* The *Masses,* though partial to the Industrial Workers of the World, supported all radical elements in the labor movement. Although the *Liberator* favored the Workers party, it honestly recognized, but did not actively support, all radical facets of the trade union movement. In contrast, the *New Masses* was bound to the Communist party's labor programs. For example, when in the midthirties the party switched from a policy of organizing independent unions to infiltrating (or "boring from within") established unions, the *New Masses* focused on the organizing drive in heavy industries to the ex- clusion of other radical labor developments.[13]

Thus, one answer to the question of why "old" *Masses* illus- trations appear original and funny—despite the masthead pro- claiming "A Revolutionary And Not A Reform Magazine"— is the unformed nature of American socialism, with its roots in bohemian revolt, before the impact of the Bolshevik model on the United States. For example, the socialist press, which in 1912-1913 reached a peak of 323 periodicals, offered no of- ficial national newspaper until 1914. All major publications, like the *Masses*, were privately owned.[14]

What *Masses* managing editor Dell said of the Transcendenta- lists of the 1840s, that "their views represented a fairly undif- ferentiated mass of anarchism, communism, feminism, and republicanism—but all of an extreme kind, and hence entitled to our respect," applies as well to the *Masses* artists who con- sidered themselves socialists. Frederick Hoffman feels such con- fusion was clarified by "the conviction," widely shared by pre- war radicals, "that there were several solutions to the crisis in capitalism." Eastman stated the general position of the *Masses*

to be socialist but undogmatic, for revolution but not necessar-
ily by violence, yet never for reform. Men, he granted, struggle
for their economic interest; in taking the workers' side in the
battle for justice, compromise was impossible, though short-term
gains would be accepted.[15]

In its simplicity the *Masses'* policy was consistent. That was
not merely because of the little time available to develop ideology,
but rather because the *Masses* did not want to develop an
ideology. It was a Progressive era periodical described as "unof-
ficially a representative of left-wing socialist thought. . . . Dedi-
cated to democracy and liberty and based on the scientific
theories of pragmatism and instrumentalism as well as Marxian
socialism, the magazine passed through a brilliant, revolutionary,
yet anti-dogmatic career which touched on every area of liberal
thought."[16] Thus, the *Masses'* "easy flexibility" allowed it to
criticize socialist politics and life with an ease and "a humor
that the artists of the thirties denied themselves." But the pre-
World War I world was more vigorous than that of the postwar
era. That is, before 1914 America did not seem as fixed and
determined. The industrial working class was growing very rapid-
ly, but the large corporations had not totally entrenched them-
selves in the state, despite the efforts of Presidents Roosevelt
and Wilson. The world of the 1910s was more open and the
Masses merely expressed this, whereas the world of the 1930s
was corporate-dominated and -structured, and seemed to be
in decline.[17]

But if "*The Masses* expressed the distinctive mood or attitude
of the prewar insurgency . . . it also expressed its contradictions
and uncertainty, and, to some extent, its vagueness." As Max
Eastman recalled:

> I don't know how many of us really believed, or how firmly,
> in the Marxian paradise where the "wage system" would
> disappear, liberty and organization lie down together like
> the lion and the lamb. . . . But that was the general idea. . . .
> I did not envisage the overthrow of the United States Govern-
> ment, and both for the law and my conscience's sake, I

> avoided "advocating violence." . . . And although we had not
> a notion of that armed assault of the proletariat on the state
> and the pillars of society which extreme-left Marxists in Con-
> tinental Europe projected, we went as far in that direction as
> any Anglo-Saxon organ of socialism had. We were . . . a "red
> paint signal post" on the road that led—how little we guessed—
> to the Russian Bolshevik Revolution.[18]

The *Liberator*, though it started with the *Masses* staff and
looked back with nostalgia at its predecessor, faced (like all
socialist publications after 1917) much harder choices than the
Masses. It advocated no new role for the radical artist, but en-
visioned only one solution to the crisis in world capitalism:
Soviet communism. The *Liberator* typically referred to "two
of the greatest events in all the history of mankind . . . social
revolution in the Empire of Russia, and . . . the dawn of social
revolution in the Empire of Germany." Then it warned that in
the United States

> we are going to . . . go forward to the day of power when we
> will establish a new constitution. . . . And the essential princi-
> ple of that constitution, as of the constitution of Russia, will
> be this, that no man or woman is a citizen entitled to vote,
> who does not live upon the income of his own labor.[19]

But while supporting the revolutionary upsurge in Europe (es-
pecially in publishing articles by Lenin, Radek, and Trotsky),
the *Liberator* avoided any call to insurrection in the United
States.[20]

The *Masses* and *Liberator* were as refreshing as the *New
Masses* was dull. The older protest—if in some ways more per-
sonal and cultural than social and political—was nevertheless at
least culturally relevant or indigenous to American life and con-
ditions. That is, the *Masses*', and to an extent the *Liberator*'s,
rebellion occurred in anarchic, native Protestant fashion which
paralleled the contemporary mood created by the participatory
immediatism of the Industrial Workers of the World. For exam-
ple, in 1912, in the SPA's "red-yellow" or "left-right" conflict
over the primacy of direct action (strikes, violence, and sabotage)

over political action (electioneering and the "immediate pro-
gram" of reformist gains—wages, hours, conditions, and the
like), the *Masses* sided with the IWW-led "reds" and with in-
dustrial unionism, as opposed to craft unionism (though it con-
sistently argued that both political and direct action were
necessary).[21] *Masses* reporter John Reed covered the famous
IWW-led silk workers' strike at Paterson in 1913. Art Young,
Maurice Becker, and Robert Minor, while on the staffs of the
Masses and *Liberator*, contributed to IWW publications such as
New Solidarity (Chicago, 1918-1920) and *Industrial Worker*
(Seattle, 1916-1939).

The point is that in siding with the Industrial Workers of the
World the *Masses* identified the "Wobbly" (as IWW members
were called) with "the proletarian hero depicted as a tramp and
hobo," a tramp implicitly similar to the Greenwich Village
bohemian-socialists comprising the *Masses*.[22] It should be added,
however, that the *Masses* was pro-IWW but not a part of that
organization. This is seen artistically in the *Industrial Worker*
cartoon, "The Brawny Gyppo" (Figure 1), by Pelaren. The
drawing is cluttered and its draftsmanship is poor, but it is
saved by the two captions done in true proletarian argot, which
no *Masses* artist ever heard of.

If the *Masses* somewhat mirrored the IWW left wing of Ameri-
can socialism, the *Liberator* in turn tended to reflect the early
American communist movement emerging in 1919. Despite the
great influx of foreign-born members after 1914 into the Social-
ist party of America, and from there to the communist parties,
before mid-1921 the communist movement attracted a number
of native-born IWWs, such as James Cannon, and acted much
like the IWW of the early 1910s. The early communist factions
(the Communist party and United Communist party, united in
June 1921 as the Communist party of America) openly advo-
cated direct action, and ridiculed political electioneering and the
idea of "boring from within" the American Federation of Labor
(AFL) craft unions. With revolution seen as imminent throughout
the capitalist world, reforms, compromises, and patient organiz-
ing were considered absurd. Lenin's " 'Left-Wing' Communism:

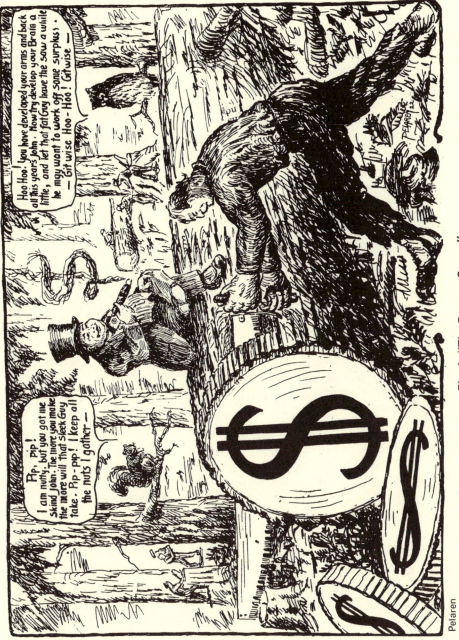

Pelaren
Industrial Worker. Feb. 25, 1922.

Fig. 1. "The Brawny Gyppo"

An Infantile Disorder" (written in 1919 but not available in the
United States until 1921), marked Moscow's recognition that the
world revolution was not imminent. However, the American
communist parties were so accustomed to the immediatist, anti-
political IWW style of radicalism that not until June 1921—under
orders from the Comintern's Second Congress of 1920, which
many American delegates to the Comintern resisted—was "the
dual-union and anti-political tradition . . . formally surrendered"
for the first time: communists were to stay in the AFL, or-
ganize no new industrial unions, participate in elections, and
establish a legal party.[23]

The (legal) Workers party began in December 1921. The
Liberator was friendly to the new party, but only after the
Liberator was turned over to the Workers party in October 1922
was more space devoted to politics. The December editorial
stated: "We expect to direct our attention more than we have
for some months past to political issues, and to direct attention
more deliberately than heretofore to The Workers' Party, the
organized political movement which . . . best represents the
revolutionary interests of the American workers." Accordingly,
from October 1922 through 1923, the *Liberator* concentrated
on specific communist programs, particularly on the "amalgama-
tion" of all unions into industrial unions and on a broadly based
Farmer-Labor party. Until that time, the *Liberator* argued that
Soviet communism was a popular movement, that with revolu-
tion pending in Europe American workers should build socialism
in the United States by militant political and industrial struggle,
but should not collaborate with Samuel Gompers' AFL leader-
ship. To the extent that from its inception the *Liberator*, like
the *Masses*, supported both political and direct action, its com-
munist position deviated from that of the pre-Workers party.
Though it devoted more space to political and economic de-
velopments than the *Masses* did, the *Liberator* through 1922
nevertheless featured a striking variety of illustrations, cartoons,
verse, and short stories, some totally apolitical. If the radical
artist on the *Liberator* faced growing tensions over the question
of his role, the *Liberator*, like the *Masses*, continued to assume
that free art complemented politics.

The *New Masses* reflected the sectarian, Comintern-oriented tactics of the Communist party during the depression, with the partial exception of the years before the Popular Front of 1935-1939, when dual unionism was advocated. The pages of the *New Masses* are replete with interminable ideological quarrels, accusations, and literary purges. The party's decision in 1935, in response to Comintern policy, to set up a Popular Front and engage in "mass action," was a euphemism for patient organizing, alliance with "progressive" antifascist elements, and reformist labor gains—again discarding revolutionary tactics and strategy until the day of the inevitable, but never to be gotten, revolutionary consensus.[24] *New Masses* cartoonists quickly switched from portraying exploited workers and fat capitalists to attacking fascists and racists at home and abroad. The AFL and Franklin Roosevelt—though not his opposition—were suddenly left alone.

One great failure of the artists of the thirties was their assumption that, in the transition from capitalism to socialism, a pure indigenous proletarian culture would simply emerge and that the artists' problem would be to portray and reflect this process. Thus, the artists' failure to sense their own worth stemmed from their view of the artistic role as basically one of reflecting or portraying proletarian culture. If the artist's role is merely to reflect, then he has as little worth as the 1930s artists. But if his role is to take part in creating new consciousness—that is, to make people aware of new things, develop new ways of looking at the world—then the artists of the 1930s undervalued that role. But, again, the theory that art must create new consciousness is another view of art altogether.

The American Communist party of the 1930s had a view, known as "socialist realism," that art either had to be a spontaneous expression of proletarian life or had to conform with the ideas of "dialectical materialism."[25] The relative mediocrity of such artists as John Sloan comes from their compulsion to reflect life rather than to create new forms. Becker, Minor, and Young on the other hand are interesting because they were not caught in the esthetic trap of having to reflect life.

The differences between the two journals also represent the peculiar crisis of the Protestant radical. The *Masses* artists were mostly lower-middle to middle class. Max Eastman, whose parents were both upstate New York Congregational ministers, could support strikers while raising money from Mrs. August Belmont. John Reed's dramatic trek to Russia, as the *Masses'* exclusive correspondent, to report firsthand on the Bolshevik Revolution (Reed's articles were subsequently published in the *Liberator*), was financed by money Eastman obtained from a New York socialite.[26] Both ethnically and in terms of class composition, the *Liberator* was closely tied to its predecessor; indeed, starting three months after the demise of the *Masses*, the *Liberator* featured most of the *Masses'* staff. But the *Liberator* was transitional in drawing a number of socially conscious artists from immigrant families.

As the Communist party went underground from late 1919 until the end of 1921, it was difficult for Protestant American artists to go with it, and some, such as K. R. Chamberlain, began to drift from the movement. Having known status, having published or shown their work, and being accustomed to the broadside attack in the *Masses* and *Liberator*, they thought communism as it developed in the early twenties to be strange and culturally irrelevant. Few of the older Protestant artists of the *Masses* and *Liberator* contributed more than a token drawing to the *New Masses*.

To the *Masses* and *Liberator* artists, though they considered themselves socialists, revolt was always a personal matter; socialism was only the backdrop for their own thinking. When John Reed, home from the Soviet Union in 1918, told Floyd Dell he would organize a Communist party in the United States, a disciplined party of professional revolutionaries, Dell replied that he would not join it because he was "a professional writer"; thus Dell expressed the very bourgeois egotism that he later criticized in his 1923-1924 *Liberator* articles. By the time of the New Economic Policy in the USSR (1921), *Liberator* editor Joseph Freeman noted that most radical American writers felt communism had been betrayed, though they themselves had

done nothing to further it. Art Young recalls of his *Liberator* days that

> beside Minor, many of the best artists and writers of that
> period thought of themselves as Anarchists, not as Socialists.
> They wanted to be at liberty to act as individuals without the
> restrictions of government, Mrs. Grundy's opinion, or any
> other frustrating element. . . . But most . . . lived to learn that
> something came before the Anarchist dream. That something
> was economic freedom, without which one could only give a
> feeble imitation of calling his soul his own.[27]

Whether or not the artists ever learned to act collectively during the course of the *Masses* and *Liberator* (at least until the end of 1922 when the *Liberator* was turned over to the Workers party), revolt was seen as an individual concern, and restrictive traditional mores seemed mere personal hindrances to be satirized. John Chamberlain says:

> The *Masses* may have been gayly savage and gleefully scornful
> . . . of the society which Herbert Croly and the *New Republi-*
> *cans* hoped to convert by laying on of hands, but for all that,
> the extreme intellectual Left of that day hobnobbed with
> liberal thought. Between a Lippmann and an Eastman the
> hopeful bourgeois convert to reformed democracy made little
> distinction. Weren't both men calling for Utopia? Freedom was
> the watchword, not the harsher slogans of the class struggle.[28]

Accordingly, a *Masses* editorial declared that "Socialism has more to gain from a free, artistic literature reflecting life as it actually is, than from an attempt to stretch points in order to make facts fit Socialist theory." Though, as *Masses* editor, Max Eastman was early irritated by what he called "the puny, artificial, sex-conscious simmering in perpetual puberty of the grey-haired Bacchantes of Greenwich Village," still, art was art and at least at this juncture the artist was beyond social criticism.[29]

Liberator staff meetings were irregular, but *Masses* meetings were held monthly. At the *Masses* meetings, though articles and illustrations were voted on by all present, cartoon captions were often suggested by Max Eastman or Floyd Dell, who sometimes

offered the cartoon idea to the artist in advance. Dell saw his
editorial task as one of choosing manuscripts to be voted on at
monthly meetings and helping to "plan political cartoons and
persuade artists to draw them." According to K. R. Chamberlain,
Eastman or Dell would sometimes say:

> There's a good idea, would fit your technique, so they give
> it to a man. But I was given some too, but most of mine I would
> hand in just as roughs. Sometimes the roughs were what they
> wanted and they ran them just as roughs. Like they do now in
> the *New Yorker*, how scribbly they are, some of them.[30]

Maurice Becker recalls that "cartoons and captions were voted
on at our monthly meetings. Occasionally captions were changed,
hopefully for the better, before press time by either Max Eastman
or Floyd Dell." But though Eastman was the *Masses'* motive
force, everyone expressed his opinion and voted accordingly (it
is unclear whether visitors, or subscriber visitors, present and
speaking out at monthly meetings, also voted). The artist whose
work was in question could insist that it be accepted in toto or
not at all.[31]

It was not that simple, however. Dell says he did not then
realize the nature of the problem, which was essentially one of
"co-operation between artists, men of genius, egotists inevitably
and rightfully, proud, sensitive, hurt by the world, each of them
the head and center of some group, large or small, of admirers
or devotees." The editors may have been manipulative at times.
Dell tells of going to the studio of an artist "whom I had been
persuading to draw certain pictures for the magazine, but doing
it—for artists are funny that way—so that he would think it was
all his own idea." Eastman's recollection was more blunt; if the
staff did "vote from time to time on a few texts and pictures,
that did not mean that many of us were deluded as to who was
editing the magazine."[32]

The question tacitly posed to artists was: can revolutionary
propaganda be art? The two journals attempted, if not a syn-
thesis or merging of art and politics, at least an equilibrium
between socialist theory and reportage, and free artistic expres-

sion. The *Masses* was probably more successful in this attempt than any other radical publication of art and politics before or since. The *Masses*, however, and the *Liberator* (through 1922) simply *assumed* art and socialism complemented one another. Eastman told *Masses* readers:

> We are going to make *The Masses* a *popular* Socialist maga-zine—a magazine of pictures and lively writing. Humorous, serious, illustrative and decorative pictures of a stimulating kind . . . and we have on our staff eight of the best known artists and illustrators in the country ready to contribute to it their most individual work. . . . We shall print every month a page of illustrated editorials reflecting life as a whole from a Socialist standpoint. . . . In our contributed columns we shall incline towards literature of especial interest to Socialists, but we shall be hospitable to free and spirited expressions of every kind—in fiction, satire, poetry and essay.[33]

In practice, politics and esthetics were not complementary. In 1916 a running battle festered over the journal's philosophy. Dell and Young said literary editors were on one side of such questions and artists on the other. Mary Heaton Vorse remem-bers that writers and artists each wanted all magazine space for their group, the artists being "more vital and more powerful" and tending to predominate. This division seems inaccurate. John Sloan led Glenn O. Coleman, Stuart Davis, Rockwell Kent, George Bellows, and the writer Robert Carleton Brown, but not Maurice Becker, Art Young, and K. R. Chamberlain, in opposition to the imposition of conscious "social propaganda" rather than inherent "social satire." (Minor and Boardman Robinson did not join the *Masses* as regular contributors until after this philosophical struggle.) To Sloan, satire, or an account of actual events rather than abstract themes, consisted of "a good observation of life that has social import and interest." Dell recalled that the fights were "usually over the question of intelligibility and propaganda versus artistic freedom; some of the artists held a smoldering grudge against the literary editors, and believed that Max Eastman and I were infringing the true freedom of art by putting jokes or titles under their pictures."

Since Sloan and Young were the only "verbally quite articulate"
illustrators and Young sided with the propagandists, Sloan, "who
was himself hotly propagandist," spoke for the artists "who
lacked parliamentary ability, and defended the extreme artistic-
freedom point of view."[34]

Apparently, these discussions were the nearest the *Masses*
staff came to explicit discussion of what socialist art should or
should not be, and the distinction between "social propaganda"
and "social satire" was crucial. Of course, the problem of main-
taining creativity and discipline is perennial, even if the *Masses*
and *Liberator* dealt with it uniquely. As Joseph Freeman, the
Russian-Jewish born poet, literary critic, and communist, said
in 1936 of his career:

> The dualism of my mind was only too evident. When I wrote
> economic or political articles, when I tried my hand at Marxist
> literary criticism, when my *mind* got busy, I was a communist.
> When I wrote poems and stories, when my emotions went into
> action, all the old feelings cropped up; the vanished village,
> the Brooklyn ghetto, the campus, the Renaissance, idealistic
> philosophy and romantic art crept out of their holes and spoke
> in my name.[35]

On the *Masses* Art Young carried the battle for greater artistic
politicization—that is, for direct attacks on capitalism in all its
manifestations. His efforts were supported by Maurice Becker,
K. R. Chamberlain, and, later, Robert Minor.

Sloan, Davis, and Coleman so resented Eastman or Dell for
putting "such a socialistic twist to the lines under the drawings
that we didn't like our drawings any more." It will be seen in
many instances that the *Masses* captions made the cartoons
radical, that the drawings made no political sense without the
captions. During one argument Young originated the phrase
"Ash Can School," adopted by art historians in the 1930s, com-
plaining, said Sloan, that "we thought we were attacking the
capitalistic system so *long as we put an ash can in a drawing.*"
At a stockholders' meeting in March 1916 Sloan objected to
Dell's and Eastman's hard-line political decisions on captions and
even on contributions. Eastman replied that cooperative editing

was impossible, though not cooperative ownership and control. Besides, he continued, "there is not a single point in the public or private policy of this magazine about which its present [contributing and managing] editors are agreed. Under such circumstances co-operation is a pretense."[36]

Such a situation doomed cooperation; the final break came the same year. Davis, Coleman, and H. J. Glintenkamp enlisted Sloan's aid for the so-called Greenwich Village Revolt meeting in April where the issue of personal versus social art was fought. "Sloan's point," his widow explained, "was that a drawing made with human sympathy often needed no title at all, and might lose its warmth of feeling if the viewer's eye were twisted by some dogmatic reference." Then Sloan, Davis, Coleman, and Robert Carleton Brown formally resigned, though Davis soon returned with drawings.[37]

More than any other event, World War I crystallized within the *Masses* these conflicts over the means of promoting socialism in a magazine of art and politics. In resigning from the *Masses*, Sloan, Coleman, and Davis specifically objected to the editors' antiwar captions under their pictures.[38] The October Revolution in Russia determined the context for debating the same question on the *Liberator* board.

Despite the problems of politics, the *Masses* continued to promote stylistic revolt: with its openness it was able to incorporate new forms and techniques. The magazine first dealt consistently with "Ash Can" or genre art when the typical American magazine cover displayed a Gibson girl or an orange sunset. But more than that. As Art Young said:

> Having a free hand on the *Masses* to attack the capitalist system and its beneficiaries loosed energies within me of which I had been unaware. I felt as many a Crusader must have felt long ago as he set forth to rescue the Holy Land from the infidels. For the first time I could draw cartoons striking openly at those who took the best years of the worker and then threw him on the scrap-heap. I didn't have to think about whether a picture of mine might offend an advertiser and thus violate a business-office policy.[39]

The *Masses* had an unusually free style of composition for
this era of American graphics—a style somewhat in the manner
of Forain and Steinlen, "done with some ease, a certain kind of
freedom, along with strong social satire, and a human quality."
As one reviewer put it: "Though many of the cartoons are
nakedly propagandistic, their use of bulky shapes in place of
line created a new pictorial style." Editor Eastman believed that
illustration in the *Masses* should be free from "the photographic,
or kodak, style of art" then dominating commercial magazines,
and "free to make enemies as well as friends."[40]

A master of the "quick and restive" style "which pierced the
essence of the subject" with "economy and force of line" was
the *Masses'* Boardman Robinson, whose "tense lines" broke
from the old pen and ink tradition of cartooning. Robinson
developed a style similar to Daumier's: with crayon, he created
sketchy, powerful, realistic illustrations. Robinson went to the
New York Morning Telegraph in 1907, about the same time Robert
Minor went to the *St. Louis Post-Dispatch.* On the *Masses* Minor
developed a more powerful but less racy style than Robinson's.
Maurice Becker, K. R. Chamberlain, and John Sloan followed
Robinson's and Minor's example, which sprang from the realism
of Forain and Steinlen's illustrations and posters. Some *Masses*
artists, such as H. J. Turner and Charles and Alice Beach Winter,
continued drawing with the cross-hatches common to the old
Life and *Puck* magazines and best exemplified in Charles A.
Winter's "The Miner" (Figure 2).[41]

A younger group of artists came to the fore on the *Liberator.*
They were heavily influenced by the German satirical magazines
Jugend and *Simplicissimus.* These were Cornelia Barns, who
began to work in this style on the *Masses,* Adolph Dehn, and
William Gropper. By the time of the *Liberator,* Robinson's and
Minor's style of broad crayoning, at first novel, then, through
the *Masses,* the hallmark of radical cartooning, was counter-
posed by the new style of "sharp linear caricature" used by
Dehn, Barns, and Gropper. They tended to use a "thin, tight,
nervous, and brittle line" and displayed an "almost micro-
scopic handling of detail." Their work was much in the manner

Charles A. Winter
Masses. June 1913. **Fig. 2. "The Miner"**

of the German satirist George Grosz's "thin linear" illustrations
of the 1920s, such as "Social-Democracy," reproduced in the
Liberator (Figure 3).[42]

The Armory Show of 1913 jolted those Ash Can people who
had never been able to assimilate modernism. The show, spon-
sored by the Ash Can-dominated Association of American
Painters and Sculptors, and including paintings and sketches by
the "Eight," demonstrated the limits of representational art
compared with expressive distortion in art.[43]

The show at the Armory demonstrated that Ash Can art was
not avant-garde compared with the new French modernists who
captured the exhibition—Cézanne, Duchamp, Gauguin, Picasso,
Matisse, Braque. Upon seeing the new French work, Ash Can
artist Jerome Myers wept, "for [organizer Arthur B.] Davies had
unlocked the door to foreign art and thrown the key away . . .
more than ever before, we had become provincials."[44] Likewise,
by 1913 the Ash Can impressionism of Sloan, Davis, Coleman,
and George Bellows, though it cooperated in introducing new,
everyday subject matter (the Bowery, Greenwich Village,
Jefferson Market Night Court) to American magazines and a
freer graphic style, was considered not nearly as creative as the
expressionism of Minor, and Robinson and Becker.

Ironically, it has been suggested that the Armory Show, which
undermined the Ash Can artists, may have been partly sponsored
by Mabel Dodge Luhan, whose salon many of them frequented
and whose admiration for the colorful rebellion of the IWW
extended also to art. "You accuse us of being a set of anarchists,"
she wrote in an article, "because we do not hunger contentedly
over the deposits of past achievement. This is as true of us as it
is of any moderns. . . . The outline around many of the old
forms must be admitted as too hard and narrow. Its inelasticity
constitutes its defeat."[45]

It is not surprising that Floyd Dell discovered Greenwich
Village had class distinctions—"high-brow" and "low-brow" or
old and new immigrants to the Village. Low-brow newcomers,
hanging around little-known basement cafes, regarded the *Masses*
and *Liberator* artists as artistically tame and conservative. Con-

George Grosz
Liberator. Sept. 1924. **Fig. 3. "Social-Democracy"**

versely, Dell found the new immigrants' Cubist and Futurist paintings and modernist prose and verse to be respectively "ugly and silly" and "unintelligible, and uninteresting."[46]

As a cultural product, the *Masses* was thus indigenous to the spirit of socialism and bohemian revolt prior to World War I. The *Liberator*, the inheritor of the tradition, was the final gasp of that ethos. The *New Masses*, on the other hand, reflected the new American left which emerged during the factionalism of the twenties. Of the three, because of a happy circumstance of time, artistic conventions, social and political developments, the *Masses* made the most intensive effort to merge art and politics. That it failed to do so should not obscure the attempt.

NOTES

1. Irving Howe, "The Force of Innocence," *Washington Post Book Week Supplement*, June 5, 1966, p. 6. Art Young, *Art Young: His Life and Times* (New York: Sheridan House, 1939), pp. 270-271, 274-275. (Quotes 2-5 from pp. 274-275.) Max Eastman, "New Masses for Old," *Modern Monthly* 8 (June 1934): 292-293. *Masses* 4 (December 1912): 3. Quote 7 from Max Eastman, *Enjoyment of Living* (New York: Harper & Brothers, 1948), p. 409. The *Masses* ran monthly, January 1911-December 1917; it absorbed the *New Review* in August 1916.

2. Louis Untermeyer, *From Another World: The Autobiography of Louis Untermeyer* (New York: Harcourt, Brace and Company, 1939), p. 42. Eastman, *Enjoyment*, pp. 403-404, 455-460, 463. Interview with K. R. Chamberlain, August 10, 1966.

3. The *Liberator* ran monthly, May 1918-October 1924.

4. James Weinstein, *The Decline of Socialism in America, 1912-1925* (New York: Monthly Review Press, 1967), pp. ix-x, 23-24, 27, 36-41, 182-184, 327.

5. Weinstein, *Decline*, pp. 2, 3-16, 22-23, 28-29, 37, 74-78. David Shannon, *The Socialist Party of America: A History* (Chicago: Quadrangle Books, 1967), pp. 48-50, 62-80. Charles Leinenweber, "Is American Socialism Unviable?," *International Socialist Journal* 5 (February 1968): 140-151. Joseph R. Conlin, "Wobblies and Syndicalists," *Studies on the Left* 6 (March-April 1966): 81-91.

6. Amos Pinchot to Berkeley G. Tobey [*Masses* business manager], March 31, 1914, Amos Pinchot Papers, Library of Congress, Washington, D. C.

7. Amos Pinchot Papers, n.d. Max Eastman, *Love and Revolution: My Journey Through an Epoch* (New York: Random House, 1964), p. 18.

8. Eastman, *Love*, p. 72. Maurice Becker to author, February 16, 1968.

9. Floyd Dell, *Homecoming: An Autobiography* (New York: Farrar & Rinehart, 1933), pp. 245-247. Caroline F. Ware, *Greenwich Village, 1920-1930* (Boston: Houghton Mifflin Company, 1935), pp. 14-15. Before arriving in New York, Dell was editor of the *Chicago Evening Post* literary supplement.

10. Dell, *Homecoming*, pp. 246-247. Quote from Frederick J. Hoffman, *The Twenties: American Writing in the Postwar Decade*, rev. ed. (New York: Macmillan Company, 1965), p. 392.

11. Dell, *Homecoming*, pp. 324-326.

12. Irving Howe, "To *The Masses*—With Love and Envy," Introduction to *Echoes of Revolt: The Masses, 1911-1917*, ed. William L. O'Neill (Chicago: Quadrangle Books, 1966), p. 5. From December 1922, the *Liberator* was under the ownership of the Workers party. The *Liberator* united with the *Labor Herald* and *Soviet Russia Pictorial* in November 1924, as the *Workers Monthly* (later the *Communist*, Chicago). The *New Masses* ran monthly, May 1926-September 1933; weekly, January 1934-January 1948. It merged with *Mainstream* in March 1948 as *Masses and Mainstream* (from September 1956 to August 1963, as *Mainstream*).

13. Martha Rose Sonnenberg, "A Contradiction within a Contradiction: The Experience of Radical Writers and Artists in America, 1912 to the 1930's," Master's thesis, University of Wisconsin, 1970, pp. 13-15. Foster Rhea Dulles, *Labor in America: A History*, 3d ed. (New York: Thomas Y. Crowell Company, 1966), p. 317.

14. Weinstein, *Decline*, pp. 84-87.

15. Floyd Dell, "An Early American Revolutionist," *Liberator* 4 (March 1921): 28. Frederick J. Hoffman et al., *The Little Magazine: A History and Bibliography* (Princeton: Princeton University Press, 1946), p. 152. Max Eastman, "Knowledge and Revolution," *Masses* 4 (December 1912): 5; 4 (January 1913): 5; 4 (April 1913): 5. John A. Waite, "*Masses*, 1911-1917: A Study in American Rebellion," Ph.D. diss., University of Maryland, 1951, pp. 49-51.

16. Waite, "Masses," p. 1. Waite stated that there was insufficient time to develop ideology (p. 58).

17. Sonnenberg, "Contradiction," pp. 13, 54.

18. Daniel Aaron, *Writers on the Left: Episodes in American Literary Communism* (New York: Harcourt, Brace & World, 1961), p. 23. Eastman, *Love*, p. 21.

19. Max Eastman, "November Seventh, 1918: A Speech in Commemoration of the Founding of the Soviet Republic in Russia," *Liberator* 1 (December 1918): 22-23.

20. Eastman, *Love*, p. 70. Certain *Liberator* editorials could be misin-
terpreted as condoning insurrection in the United States: 1 (March 1918): 3;
1 (January 1919): 5; 1 (February 1919): 5-6. But in the same period the
magazine advocated the election of socialists to Congress (1, July 1918: 5),
and opposed terrorist bombings (2, July 1919: 6; 2, August 1919: 30).
Beginning in April 1921, the *Liberator* began to drop its immediatist
posture, a process completed by October 1922.

21. William English Walling discussed industrial unionism in "Class Strug-
gle Within the Working Class," *Masses* 4 (January 1913): 12-13. Eastman
frequently dealt with direct and political action in his column "Knowledge
and Revolution": 4 (December 1912); 5-6; 4 (January 1913): 5-6; 4
(February 1913): 5; 4 (August 1913): 6.

22. James Burkhart Gilbert, *Writers and Partisans: A History of Literary
Radicalism in America* (New York: John Wiley and Sons, 1968), pp. 13,
25-26.

23. Theodore Draper, *The Roots of American Communism* (New York:
Viking Press, 1963), pp. 159, 198-201, 223-225, 248-249, 251, 255-257,
270-272, 273-274, 304-306. (Quote from p. 273.) A Communist party splinter
group formed the Proletarian party in 1920, and another formed a separate
Communist party, which joined the Communist Labor party the same
year to establish the United Communist party. The Workers party, under
formal Communist party of America (CPA) control, was established in
December 1921. The CPA, formally dissolved by the Workers party in
1923, was changed to the Workers (Communist) party of America in
1925, then to the Communist party of the United States of America
(CPUSA) in 1929. Theodore Draper, *Roots*, pp. 211, 218-222, 267-272,
390.

24. Leon Samson, *Toward a United Front: A Philosophy for American
Workers* (New York: Farrar & Rinehart, 1933). Probably the sharpest
policy switches were in the August 29, 1939 and July 1, 1941 numbers.
The former supported the Soviet-German Pact and the latter United States
intervention in World War II. Before August 29, 1939, the *New Masses*
considered compromises with fascism appeasement, and before July 1,
1941 saw the European war as an imperialist struggle.

25. Sonnenberg, "Contradiction," pp. 14-23. Socialist realism was first
introduced in the USSR in 1932 in conjunction with the first five-year
plans. Jean-Pierre Morel, "A 'Revolutionary' Poetics?" in *Yale French
Studies*, ed. Jacques Ehrmann, vol. 39 (New Haven, 1967), p. 160. Before
1932 there had been a great deal of artistic experimentation in the Soviet
Union, especially in the 1910s, with the Futurist painting of Kandinsky
and Chagall, and the Futurist verse of Maiakovski. Dialectical materialism
was the philosophy and method for the study of "the conflict of contra-
dictions that takes place . . . both in nature and society." V. Adoratsky,

Dialectical Materialism: The Theoretical Foundation of Marxism-Leninism (New York: International Publishers, 1934), p. 23. For these purposes, the "dialectical" side of the term dialectical materialism refers to the fact that there are objectively describable, irreconcilable conflicts within nature and society. And "materialism" is taken to be a denial of any attempt at treating these conflicts as simply subjective or ideological.

26. Interview with K. R. Chamberlain, August 10, 1966. Eastman, *Enjoyment*, pp. 402-404; *Love*, p. 63.

27. Dell, *Homecoming*, p. 328. Joseph Freeman, unpublished chapter of *An American Testament: A Narrative of Rebels and Romantics* (New York: Farrar & Rinehart, 1936), in Aaron, *Writers*, p. 102. Young, *Young*, pp. 387-388. The *Liberator* pieces, "Literature and the Machine Age," 6-7 (October 1923-October 1924), were republished as *Intellectual Vagabondage: An Apology for the Intelligentsia* (New York: George H. Doran Company, 1926). Caroline Ware wrote that after World War I Greenwich Village "social radicals" had three options: submitting to party discipline, contributing to various reform drives, or becoming mere observers. Most chose the last course. *Village*, p. 262.

28. Hoffman, *Magazine*, p. 28. John Chamberlain, *Farewell to Reform: The Rise, Life and Decay of the Progressive Mind in America*, 2d ed. (Chicago: Quadrangle Books, 1965), pp. 278-279.

29. *Masses* 1 (February 1911): 3. Eastman, "New Masses," p. 297.

30. Young, *Young*, p. 386. John Sloan, verbatim notes of Helen Farr Sloan, interview with Arthur deBra, c. 1945, Delaware Art Center, Wilmington [hereafter cited as Sloan, notes]. Dell, *Homecoming*, p. 249. Interview with K. R. Chamberlain, August 10, 1966.

31. Maurice Becker to author, July 19, 1968. Eastman, *Enjoyment*, pp. 439-440; *Love*, pp. 16-17, 72.

32. Dell, *Homecoming*, pp. 251, 256. Eastman, "Bunk about Bohemia," *Modern Monthly* 8 (May 1934): 207.

33. *Masses* 4 (December 1912): 3.

34. Helen Farr Sloan to author, August 22, 1966, and July 20, 1965. (Quote 1 from August 22, 1966.) Dell, *Homecoming*, p. 251. Art Young, *On My Way: Being the Book of Art Young in Text and Picture* (New York: H. Liveright, 1928), p. 280. Mary Heaton Vorse, *A Footnote to Folly: Reminiscences of Mary Heaton Vorse* (New York: Farrar & Rinehart, 1935), p. 42. Quotes 3-5 from Sloan, notes, interview with Arthur deBra. Interview with K. R. Chamberlain, August 10, 1966. K. R. Chamberlain to author, December 22, 1970.

35. Freeman, *Testament*, p. 657.

36. Quote 1 from Sloan, notes, interview with Arthur deBra. Helen Farr Sloan to author, July 9, 1967. Quote 2 from Sloan, notes, interview for *Art Student's League Bulletin*, 1946 [italics in original]. Eastman, *Enjoy-*

ment, pp. 548-552. There is a discussion of the origin of the term "Ash Can School" in Bennard B. Perlman, *The Immortal Eight: American Painting from Eakins to the Armory Show, 1870-1913* (New York: Exposition Press, 1962), p. 202, note, and William Innes Homer, *Robert Henri and His Circle* (Ithaca: Cornell University Press, 1969), pp. 280-281, note.

37. Helen Farr Sloan to author, July 9, 1967. Eastman, *Enjoyment*, p. 555; *Love*, p. 74. K. R. Chamberlain to author, December 22, 1970. Eastman stated in *Enjoyment* and *Love*, and William L. O'Neill in editing *Echoes*, p. 21, that Maurice Becker joined Sloan, Coleman, and Davis in walking out. Becker said this is incorrect; to author, July 31, 1968. Becker seems to be correct. In the next six *Masses* issues, for example, Becker contributed in three numbers.

38. Sloan, notes, interview with Mae Larsen for Santa Fe *New Mexican*, 1945. Helen Farr Sloan to author, July 9, 1967.

39. Interview with K. R. Chamberlain, August 10, 1966. Eastman, *Enjoyment*, p. 412. Young, *Young*, p. 277. Contrary to Eastman, the *Masses* was not the first magazine to utilize the one line cartoon caption. *Collier's*, *Life*, and *Puck* had earlier done so, and had used the two page cartoon spread.

40. Sloan, notes, interview with Mae Larsen. William Phillips, "Old Flames," *New York Review of Books* 8 (March 9, 1967): 7. Max Eastman, "What is the Matter with Magazine Art," *Masses* 6 (January 1915): 13, 15.

41. Albert Christ-Janer, *Boardman Robinson* (Chicago: University of Chicago Press, 1946), pp. 16-17. (Quotes 1-3 from p. 17.) Milton W. Brown *American Painting: From the Armory Show to the Depression* (Princeton: Princeton University Press, 1955), pp. 30, 187. Quote 4 from Oliver W. Larkin, *Art and Life in America*, rev. ed. (New York: Holt, Rinehart and Winston, 1960), p. 329. Joseph North, *Robert Minor: Artist and Crusader* (New York: International Publishers, 1956), pp. 48-50.

42. Quotes 1-3 from Brown, *Painting*, pp. 187-188. Quote 4 from Donald Drew Egbert, *Socialism and American Art: In the Light of European Utopianism, Marxism, and Anarchism* (Princeton: Princeton University Press, 1967), p. 99. Gropper was versatile in many styles.

43. Daniel Catton Rich, introduction, *George Bellows*, pp. 12-13. Charles Hirschfield, " 'Ash Can' Versus 'Modern' Art in America," *Western Humanities Review* 10 (Autumn 1956): 363-365. Bennard B. Perlman, "The Years Before," *Art in America* 51 (February 1963): 42. Modernism is that art characterized by two features: first, increased emphasis on expressive distortion—that is, giving up attempts at verisimilitude (such as Modigliani looking back, in some cases, to primitive art forms); second, a tendency towards nonrepresentational art. Modernism is one or the other feature, or a combination of both (and it excludes the Impressionists). It can be described as a revolt against art describing reality, and could be

dated beginning with the Post-Impressionism of Cézanne and Van Gogh. The "Eight" were named after the 1908 group exhibition of Arthur B. Davies, William Glackens, Robert Henri, Ernest Lawson, Everett Shinn, John Sloan, Maurice Prendergast, and George Bellows.

44. Jerome Myers, *Artist in Manhattan* (New York: American Artists Group, 1940), p. 36. The show was representative of current art trends except for the weak German Expressionist section and the absence of the Futurists. Milton W. Brown, *The Story of the Armory Show* (Greenwich, Conn.: New York Graphic Society, 1963), pp. 89-92; *Painting*, pp. 48-49.

45. Christopher Lasch, *The New Radicalism in America, 1889-1963: The Intellectual as a Social Type* (New York: Alfred A. Knopf, 1965), p. 107. Mabel Dodge Luhan, *Intimate Memories*, Vol. 3, *Movers and Shakers* (New York: Harcourt Brace and Company, 1936), p. 94.

46. Dell, *Homecoming*, pp. 279-281.

2
Art Young

Arthur Henry Young (1866-1943) grew up in Monroe, Wisconsin, a town of 2,000 near the Illinois line. His father ran a general store and a twenty-acre farm. Young's store on the square was a "gathering place" for local leading citizens and farmers from the countryside who told stories, all of them full of imaginative exaggerations.

> All these debaters were rugged individualists, who believed
> there was equal opportunity in the world for everybody who
> was willing to work hard and keep an eye open for the main
> chance. . . . I was frequently reminded that a farm boy who
> looked very much like my father [Garfield] also had attained
> to the nation's highest office.[1]

While listening to their stories, Young would caricature the talkers.

For a while Young worked for Monroe's leading photographer and thought about the "value of the creative craftsman" vis à vis the camera. He wondered if one who could not "draw as realistically, and catch light and shade accurately enough" to "beat a camera" should not give up art. But as photography developed, he came to see that the camera could not "successfully compete" with that art where "ideas, imagination, fancy, and symbolism are factors of supreme importance."[2]

Young liked poetry but not novels or serial stories which de-

41

manded "wading through too much type." Gustave Doré's
(1833-1883) wood engravings made the parlor volume of *The
Inferno* the first book to give Young a "real thrill." When a
lecturer on Doré came to Monroe and showed slides, Young felt,
as he later noted, that "I must escape from the humdrum life of
Monroe, and get away to Chicago. There, I felt, lay my big
chance," since "Chicago newspapers were just beginning to use
pen drawings." With a year to go, Young quit high school.[3]

In 1883, when *Judge* magazine sent Young (then only seven-
teen years of age) a check for a cartoon, he left for Chicago. He
signed up in anatomy at Chicago's Academy of Design (later
merged into the Art Institute of Chicago) and arranged enough
free lance drawing sales with the wholesale grocery publication,
Nimble Nickel, to cover tuition for two terms. After almost a
year in Chicago, Young called on the editor of the *Evening Mail*,
Clinton Snowden, for a job. Snowden saw "promising qualities"
in Young's samples and eventually gave him work illustrating
news stories or celebrity interviews.[4]

Generally, Young would suggest pictures to Snowden. While
roving Chicago in the 1880s, he found and attended some labor
meetings. At the age of twenty, he knew little of the working
class, and what he knew he had picked up from a few speeches
and sporadic reading.

> I lacked a foundation for such understanding. . . . In a vague
> way I sensed that the social system was not perfect, but all
> that seemed remote from my life. The questions raised by the
> soap-boxers were disturbing at the moment, but there was
> little I could do . . . to better the situation. I would give a
> hungry man on the street the price of a meal and bed, but that
> would help him only for the time being. And if I drew pictures
> of hungry people, as such, the *Evening Mail* certainly wouldn't
> publish them. It might use a news report of some man dying in
> the street from starvation, but it wouldn't go out of its way to
> air the causes which led to deaths of that kind.[5]

At one of these labor rallies, in 1886, when police interrupted
a speech at the Haymarket Square, a bomb was thrown, police
fired into the crowd, hundreds of known or suspected "anarch-

ists" were arrested, and the speaker and others were indicted.
Young accepted the press version of the incident—an anarchist
plot. Snowden assigned Young to draw courtroom scenes during
the resulting trial. The defendants were found guilty and their
appeals were unsuccessful; Young was assigned, two days before
the hangings, to sketch the "anarchists." One of the defendants,
Louis Lingg, committed suicide the day before the execution.
Young remembered Lingg well: "Had he opened his lips . . . he
probably would have said: 'Go ahead, you reporters, do what
your masters want you to do.'" Young later drew the cover for
a paperback, *Anarchists and Bomb-Throwers:* his picture showed
"law and order personified by an Amazonian woman, throttling
a bunch of dangerous-looking men."[6]

After the Haymarket trial, Young accepted a job offer from
Melville E. Stone, editor and part owner of the *Daily News.* Most
of Young's assignments came from editors and some from Stone
himself, who would contravene public taste if necessary. Once,
Young proposed a certain idea to Stone, saying "I think the pub-
lic likes such pictures." According to Young, the editor answered:
" 'Never mind what the public likes. I'll take care of that.' "
Daily News assignments gave Young "entree everywhere that
[he] wanted to go, and [his] life moved along smoothly."[7]

Young left the *Daily News* shortly and accepted a good offer
for work from the *Tribune.* But he was jolted by being quickly
fired by the *Tribune,* and he suspected that he had been hired
only to weaken the *Tribune's* competitor, the *News.* He could
return to the *News,* but decided to study art in New York instead.
On the train east, as he had for years, Young sketched fellow
passengers and wrote memoranda for travel jokes, doing about
ten drawings with dialogue for every one that was published. In
New York he signed up at the Art Student's League, "for I knew
that my flip sketches needed a basic understanding, especially
of anatomy." Bored by drawing from casts, Young sketched
comic pictures on sheets, awaiting criticism, and finally switched
to life classes.[8]

In response to what Young read in the New York dailies,
especially Pulitzer's *World,* of the evil of tenement conditions, he

"now and then . . . meandered into the heart of the [Lower]
East Side." Seeing this side of New York, Young "felt instinc-
tively" that people did not prefer filth to working. So the *World's*
accounts were true. "Yet what could one do about it? Nothing,
it seemed to me, except through reforms: cleaning streets, pay-
ing good wages, providing for cheap carfare, etcetera."[9]

He kept thinking of studying art in Paris, the "shining goal"
of Chicago and New York students. His friend Clarence Webster
wrote in 1889 that he had signed to do European travel articles
for the *Chicago Inter-Ocean,* and that if Young would accompany
his articles with pen-and-ink sketches the *Inter-Ocean* would pay
Young's passage to Europe. Young, now twenty-three, contem-
plated studying for at least a year. Once in Paris he signed up at
the Académie Julian to draw nudes during the days; he spent
evenings at the Colarossi School sketching costumed models.
Young worked hard, refrained from carousing, and decided
"graphic art was my road to recognition." Paintings were "for a
rich man to own in his private gallery," but a cartoon was re-
producible en masse. Young was the last person to leave the
Paris Exposition of 1889 on closing night, making sketches
which to his surprise were printed on a full page by the *London
Pall Mall Budget.* Now he planned "romantic and bizarre" travel
illustrations. "The market was waiting," but suddenly he dis-
covered he had contracted pleurisy.[10]

After a year and a half recovering in Monroe, he accepted in
early 1892 an offer from the *Chicago Inter-Ocean.* The editor
wanted to publish a cartoon a day, a practice common in New
York but novel in Chicago. After covering the Democratic con-
vention, Young's assignment was to depict the inequities of the
Democrats. John P. Altgeld ran for governor of Illinois that year
and Young drew a cartoon of him as being in "alliance with
thugs and bum element," for criticizing prison contract labor. It
was clear to Young that during a campaign "one's personal atti-
tudes, if one had any attitudes, were shelved . . . if they happened
to run counter to those of the publication." But being an *Inter-
Ocean* cartoonist gave him a chance to work with Thomas Nast,
who in 1892 came to the *Inter-Ocean* after it had installed the
country's first color press.[11]

There was long an "unspoken agreement" that Arthur Young and Elizabeth North, childhood sweethearts, would marry, the "usual understanding" in a small town when a couple went together, and it was fulfilled in 1895. Meanwhile, the *Inter-Ocean* came under the majority control of Charles Yerkes, a local "traction magnate," who tightened up schedules and began firing old employees. Young worked briefly for the *Denver Times*, but, tired of "boosting a locality," he quit.[12]

Once settled in New York in late 1895, Young free lanced for *Life, Puck*, and *Judge*. Arthur Brisbane, who managed Hearst's *Evening Journal*, gave him a job drawing cartoons against tenements and corruption, and illustrating Brisbane's editorials. Young liked the work, but was depressed over marital tensions. His work suffered and he was fired after six months, though with a standing offer from Brisbane for free lance work. Soon he separated from his wife. Politically, he was still a Republican: "Now and then some of my bourgeois beliefs had been shaken a bit by some ironic episode in the human struggle, or by some speech like that of Keir Hardie [the Scottish Laborite] in Denver, but I clung to my inherited beliefs."[13]

At the urging of friends the Youngs were reconciled. But when his wife announced she was pregnant, Young only feigned happiness and escaped to libraries and lectures. With the additional emotional and financial responsibility of having a son, he needed concrete answers to questions raised by Hardie and Myron Reid, an ex-preacher whom Young occasionally heard in Denver. Reid had been ousted from the pulpit for his outspoken radical views, and in listening to such speakers Young began wondering if capitalism did indeed exploit the producing masses. Young finally decided he had a common interest with the workers. He later wrote:

> In other years I had felt that as a newspaper artist I was a member of a profession which enjoyed important privileges and in which a man might possibly rise to fame and fortune. But I saw now that everyone who did productive work of any kind was at the mercy of those who employed him. They could make or break him whenever they so willed.[14]

When John Altgeld died in 1902, Young reread Altgeld's
"Reasons for Pardoning Fielden, Neebe, and Schwab," by that
time a pamphlet. Concluding that the defendants were innocent,
he felt "a deep sense of shame" for his earlier attacks on the
governor. He then decided that many of his beliefs were no more
than "copy-book maxims drilled into" him as a child, nothing
else but "glittering emblems set up by the moneyed class to
serve its own purposes. . . . [He] had been a drifter, innocent and
sheep-minded long enough."[15] Young's last politically objec-
tionable cartoon was "At An American Railway Station" (March
27, 1902), done in the nativist theme which was typical of *Life*
in the early 1900s.

At the same time Young moved closer to socialism. Acting
deliberately, he decided he "could no longer conscientiously"
deal with political subjects as editors wished. He wanted to spoof
the "money power," but there was no outlet for such cartoons.
Radical publications were unable to pay for his work. Young did
not know where he was going.

> [He] had talent, facility, and a desire to produce—but steadily
> [his] market was diminishing. [He] fell back on illustrated
> jokes, and even here struck a snag. Tramps were no longer so
> funny . . . as they had been. And [his] attitude toward the
> farmer had changed—[He] no longer wanted to depict him as
> a mere comic character. . . . The Populists had been right in
> many of the things they had said about the farmer's plight.[16]

Having been impressed by Robert LaFollette's 1902 reelection
campaign for Wisconsin's governorship and desiring to "re-shape
the course of [his] working life," Young volunteered his services
without pay to the *Milwaukee Free Press*, established to back the
governor. The *Free Press* agreed, and Young, believing LaFollette
"represented the honest Americanism which flowed from the
pioneers," produced cartoons regularly during the campaign.[17]

When another baby was expected, the Youngs relocated to
larger quarters. But Young faced more rejected drawings than
before and continued to read massively in order to fathom the
"causes behind the human struggle." He was leaving the Cooper

Union Library (just east of the Village) one evening when he
passed a debate class and, feeling that his inadequacy with words
contributed to the rejections of, or underpayment for, his politi-
cal cartoons, he decided to enroll in the course. He prepared
diligently for the class, hoping to learn to "defend my point of
view," always taking the side "which seemed to me *right.*"
In 1905, after the second child was born, Art Young and his
wife separated permanently.[18]

Young's new-found freedom seemed to open "the doors of
opportunity . . . just as in [his] youth. . . . But now [he] was
developing a hatred for all bourgeois institutions in addition to
marriage." Three years after his anti-immigrant "At An American
Railway Station" (March 27, 1902), Young sent back a much
needed $100 to *Life* after drawing a cartoon (at the suggestion of
editor John Ames Mitchell) which he later decided was false.
Life had repeatedly attacked the "theatrical trust," openly char-
acterized as a crass Jewish monopoly which stifled art. In Young's
anti-Semitic cartoon a woman, "The Drama," was being cruci-
fied by smiling Jewish theater owners. He thought of saving the
"tragic concept" of the crucifixion for "a cause greater" than
histrionics. After telling Mitchell he did not want the drawing
published, Young felt his work with *Life* was ended. Surprising-
ly, *Life* was still interested in him, and he began to think that
with his continued Cooper Union training he could "hold [his]
own" in argument with Mitchell. From his reading Young col-
lected famous maxims, illustrating them for *Life* as "Shots at
Truth." Underlying the idea of illustrated quotations was his con-
fidence that a title by Shakespeare allowed him to deal with
social questions under the sanction of tradition.[19]

Young had not yet thought of drawing for socialist publica-
tions, and had not been asked to. He was sympathetic "but was
not yet ready to speak out," though friends had told him, "With
your equipment as an artist, you ought to be a Socialist." He
still contributed to those established publications willing to take
his work, "endeavoring to put across pointed cartoons which
would in some way help the cause of Socialism. For [by the late
1900s] *Life, Puck,* and *Judge* would take pictures aimed at fire-

trap tenements, John D. Rockefeller, child labor, grafting public officials, sweat shops, deified money, exploiters of the poor, and related evils."[20] *Life* also accepted cartoons supporting women's rights, such as Young's "Not to Be Taken from Her Cross" (November 17, 1910). This attack on divorce laws utilized the crucifixion theme for an end acceptable to Young.

As Young concentrated more on social criticism, Brisbane requested special work for the *Journal* and then for the *Sunday American*'s "World Events" sections, but Young was "striking at effects rather than causes, and it was never possible to point to the institution which [he] was now convinced lay at the bottom of all these dark manifestations." Once, when he labeled a "fat silk-hatted figure" "Capitalism," Hearst's editor said "We can't do that. Call him *Greed*. That means the same thing, and it won't get us into trouble."[21]

In about 1910 Young "realized [he] belonged with the socialists in their fight to destroy capitalism. [He] had been a long time arriving at that conclusion. Often [he had] been asked: 'What made you a radical?'" To which he replied:

> It was no thunderbolt revelation that hit me like the one which struck Paul of Tarsus. . . . For years the truth about the underlying cause of the exploitation and misery of the world's multitudes had been knocking at the door of my consciousness, but not until that year did it begin to sound clearly. Earlier I had devoted a great deal of enthusiasm in certain periods to profit-sharing and public ownership, but I saw now that while these were moves in the right direction, the ultimate solution of society's greatest problem was the co-operative commonwealth, with production for use as the first point in the program, so that no human would ever again have to suffer for want of food, clothing, or shelter.[22]

Young began drawing cartoons "hitting directly at capitalism" as a system, publishing them when they were accepted or saving them for the day when they would be. Mitchell of *Life* accepted some. One, "Capitalism" (February 23, 1911), shows a "grossly fat gentleman at a table" on the edge of a cliff "which is littered with the leavings from a rich feast which he has just gorged. As he

leans back in his chair to drain a big golden bowl for his final fill, the chair is dangerously close to teetering over the brink."[23]

"Now," decided Young, "I was past forty years of age [forty-four] and I knew definitely where I was going. I was in such a state as our Christian forebears would have called 'righteous indignation.'" He felt he must guard against fanaticism, but devote his pen "to attacking the System which engendered so much woe." With this sense of purpose he moved to Greenwich Village, "then the radical center of artistic and economic ferment—in a sense the American *Montmartre.*" Though "days of real doing had set in," Young faced weekly economic crises meeting bills. "Not even if [he] were able to bring about the industrial commonwealth single-handed" would any radical publication be "turning [him] loose against the System and paying [him] for it."

> What money they had went to business upkeep and to sustain editors and writers expert at spreading out columns of wordage on the difference between the *tweedledee* of their wing of the movement and the *tweedledum* of the other wing. Of course these editorial writers had to know Karl Marx, the materialist conception of history, and how to use invective—with such equipment they would write a thousand words to say what a good cartoon could say at a glance.[24]

He survived financially by selling drawings to *Life* and *Judge,* occasionally to *Collier's.*

Later in 1910 Piet Vlag, whom Young had met at the Rand School of Social Science (north of the Village), came to his studio to discuss starting a magazine dealing with cooperatives, socialism, art, and literature. This magazine became the *Masses.* Vlag made monthly visits to Young's studio to pick up a *Masses* cartoon. Young usually had a drawing ready or they would agree on an idea dealing with a current topic. These pictures were generally easier for Young to draw than those for commercial magazines. "If you are getting paid for work most editors, like true business men, make it a rule to find fault. Anyhow they offer no praise, for fear you will think they need you and that

your money is earned too easily." But with Vlag, he could
develop the idea as he wished. "It was up to me, and I felt that
an audience was waiting to see what would be in the next issue."
Young was free under Vlag or Eastman to attack the capitalist
system or individuals representing it, and "it was gratifying . . .
occasionally to hear yelps of pain from the persons attacked."[25]

Two yelps of pain came from the Associated Press. In late
1913, during the West Virginia coal strike, Young and Eastman
were indicted for criminal libel by the Associated Press, an in-
dictment stemming from Eastman's *Masses* editorial, "The Worst
Monopoly," and Young's cartoon "Poisoned at the Source"
(July 1913). Eastman charged that the Associated Press dis-
torted or withheld news of the strike, calling it a "Truth Trust"
which adulterated the news. Young's cartoon showed the As-
sociated Press pouring a bottle of lies into the public news
reservoir. In January 1914 Floyd Dell, who had come to the
Masses from Chicago, was made associate editor, and the maga-
zine continued the attack on the Associated Press. Once again,
Eastman and then Dell were indicted for criminal libel by the
Associated Press, but after over a year the Associated Press
dropped the suits. When the *Masses* celebrated, Young drew
two cartoons, one showing the Associated Press as a well-
dressed matron dropping a scroll reading "The *Masses* Case,"
the other picturing the Associated Press as a white angel pour-
ing perfume labeled "Truth" into the reservoir.[26]

Art Young contributed to the *Masses* early and late, tangled
often with John Sloan and others who saw the magazine as a
vehicle of socialist *and* artistic expression. As Eastman recalled,
Young snapped, with "his mild eyes burning," at the Greenwich
Village rebels of 1916: "To me this magazine exists for socialism.
That's why I give my drawings to it, and anybody who doesn't
believe in a socialist policy, as far as I go, can get out."[27]

Although Young had only a fair sense of formal composition,
Sloan called him "our best cartoonist." Young's captions dealt
with appearances, with the maxims he was raised with, such as
"The Freedom of the Press" (Figure 4), whereas his pictures
went to the reality behind the appearance. Thus, the caption is

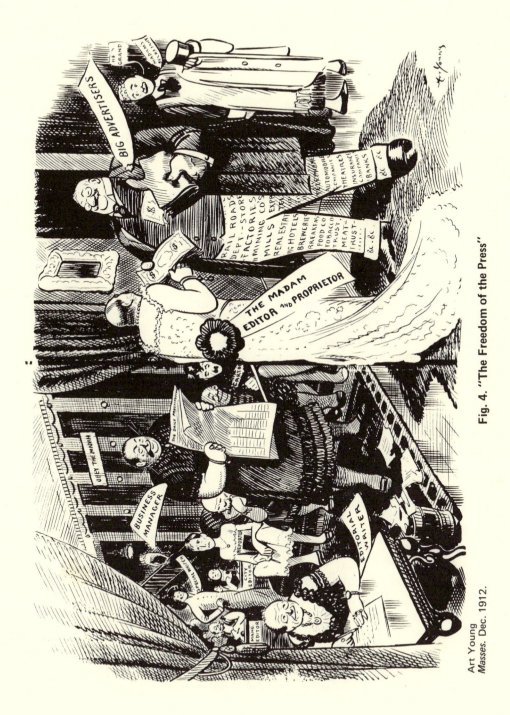

Art Young
Masses. Dec. 1912.

Fig. 4. "The Freedom of the Press"

necessary to understand a Young cartoon, and he devised very
good captions which were integral to the pictures. Other car-
toonists were unequal to Young in this respect. Chamberlain's
captions were often out of joint with his pictures, while Minor
and Becker depended less on captions. Max Eastman credited
Young as "a past master of the art of the caption. You could
never improve by a syllable the words he placed under a
picture."[28]

"Mr. Callahan" (Figure 5) illustrates the sort of play on words
Young frequently enjoyed doing. There is a certain ambiguity to
this cartoon. Superficially, Callahan represents a kind of stupid re-
ligiosity among the immigrant working class. Young thus mocks
the ignorance of the working class. On the other hand, Callahan's
way of looking at things shows an ironical temperament, reflect-
ed in his pedestrian attitude toward the other religious holidays
mentioned in the caption. In this sense, the holidays are merely
part of the passing scene. Going beyond first appearances, it
seems that Callahan is wryly detached from everything that
these religious symbols are supposed to evoke, yet did not evoke,
among the Irish working class.

The crux of "'I Gorry, I'm Tired!'" (Figure 6) is the hard lot
of the Irish working class. It is clear that a weary workingman,
far from finding soothing love and comfort at home, faces an
equally bitter and exploited soul in the person of his wife. He
has to work a hard day in a sewer; she spends an equally hard
day over a hot stove. In some ways this is bitter humor, but Young
chose a gentle way of making the point that for both the man and
the woman, with "hands like catchers' mitts," weary heads and
shoulders, working-class life was an ordeal of eking out a meager
existence.[29] Yet, Young did it gracefully, with a joke. The per-
fectly vernacular caption shows Young's real ear and feeling for
folk sentiments and folk humor. And it also brilliantly portrays
the pathos of the working class in both the husband's and wife's
struggle to keep body and soul together.

At the other end of the social ladder, the gentleman in "Re-
spectability" (Figure 7) is drawn to indicate that being respectable
means hiding all one's vices. Behind the facade of respectability

Art Young
Masses. Dec. 1913. **Fig. 5.** "Mr. Callahan (Reflectively): 'Ash Wednesday—Shrove Tuesday—Good Friday—Say, This is a New Wan on Me!!'"

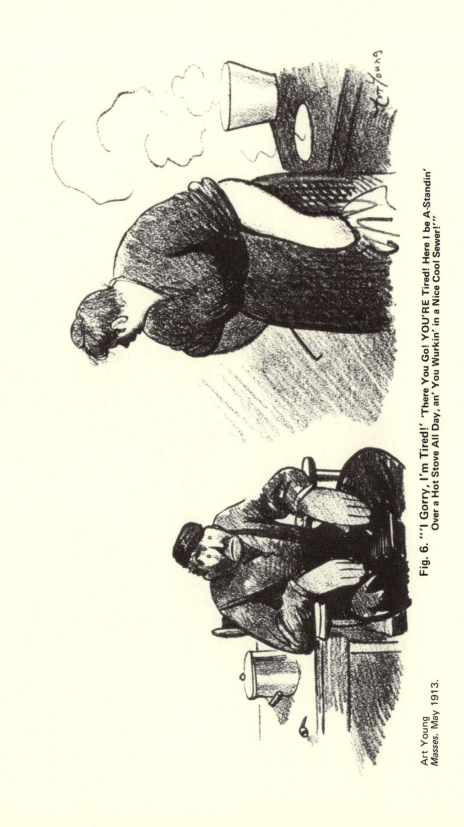

Fig. 6. "'I Gorry, I'm Tired!' 'There You Go! YOU'RE Tired! Here I be A-Standin' Over a Hot Stove All Day, an' You Wurkin' in a Nice Cool Sewer!'"

Art Young
Masses. May 1913.

Art Young
Masses. Aug. 1915.　　　**Fig. 7. "Respectability"**

are—on the psychological level—all kinds of desperate, hidden neurotic syndromes. Or more plainly, behind the facade is the pious fraud caught out. In either case Young always aimed to puncture hypocrisy and show the real truth behind the official image, the respectable symbol. In this case, a man who could be a railroad magnate, a pillar of society, is shown in a private moment of desperate anxiety and fear symbolically concealing objects that no doubt represent the various deviant tendencies behind the facade of respectability.

Young used a great deal of cross-hatching and though he added shading, especially to backgrounds but also to figures, his characters still have heavy outlines. They could be mistaken for woodcuts. But his general style, as in "The Freedom of the Press," was even more than woodcut; it was lithographic in that his work was densely populated, all space filled with fine scratchings. Young relied more than any of the other artists on a combination of literary *and* graphic imagination. His work cannot be understood purely as graphic art, for it is really a combination of a literary and an artistic imagination. The artistic resources that he used and relied upon were relatively eccentric; they were from a relatively obscure kind of art—namely, the art of woodcuts, which was not in the center of the artistic tradition. To that extent his was an inimitable style, but as a result it had a kind of wooden, stiff quality. Yet, in another way, it served Art Young's very good literary imagination as well as anything else could have.

There is almost never the same sort of conflict in Young's work that we find in Minor's and Becker's. A literary point or moral point is to be gotten from his drawings. But each element in the drawing is static, not in conflict: all the whores in "The Freedom of the Press," for example, are simply taking money. Similarly, Edmund Wilson must have been looking at "A Compulsory Religion" (Figure 8), in which everyone worships Mammon, when he referred to Young's "humans on the scale of tiny tin soldiers, set up as a distant set of ten-pins for some general or prince to knock over."[30] Such epic-scale scenes are a contrast to Young's usual cartoons, which involve only a few elements. But

Art Young
Masses. Dec. 1912.

Fig. 8. "A Compulsory Religion"

even if we do admit seeing tiny tin soldiers in "A Compulsory
Religion," there is no conflict in the picture, for the troops
cannot resist and are not resisting a general who has not even
appeared. To Minor and Becker, on the other hand, rebellion
was a common theme.

Art Young gave the viewer an inside picture of what social
relations were. He portrayed people as social types in stylized
activities, but unlike Sloan he did not show them as individuals.
As in "'I Gorry,'" Young portrayed not conflict, but one set of
dominant values; the conflict is generated in one's mind by
looking at the picture and the caption. That is, he forces one to
be a moral witness to this scene, which as Max Eastman pointed
out in reference to Young's humor was "the gradually-dawning-
on-you, not the flashing kind." One slowly witnesses Young's
work.[31]

Young frequently took Christian imagery—Jesus, the devil—
or a biblical saying and twisted it into a non-Christian theme,
as in "Nearer, My God to Thee" (Figure 9). Nietzsche sup-
posedly said a joke is the epitaph of an emotion. "Nearer, My
God to Thee" shows the death of Young's own religious senti-
ments as well as the death of that same sentiment in the modern
world. It also demonstrates the real social relationship behind
the time-honored religious formula of the caption: the close
relation between religion and capitalism. The church, stuck
beneath and between the towering "Business School" and the
"Business Temple," is "nearer" the exchange than people,
nature, or God. The question is where does God dwell. Not in
the church; Mammon is with the money changers.

Again, in "Britannia" (Figure 10) there is no trace of con-
flict—just Great Britain seen alone in all her outrageous
absurdity. As a child Young had thought of England as
beautiful; now he saw it as ludicrous and even rapacious.
Accordingly, the picture is a cartoon, and the caption a joke,
describing the death of a whole world view. For the death of
England is the death of everything once thought good, decent,
in perspective, and in proportion. For Young to view Britain
as the center of imperialist exploitation was especially signifi-

Art Young
Masses. Dec. 1913. **Fig. 9. "Nearer, My God to Thee"**

Art Young
Masses. Oct. 1914. **Fig. 10. "Britannia in Righteous Wrath Resolves to Crush Out German Militarism"**

cant with the coming of the war and America's new-found Anglo-
philia. Thus, he was ideologically latitudinarian and could create
cartoons for many groups and publications, from the communist
New Masses to the liberal *Nation,* always demanding that we see
the phoniness and absurdity in life. Young's main sensibility is
in pointing to the hypocrisy and irrationality of those sacred
dreams he so long believed in.

There is a constant quality to Art Young's *Masses* humor. The
bitterness, which is plainly before the viewer in Maurice Becker,
is beneath the surface in Young's work. The obvious question is,
why not, like Becker, expose hypocrisy with moral outrage?
"'I Gorry,'" only indirectly shows the cruelty in poor working
people's lives. Becker knew tenement life, whereas Young and
Sloan drew it because they were discovering life beneath the
surface, behind tenement windows. So with Young in particular
there is the sensibility of discovery, his humor is "gradually-
dawning-on-you" because he had no inherited bitterness; it is
something he had come to. Not being inherently bitter, Young
could give no clear focus to this feeling.

From looking at "Wilson's Last and Best Joke" (Figure 11)—
reminding us of Nietzsche again—and "The Rake's Progress"
(Figure 12), we see that compared with his *Masses* work Young
introduced a new element into his *Good Morning* (1919-1921)
and *Liberator* cartoons. Though stylistically little changed from
the *Masses* period, they evoke—in Wilson and Rockefeller—a kind
of diabolical quality. That is, Young's capitalists were formerly
simply fat and arrogant stereotypes, almost cheap vaudeville
performers (except in such epic cartoons as "A Compulsory
Religion"), and occasionally they still were after 1917. But in-
creasingly now they devilishly personified evil. In this sense the
Liberator and *Good Morning* cartoons are transitional to the
later, fully developed, grotesque, monster, even Goyesque quality
in the *New Masses* drawing "After Twenty Years" (Figure 13).

Young did not change styles, though in his later career he
relied more on shading, especially after 1923. But the emphasis
now on the grotesque is different. When he was on the *Masses*,
though he exposed the reality behind bland platitudes, his

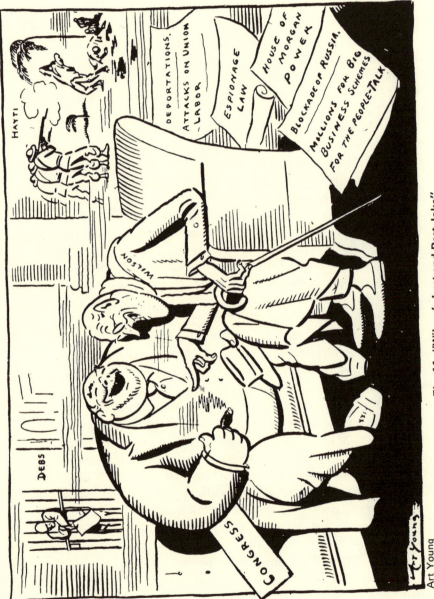

Art Young
Good Morning. Feb. 15, 1921.

Fig. 11. "Wilson's Last and Best Joke"
'We must set an example of democracy for the world.'
(Excerpt from last message to Congress)

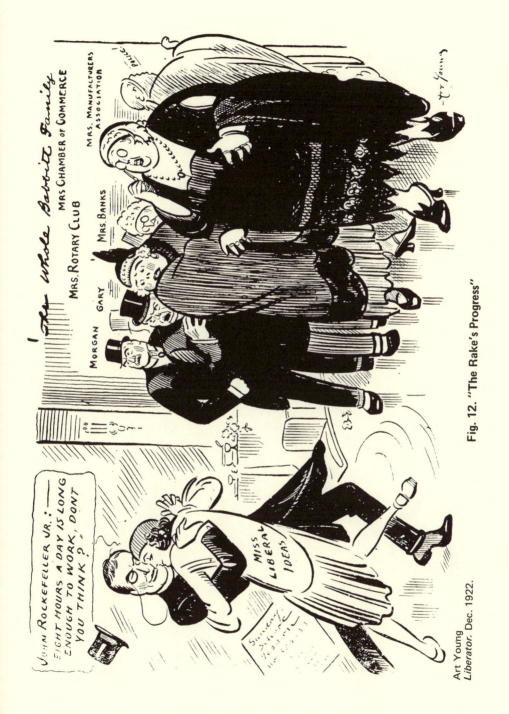

Fig. 12. "The Rake's Progress"

Art Young
Liberator. Dec. 1922.

Art Young
New Masses. Jan. 2, 1934. **Fig. 13. "After Twenty Years"**

figures were not diabolical but cardboard role-players. The emphasis was on hypocrisy and absurdity. But in *Good Morning* and the *Liberator* an emotional, grotesque quality creeps into and develops in Young's work. His figures assume monster-like characteristics: they are actively evil beings rather than predatory capitalists who merely stood for the trusts, railroad magnates, and social wrongs, and who were gross but not grotesque. The grotesque quality is present in "A Compulsory Religion" but is negligible and takes on larger proportions later. That is, the capitalist in "The Freedom of the Press" seems almost a natural phenomenon, but the president in "Wilson's Last and Best Joke" is no longer a puppet politician but a devil.

By the 1940s, with "The Big Shots" (Figure 14), Young exceeded even the emphasis on the grotesque. The magnates in the *Masses* are hypocritical or shysterish human beings. But "The Big Shots" are not merely hypocritical; they represent something much deeper. Nor are they Goyesque monsters. They are now mere roles, things; they are no longer human or even animal. That which informs Young's use of the grotesque in "After Twenty Years" also informs the profound disillusionment in "The Big Shots." Young's attacks on hypocrisy and corruption in the *Masses* were infused with almost a Progressive vision of antihypocrisy, anticorruption. But by the end of his career, with "The Big Shots," the theme is one of hopelessness in people who are caught in what they are—in this instance, cannon who can only mechanically fire away.

Young had two visions. One poked fun at pious platitudes; the other, a darker view, personified evil. As a socialist artist, he started with exposés of the phoniness behind pious Christian middle-class platitudes. After the *Masses,* the Goyesque emphasis emerged, seeking expressive qualities beyond mere exposure of the beast—as Young saw him—to the characteristic nature of the beast. In the process his illustrations became more expressive and less humorous. That is, Young's *Masses* cartoons were jokes. But by the time of the *Liberator* and *Good Morning* cartoons, and due largely to the repression and disintegration of radicalism in the United States, positive emotions of hatred were entering into Young's social perception.

Young's perception of reality became so acute that he began
to hate Woodrow Wilson and drew him not only as a diabolical
figure but as a decrepit bum. In his *Masses* period, Young gen-
erally limited his views to saying these sermons were lies. In his
Good Morning and the *Liberator* period he delved into his
Christian soul to develop a Christian vision of evil. His barbs
all became marked by an increasingly religious spirit. He had
attacked hypocrisy on the *Masses*, as in "Respectability." A
portion of his *Masses* work, however, such as "'I Gorry,'" mere-
ly satirized the colloquialisms of the working class for a mass
audience. But in *Good Morning* and the *Liberator* he embodied
capitalists and their agents as devils in a morality play.

In developing the grotesque, Young offered three social types:
the devil in "After Twenty Years," the rake in "The Rake's
Progress," and a disreputable chap who neither worked nor
shaved, namely, Wilson in "Wilson's Last and Best Joke," a type
most fully characterized as capitalism itself in "Getting Shaky
in Europe" (Figure 15). There is only a fine line between these
three types. They contrast markedly to the fat, pompous buf-
foons representing capitalism in the *Masses*.

Thus, Young was correct that "a good deal of [his] best work"
was done on the *Liberator*, for at this time he achieved a balance
between his *Masses* affinity for making jokes of social types
through stereotypes and his later proclivity for devising moral
aphorisms personifying evil.[32] In "The Rake's Progress" we see
a diabolical Rockefeller, but the Babbitt Family, looking on, is
out of the old *Masses* menagerie of heavy, cardboard types. In
his *Masses* period Young drew as a spectator of the moral scene
and his figures were elements thereof; on the *Liberator* and *Good
Morning* he drew as a participant, and his figures take on an
aspect of the menacing enemy.

In 1912, the same year Young and John Sloan ran unsuccess-
fully for the New York state assembly on the Socialist ticket,
Young was asked to write a monthly Washington review in words
and pictures for *Metropolitan* for five years. Up to American
participation in World War I *Metropolitan*'s policy, backed by
pro-socialist millionaire Harry Payne Whitney, was "definitely

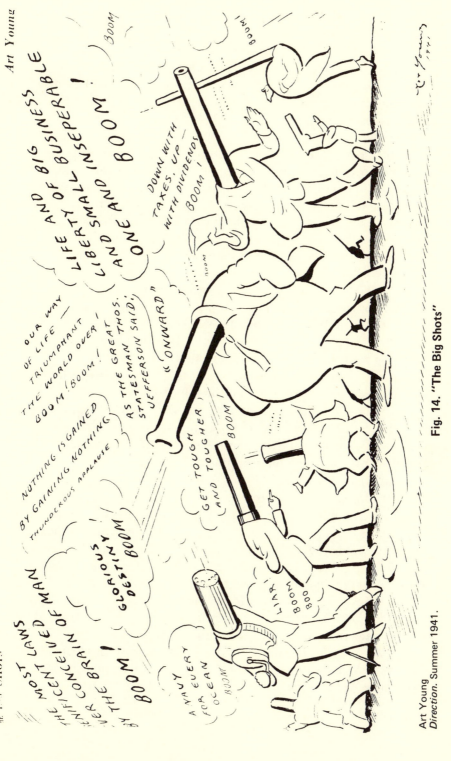

Fig. 14. "The Big Shots"

Socialistic"; the magazine asked, for example, why socialists
did not stop the war. Therefore, Young was free, usually in his
monthly double-page spread, to ridicule the "solemn gestures
and grotesque antics of Congress."[33]

The *Metropolitan* attacked Wilson as an unreliable reactionary,
though starting in 1916 contributing editor Theodore Roosevelt
clamored for intervention. Finally, in August 1917 the magazine
began to support the war, but argued that it advocated only the
"shortest and most effective way" to win the conflict. The
Metropolitan, which hired the jingoistic Theodore Roosevelt, is
better described as a magazine "flirting with socialism" until
the socialist movement began to feel wartime government
repression.[34]

In 1915 Robert Minor was fired from the *New York Evening
Journal* for refusing to do pro-war cartoons when the paper's
policy changed. In 1917, when the *Metropolitan* turned pro-war,
it dealt with Art Young similarly but somewhat more subtly,
reducing his space to a page, then to two-thirds, while at the
same time it became harder for Young to draw or write satire
which would pass the editors. In the fall of 1917 the editors
wrote Young: "You're not catching the spirit of Washington. We
wish you would come to New York and talk it over." Young
went, knowing what they had in mind. H. J. Whigham and Carl
Hovey "both seemed a bit abrupt—and it was all over." As Amos
Pinchot wrote President Wilson, "You know Young's work
yourself. Lately he resigned from the Metropolitan Magazine,
partly on account of his indictment, and partly because he would
not preach the kind of camouflage parlor socialism that Whigham
and Hovey demanded."[35] The point is that Young, as a socialist
on the *Metropolitan,* and Minor, as an anarchist on the *Evening
Journal,* were talented, highly paid cartoonists for established
publications, and yet still could remain active radicals until the
Great War. At that moment, however, an artistic radical had to
choose between income and conviction.

The *Masses* always had difficulties with censorship. When the
August 1917 issue was held up by the Post Office under the
Espionage Act and the *Masses* petitioned for an injunction

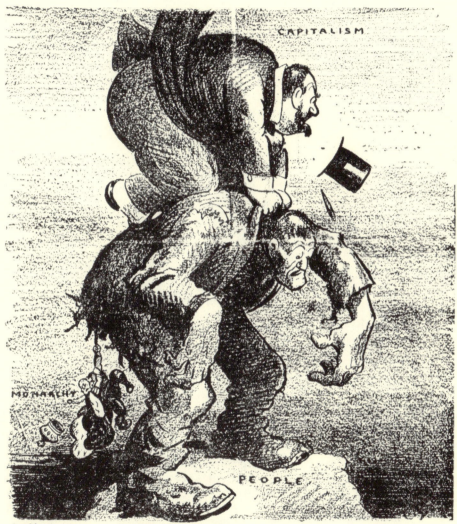

Art Young
Worker. Nov. 3, 1923.

Fig. 15. "Getting Shaky in Europe.
It's Merely a Question of Time When the Real
Tyrant—Capitalism—Will Have to Go."

against Post Office interference, the Attorney General's office
exhibited four cartoons as violations of the Espionage Act,
including one by Young on "Congress and Big Business." The
September issue included several Young cartoons. "'Having Their
Fling' pictured an editor, capitalist, politician, and clergyman
dancing to the music of a devil's orchestra, playing instruments
shaped like cannon, machine guns, and hand grenades." In
October Eastman, Dell, Glintenkamp, Josephine Bell, Reed, the
business manager, and Young were indicted under the Espionage
Act for obstructing recruitment into the armed forces.[36]

Like most of his *Masses* associates, Young felt that with gov-
ernment repression some medium should keep alive "the spirit
of protest," especially in view of their approaching trial for
seditious conspiracy. The *Liberator* was begun in March 1918.
Young attended staff meetings, and although he had led fights
in the *Masses* editorial conference for propaganda in art, he was
by this time more concerned with having cartoons hit "a vulner-
able point in the armor of the common enemy" than he was
with ideology. Ideology was important, but the process of having
to formulate it on the *Liberator* "could become ridiculous and
frequently did." Young's 1918 *Liberator* drawings did project a
socialist takeover in the United States, but he later labeled these
cartoons as "wishful thinking."[37]

The first *Masses* trial began in April 1918. It was a hung jury,
so that fall Young campaigned, again unsuccessfully, for the New
York state senate. After the *Masses* indictment, he had an
increasingly difficult time making a living and maintaining
friendships. He was ostracized by many former friends as though
he were a "treasonable being." In the Village and in the Dutch
Treat Club, which he had helped found, the "atmosphere
exuded" was so chilling that Young and John Reed resigned.
Editors who had long used Young's work found excuses to
decline it. He survived financially in the early twenties only
because Jacob Marinoff's humorous weekly, the *Big Stick*, used
his work weekly and responded with a check covering room and
board.[38] Thus, an increasing note of bitterness and doubt as to
the imminence of socialism entered into Young's work after his
initial *Liberator* enthusiasm.

Early in 1919, with the second *Masses* trial ending in a hung
jury, the war over, and censorship easing, Ellis O. Jones, a *Masses*
contributor, told Young: "Now is the time for us to start a maga-
zine." "We agreed," says Young, that "people ought to laugh
again (or at least try to laugh)." One reason for Young's interest
in a new magazine was that, although the *Liberator* featured his
work, he thought "it wasn't quite right that engravers, printers,
paper dealers, and desk-editors should have their pay or the
magazine would not go on, while those who did the creative
work had to forego compensation."[39]

A meeting was held to form the new magazine. "We thought
it time to satirize the whole capitalistic works. Not with subtle
analysis of conditions in essays and the like," as in the *Masses*
and *Liberator*, "but with straightforward exposé in cartoons and
comment, and with comedy rampant." They hoped "the people"
would like this approach, but believed that many radicals and
liberals were "weary—and worn out with vain hope." *Good
Morning*'s emphasis on humor—some of it very acidic—and its
avoidance of analytical reporting reflected the feeling of ennui
masked by satire that had begun to set in by 1919 among many
artistic radicals such as Young.[40]

After five months, Jones resigned over lack of business man-
agement. "Now it was [Young's] responsibility alone [as]
editor, publisher, and goat." Young originated the character
Poor Fish, the eternal loser in his *Good Morning* cartoons, whose
"wise sayings" in the "naive language of common street talk"
were reprinted in many labor publications, such as the *Worker.*[41]
Typical of the Poor Fish's "authentic wisdom" was "The Poor
Fish Says: That Human Nature Can't Be Changed and What We
Need Is a Great Religious Revival" (*Good Morning*, February
15, 1921).

Because of inadequate financing, *Good Morning* made its last
appearance in October 1921. By 1922 *Liberator* circulation had
also sagged, its readership "displaying great weariness." When,
in October 1922, *Liberator* editors met with Charles E. Ruthen-
berg, secretary of the Workers party, to discuss turning the maga-
zine over to the communists, Young said:

That goes with me. . . . If a broker for a Wall Street syndicate
had been there and had offered a large sum of money for our
name, prestige, etcetera, as had been done with other maga-
zines of protest—to make them conservative while outwardly
appearing the same—I think I might have approved the sale. . . .
We could have sent Christmas gifts to old contributors to both
the *Liberator* and the *Masses* who had never received a cent.
I had experienced so much trouble as an editor, publisher, and
contributor that on this particular evening I was in one of my
what's-the-use? moods.[42]

In the early 1920s, "though *Life* and *Judge* were friendly, it
was seldom that [Young] could produce anything to their
liking." But in the spring of 1922 Oswald Garrison Villard opened
the *Nation* to cartoons, featuring Art Young, who could pick his
own themes, with "occasional suggestions" from Villard or the
managing editor. Young was with the *Nation* for three years,
covering the 1924 Republican convention with Villard, also
doing pro-LaFollette campaign drawings for *Collier's* and *Life*.
In 1924 Young, like most noncommunist socialists, backed
LaFollette, who had kicked all communists out of his campaign
from the beginning.[43] Thus, as a democratic socialist who fre-
quently supported Progressive causes and candidates, he found
employment by 1922 with liberal magazines and even received
occasional work from Arthur Brisbane, whereas the Commun-
ist party's Robert Minor was by then anathema to the popular
and liberal press.

Late in 1925 Young got unexpected requests for work from
established magazines, such as the *Saturday Evening Post.* Know-
ing the *Post* would reject "my kind of propaganda," he did a
series running through 1926, "Trees at Night," depicting trees
"as fantastic, grotesque, humanized, or animalized." When the
New Masses started in 1926, Young was a contributing editor.
Again, "establishment of [a new] enterprise gave [him] a sense
of fresh hope."[44]

In the 1928 campaign the Socialist party weekly *New Leader*
took his cartoons, but after the election "the social millenium
seemed farther and farther away." Young felt "tired, moody,
and a bit irascible. Perhaps the great drop in the protest-vote had

something to do with [his] state of mind."[45] To Young the
protest vote was registered in the Progressive and Socialist
parties, since the Communist presidential candidate, William Z.
Foster, won a tiny number of votes in 1928 but more than in
1924.

When the market crashed in October 1929 and the depression
set in, Young had much greater difficulty selling cartoons. "It
was of course no phenomenon for me to be passing through a
financial depression. . . . My life had been one depression after
another." In 1930, now sixty-four, without savings, and in poor
health, Young made drawings for a new edition of a Socialist
party pamphlet he had written and illustrated in 1920, "The
Campaign Primer," retitled "The Socialist Primer." When a
friend saw Young's bankbook, he talked with Norman Thomas
and others in the Socialist party who raised enough money to
allow Young to get well without worry. K. R. Chamberlain re-
called that "Arthur was busted all the time. Toward the end we
all chipped in to keep him going. I always had him to dinner on
Christmas and things like that."[46]

Young "still had dark hours . . . weighted down with melan-
choly." On one of those days he was cheered by an idea:
"Before I go to the poorhouse . . . I'll write and illustrate one
more book." In 1892 he had written *Hell Up to Date.* Again his
interest in the inferno awakened. In his first book he had seen so
much industrialization that he had asked the devil if capitalists
would not take over "the smoky regions below." Satan had
laughed and said that he could handle anything. "But he was
more confident than clever, for I found in 1931 that he had been
compelled to resign his great power to the industrialists and
bankers."[47]

Young interrupted his hell book to do two cartoons a week
for the Socialist party during the 1932 campaign. He continued
to draw a few cartoons for radical and liberal publications and
for the weekly *Today.* But income was uncertain, and friends
who suspected his near bankruptcy arranged a testimonial bene-
fit in the Civic Repertory Theatre in November 1934. The house
was full, and, as Young says, of a "united-front character." Even

though it was held on the eve of the Popular Front, it was a
remarkable tribute to Young that such bitter liberal, socialist,
and communist enemies as Max Eastman, Norman Thomas, and
Earl Browder would come together in his behalf. Young could
not attend, but sent a letter, saying

> I'm a little worse for wear. . . . But I will try . . . to express
> myself hereafter with bigger and better bitterness. . . . I don't
> know the meaning of "dialectical materialism." . . . All I know
> is . . . The cause of the workers is right and the rule of Capital-
> ism is wrong, and right will win.[48]

He felt that when he grew up, "after the Civil War, America
was still homespun." In his twenties he had been influenced by
late eighteenth-early nineteenth century English and French
caricaturists, and had hoped to influence public life through his
art. But he felt he was successful only in a limited sense, for
"I was compelled to waste about half my life scheming and
worrying over the problem of making enough money to keep
going."[49]

Young considered his problems to be the same as those of most
Americans. Most are born with talent, but their potential is
crushed by "the duty of getting on"—that is, by the pressure to
survive. Young "managed to find his direction" again in his
forties by concluding that "the unjust treatment of those who
produce the wealth . . . by those who own most of that wealth"
was the "one wrong" hindering "honest and contented living."
He saw the 1930s evolving into the age of "industrial democracy"
and had "some hope" the change would be peaceful and planned.
What Young (and Sloan and Chamberlain) wanted was better
administration of a welfare state, not revolution and a workers'
republic. "Whoever the administrators of the future state," said
Young, "they must be exemplars of kindness—or perhaps my
meaning is scientific helpfulness . . . to the majority who do the
world's work."[50]

Art Young died unsatisfied in 1943; he had remained a pre-
World War I latitudinarian socialist. He could "often wonder" in
1928, "why my radical views never take definite form," then

announce his agreement with the socialists on the cooperative commonwealth, liberals on reform, communists on temporary dictatorship, capitalists on the achievements of free enterprise, and still keep his firm Protestant sensibility. Writing to the muralist Gil Wilson in 1940, Young summed up his socialism:

> I think we have the true religion. If only the crusade would take on more converts. . . . But faith, like the faith they talk about in the churches, is ours and the goal is not unlike theirs in that we want the same objective but want it here on earth and not in the sky when we die.[51]

NOTES

1. Young, *Young*, pp. 32, 35, 39-40, 52.
2. Ibid., pp. 57-58, 60.
3. Ibid., p. 52.
4. Ibid., pp. 61, 62-64, 69-70.
5. Ibid., pp. 74, 76-77.
6. Ibid., pp. 83, 102, 104, 108. One policeman was killed but it is unclear how many persons were killed or wounded by the police. Based on the evidence presented in court, the defendants were not guilty of the murder of the policeman, although the bomb probably was thrown by someone in the Chicago anarchist movement. Henry David, *The History of the Haymarket Affair: A Study in the American Social-Revolutionary and Labor Movements*, 2d ed. (New York: Russell & Russell, 1958), pp. 204, 206-207, 209-210, 523-525, 541.
7. Young, *Young*, pp. 88-89, 91.
8. Ibid., pp. 110-112, 116, 120.
9. Ibid., pp. 120-121.
10. Ibid., pp. 3-4, 8-9, 14, 16, 123.
11. Ibid., pp. 144-145, 148-150, 153, 160, 165. Young says the *New York World* is often incorrectly credited with introducing the first color supplement in September 1893 (p. 155, note).
12. Ibid., pp. 175, 177-178, 186-187.
13. Ibid., pp. 190-191, 202, 205-206, 211.
14. Ibid., pp. 181-182, 213-216.
15. Ibid., pp. 219, 221. John P. Altgeld, "Reasons for Pardoning Fielden, Neebe, and Schwab" (Chicago, 1893).

16. Young, *Young*, p. 222.

17. Ibid., p. 223.

18. Young, *Young*, pp. 225-227, 243-244. (Quotes from pp. 226-227.) Maurice Becker, "From Art Young's Friends: Tributes and Remembrances from Those Who Knew and Loved Him," *New Masses* 50 (February 8, 1944):27.

19. Young, *Young*, pp. 245-249.

20. Ibid., pp. 260-262.

21. Ibid., p. 262.

22. Ibid., pp. 262, 264.

23. Ibid., p. 264.

24. Ibid., pp. 269-270.

25. Ibid., pp. 270-272, 277.

26. Ibid., pp. 295, 297, 299-300.

27. Eastman, *Enjoyment*, p. 554.

28. Brooks, *Sloan*, p. 87. Eastman, *Love*, p. 75.

29. Edmund Wilson, *The Shores of Light: A Literary Chronicle of the Twenties and Thirties* (New York: Farrar, Straus and Young, 1952), p. 353.

30. Wilson, *Shores*, pp. 353-354.

31. Eastman, *Love*, p. 75.

32. Young, *Young*, p. 390.

33. Ibid., pp. 282, 287, 302.

34. Young, *On My Way*, p. 158; quote 1 from *Young*, p. 317. Quote 2 from Lillian Symes and Travers Clement, *Rebel America: The Story of Social Revolt in the United States* (New York: Harper, 1934), p. 271.

35. Young, *Young*, p. 326. Amos Pinchot to Woodrow Wilson, May 24, 1918, Amos Pinchot Papers.

36. Young, *Young*, pp. 319-320, 322, 324.

37. Ibid., pp. 328, 330, 386-387.

38. Ibid., pp. 338-340.

39. Ibid., p. 352. William Gropper later complained that Eastman received a salary of $75 a week "for lying on a couch and composing poetry and reading books." Joseph Anthony Gahn, "The America of William Gropper, Radical Cartoonist," Ph.D. diss., Syracuse University, 1966, p. 47.

40. Young, *Young*, pp. 353-354. *Good Morning* ran weekly, May 18, 1919-January 1, 1920; semi-monthly, May 1, 1920-May 1, 1921; monthly, June 15, 1921-October 1921. Among the *Masses* and/or *Liberator* cartoonists contributing to *Good Morning* were Peggy Bacon, John Barber, Cornelia Barns, Maurice Becker, K. R. Chamberlain, Adolph Dehn, Edmund Duffy, William Gropper, Robert Minor, Boardman Robinson, and Frank Walts.

41. Young, *Young*, pp. 357, 369.

42. Ibid., pp. 375, 391-392. Ruthenberg, at the second Workers party

convention (the legal party) in December 1922, was elected to the Central Executive Committee and the Executive Council when the illegal Communist party was absorbed into the Workers party. Draper, *Roots*, pp. 389-390, 457, note.

43. Young, *Young*, p. 378. Belle Case and Fola LaFollette, *Robert M. LaFollette*, vol. 2 (New York: Macmillan, 1953), pp. 1100-1104, 1140.

44. Young, *Young*, pp. 384, 394.

45. Ibid., pp. 408-409.

46. Ibid., pp. 409-411, 413-414. Interview with K. R. Chamberlain, August 10, 1966.

47. Young, *Young*, pp. 415-416. Art Young, *Hell Up to Date: The Reckless Journey of R. Palasco Drant, Newspaper Correspondent, Through the Infernal Regions, as Reported by Himself* (Chicago: Schulte Publishing Company, 1893).

48. Young, *Young*, pp. 418, 421-423. Hell revised was published as *Art Young's Inferno: A Journey through Hell Six Hundred Years After Dante* (New York: Delphic Studios, 1934). Among the sponsoring committee were Floyd Dell, H. J. Glintenkamp, Mike Gold, William Gropper, Amos Pinchot, John Sloan, and Otto Soglow of the *Masses* and/or *Liberator*. In the early 1940s muralist Gil Wilson recalled seeing "in one afternoon . . . three violently opposed people—A Communist, a Socialist, and a Trotsky-ite—each visiting Art Young on the friendliest of terms . . . each leaving with the entire conviction that [Young] was completely in sympathy with them. . . . He simply had a larger view . . . which encompassed all three viewpoints." To author, June 10, 1970; Art Young's only exhibition was held in 1939 at the ACA Gallery. No drawing was sold. Maude Riley, "Art Young, Famous Cartoonist, Dies at 77," *Art Digest* 18 (January 15, 1944): 21.

49. Quote 1 from Young, *On My Way*, p. 228; quote 2 from *Young*, p. 450.

50. Quote 1 from Young, *On My Way*, p. 12; quotes 2-8 from *Young*, pp. 293, 453, 457.

51. Young, *On My Way*, p. 266. Art Young to Gil Wilson, May 28, 1940. Gil Wilson Papers, Woodrow Wilson Junior High School, Terre Haute, Indiana.

3
Robert Minor

Robert Minor (1884-1952) was born in a San Antonio, Texas, cottage and was raised on the edge of the city's slums. Since his father was unsuccessful as a lawyer, Minor was forced to quit school at fourteen to support his family. He had irregular employment as a kind of migratory handyman throughout the Southwest.[1]

Minor, who knew poverty, hard work, and the insecurity of the industrial system first hand, began his artistic career in 1904 when he was hired as an assistant stereotypist and handyman for the *San Antonio Gazette.* He etched corrections on plates but soon was submitting unsigned cartoons. He admired the *St. Louis Post-Dispatch*'s cartoons, and the next year moved north to work for big-time newspapers. In St. Louis he first drew for an engraving shop, but frequented the *Post-Dispatch*'s offices until he was finally hired. The paper was then under Joseph Pulitzer and occasionally supported Populist causes. One of Minor's jobs for the *Post-Dispatch* involved arriving in the morning at the morgue and sketching the night's arrivals. He recalled in 1935 that the cadavers from violent deaths were

> swolen [*sic*], battered, dripping blood, or dull grey and
> bloated. . . . My task was to make these sketches . . . look
> as though they were pictures of men and women in life. . .
> and for 29 years it has stood, in my feeling, as a sort of intro-
> duction to what an artist is expected to do in the service of
> Capitalism.[2]

Minor was greatly influenced in 1907 by the thinking
of Dr. Joseph Kaplan, a left wing socialist physician he had con-
sulted for growing deafness. It was Kaplan who Minor said had
greater impact on him than any other man except Lenin and
who introduced him to Daumier and Goya, the Socialist party
of America, and the cases of Haywood, Moyer, and Pettibone
of the Western Federation of Miners, accused of assassinating
former Idaho Governor Frank Steunenberg.[3]

The Haywood case was the first of many famous legal strug-
gles in which Minor participated, and it helped to develop his
conception of the class aspect of legal struggle. Years later Minor
argued that the Haywood case drew him, then twenty-three,
"from a purely AFL position into the position of a class fight
at all costs and with all means to prevent the hanging of the
militant leaders of the working class." Each of these cases brought
thousands into action, many of whom remained devoted to "the
one great sacred cause." Minor joined the SPA and became a
regular contributor to the socialist weekly *Appeal to Reason.*
Although he was interested in Haywood and the IWW, the "idol
of all of us at the time" was the conservative socialist, Victor
Berger.[4]

Minor's father objected to his new affiliation, and sent him a
copy of Henry George's *Progress and Poverty*, which Minor read
and with which he disagreed. He distributed literature defending
Haywood, Moyer, and Pettibone, and talked socialism to every-
one he met, including those on the *Post-Dispatch.* According to
Orrick Johns, Minor puzzled his associates on the *Post-Dispatch*
with his "tremendous definiteness; implacable rejections." His
great preference in St. Louis was, in his catch phrase, "tough-
minded" people.[5]

Increasingly, the *Post-Dispatch*'s city editor, Oliver K. Bovard,
used Minor to supplement the work of the chief cartoonist.
Bovard assigned Clark McAdams, columnist and editor, to work
out the day's cartoon with Minor. Apparently, the two worked
together harmoniously, McAdams being a Jeffersonian of anti-
industrial bias, who as "talk-man" would verbalize the idea—not
visualize the cartoon—for Minor.[6]

By 1911, at twenty-seven, Minor was the *Post-Dispatch*'s chief editorial cartoonist, and was soon regarded as the country's greatest and most highly paid cartoonist. Minor had no formal art training. "Art, to him, was a means of waging the war of politics." He had not yet had the opportunity to compare ideas with other gifted illustrators, his only guidance having been a few months' work in a San Antonio sign painter's shop. Conscious of his lack of knowledge of his field, Minor decided to spend his 1910 vacation seeing things in New York.[7]

Collier's Weekly had run several of Minor's cartoons. Its editor, Mark Sullivan, invited Minor to visit him in New York. When Minor met Sullivan, the editor remarked, "I think you have Socialistic ideas, haven't you?" Minor replied that he was a member of the Socialist party. Then Sullivan said that he wanted Minor to see Theodore Roosevelt, recently returned from an African hunting trip and Europe: "Just get acquainted with him. That's all." In private conversation with Minor, T. R. said that he would fight Taft, but back at *Collier's* Sullivan warned Minor never to repeat his conversation with Roosevelt because Roosevelt would "call [him] a liar to the ends of the earth." The request for silence created so unfavorable an impression on Minor that when Sullivan offered him a job with *Collier's* at better than his current salary Minor refused and returned to St. Louis.[8]

In 1911 Ralph Pulitzer's *New York Evening World* offered Minor a quarter of the editorial page, seven cartoons a week, a research department at his service, and an even higher salary. But Minor refused the offer, stating that he had never studied art and wanted to study in Paris. Pulitzer offered him a year's leave and salary advance, providing he would return to the *Evening World.* To this Minor agreed, and was off.[9]

Minor studied three months at the Académie Julian, but he rejected academic drawing and spent most of his time studying Goya, Delacroix, and Daumier. He sketched genre and listened to French workers discuss anarcho-syndicalism and to their argument that the union, not the state, must be the ultimate political institution. He had become critical of the American Socialist party and in France he became an anarchist.[10]

Minor returned to the United States in 1913. The *Evening World* had supported Wilson, and when World War I broke out the newspaper promptly took a Wilsonian stance against the conflict. Minor, who began working for the *Evening World* in 1914, also opposed the war, and he "was allowed to make anti-war cartoons to [his] heart's content . . . for about a year." But in 1915 the *Evening World*'s editorial position shifted in favor of the Allies. An editor, Horatio Seymour, called Minor into his office to explain that Germany represented the greatest danger to the world and that Minor's cartoons must change to prepare the public for the day of American intervention. Faced with such a decision, Minor chose ethical duty over self-interest and said "I can't go along with that. . . . It's a rich man's war and a poor man's fight." He was advised to think the matter over and meanwhile was not fired. He was simply given the silent treatment.[11]

As a result, Minor decided to break his contract in such a way that he would be free to work where he wanted without legal penalty: he drew a cartoon for Emma Goldman's anarchist monthly, *Mother Earth* (1906-1917). The cartoon, called "Billy Sunday Tango" (May 1915), depicted the antilabor evangelist (who invoked God's wrath on strikers) dragging a reluctant Jesus, who is down from the cross and bleeding, into a dance. The *Evening World* promptly terminated its contract. "This will free me," he explained to Emma Goldman, "from making cartoons that show the blessings of the capitalistic régime and injure the cause of labour." Minor drew a few more cartoons for *Mother Earth*, a magazine which did not usually feature graphics, and began contributing to the *Masses* in August 1915. Though he had broken with the Socialist party, he became political cartoonist for the New York socialist daily, the *Call* (1908-1923), and made speaking tours under its auspices, calling for "mass action" against World War I.[12] That Minor, an anarchist, could put out such a call is an incidental indication of the latitudinarianism of American socialism before the Russian Revolution.

Faced with the demands of the art market, Minor would not submit; he refused to draw pro-war cartoons and continued

donating illustrations to socialist publications. As a result, he lost his job as the country's highest paid illustrator. Compared with Becker, Chamberlain, Sloan, and Young, Minor was the most intransigent of artists: he gave up his whole identity as a professional artist. One cannot understand Minor's subsequent career as a communist without understanding his absolute intransigence. He would not be dominated by commerce in the art market. As he said in a later article, "There is an intimate bodily connection . . . between a man and a piece of canvas or paper that his hands have worked upon to the aim of beauty." Once,

> someone in a matter-of-fact conversation said that certain drawings that I made were his property. I flew into a rage . . . in my heart was almost the desire to murder the man for this brazen impudence, this tyrannical assault upon me. He dares to say that he *owns* my drawing! My hand made that; my fingers—*my* fingers tingled to the joy of shaping those lines—and this impudent cannibal dares to put a claim upon it! This work is mine; it is a part of me.[13]

The same year, 1915, Minor decided to see World War I at first hand. Since the *Call* could not afford to send him to Europe as a war artist, he went to the Newspaper Enterprise Association and signed a contract covering travel expenses. For six months he mailed back sketches and stories describing the horrors of the war. He wrote, "Paris is full of one-legged, one-armed men." At the arrival of a hospital train, "it looked as though the only part of the human body sure to be found on the stretcher was the head." Understandably, Minor felt that a "trench revolt" and revolution would break out in France or Italy.[14]

Minor returned to the United States, sketching his daily cartoon for the *Call*, and continued to contribute to the *Masses*. K. R. Chamberlain recalled Minor on the *Masses*: "Minor was altogether a cartoonist. . . . I'd hear him run around, 'Defend your country? Who the hell's got any country around here?' That sort of thing. He was always upset about everything. He was quite an anarchist . . . and he and Emma Goldman got together and Alexander Berkman."[15]

In comparing Minor's *Post-Dispatch* (Figure 16), *Evening
World* (Figure 17), and *Masses* (Figure 18) cartoons, it is evident
that his style changed considerably while on the *Masses*. As he
became more political, a kind of pointed simplification suffused
his work. The art works involved fewer figures, and the use of
space became more dramatic and subtle—that is, the drawings
were less cluttered with detail. It is true that "Jumping In" is
less cluttered than "The New Man on the Job." But with "Jump-
ing In," Minor achieved his effects more by shading and dots,
whereas with "In Georgia" the tendency was to get effects
through sharp use of lines. On the *Masses* he no longer achieved
his effects so much through shading as through lines to suggest
the helplessness of the victims against the massive victimizers.
Thus, while "Jumping In" is as dramatic as his later cartoons,
there is a definite stylistic shift in the *Masses* cartoons.

With "The New Man on the Job" the use of space is not
particularly interesting: the scene is simply centered in the
middle. But with "Jumping In," as well as in his *Masses* work,
it is as if the whole picture is being looked at from an oblique
angle. This creates a much more dramatic effect, almost as if
from a movie projector. Thus, "Jumping In" is intermediate
between Minor's *Post-Dispatch* and *Masses* style in that there is
the sense of victim-victimizer, big against little, and space is not
used head-on but obliquely. On the other hand, he made less
use of lines to express dramatic qualities in "Jumping In" than
in his *Masses* work; these qualities were still achieved more
through shading than through expressive lines.

As a cartoonist on the *Masses*, Minor had a superb sense of
composition—a genius for ordering elements according to their
significance, even in simple strokes. His brilliance lies in the
feeling of dramatic conflict—of movement and conflict of
opposite elements—evoked by each composition. Minor's
sense of conflict and sharp simplicity (strong versus weak, large
versus small), all for emphasis and contrast, developed on the
Masses. The tension of opposites, simplified and synthesized,
was dialectical.

But on the *Masses*, as opposed to the *Evening World*, Minor

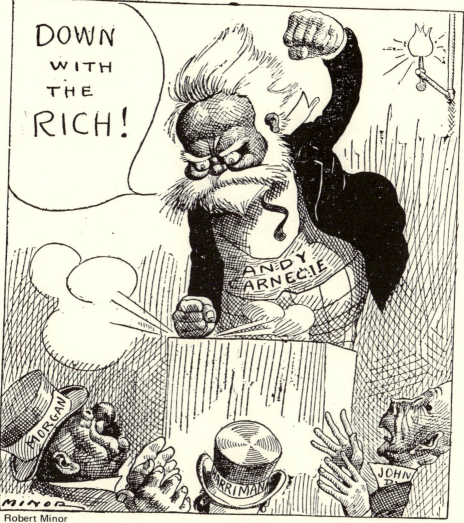

Robert Minor
St. Louis *Post-Dispatch*. Nov. 25, 1908.

Fig. 16. "The New Man on the Job"

Robert Minor
New York *Evening World.*
Aug. 6, 1914.

Fig. 17. "Jumping In"

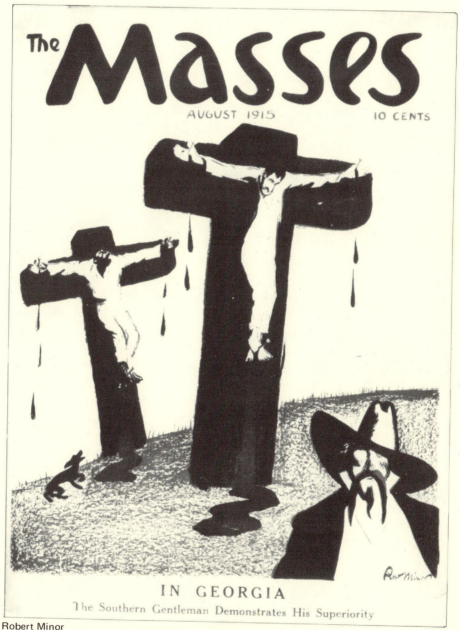

Robert Minor
Masses. Aug. 1915. **Fig. 18. "In Georgia.**
The Southern Gentleman Demonstrates His Superiority"

was more an epic artist than a newspaper cartoonist. "In Georgia"
depicts big crosses of massive volume but against them are small,
delicately drawn individuals. This cartoon also suggests why
Minor developed a cartooning style replacing cross-hatches.
A means of getting the proper effect of mass and volume
was needed, a third dimension, to contrast massiveness with the
delicate curved forms of individuals—the tenant farmers on the
crosses, the worker in "Pittsburgh" (Figure 19), for example. Not
only had Minor brought the "bold, black and shaded stroke of
the lithographer's crayon in cartooning. Nobody could get size
into a space as he did, nobody made such men of tiger-like
energy."[16]

Minor's artistic resources were simplicity, directness of line,
and a sense of motion and conflict. But as a result of applying
a kind of epic sense, he tended to overdramatize and too often
created a situation of victim-victimizer. And yet he did apply
that particular sense very well.

Minor's *Liberator* cartoons are generally quite different from
his *Masses* cartoons. Largely gone is the old sense of dramatic
conflict between oppressor and oppressed, and his lines, though
still in his "inimitable grays and blacks and whites," are sketchier
and have less sense of motion.[17] Captions become more important,
the story being more in the caption than in the picture alone.
Composition is still good but much more shadowy, as in "'Having
Made the World Safe for Democracy.'" (Figure 20). "Army Medical
Examiner" (Figure 21) is transitional between Minor's *Masses* and
Liberator work. There is some shading but still with contrast and
strong lines. Massiveness is used to create contrast rather than
conflict between the strong muscled soldier and the weak, flitty
physician.

In seeing Minor at work, fellow *Liberator* editor Joseph Freeman
referred to the "gleam of fanaticism" in Minor's eyes and the
"pontifical finality" to his utterances, but he was impressed
nevertheless with the "stubborn sincerity" of everything Minor
did. What he remembered "most vitally" about Minor were his
"vast massive black-and-white figures full of muscle, action and
an internal spiritual power which marked itself indelibly on all

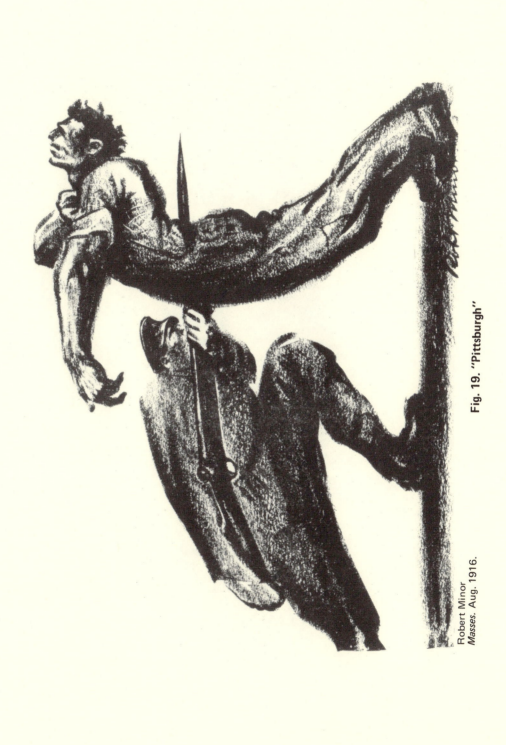

Fig. 19. "Pittsburgh"

Robert Minor
Masses. Aug. 1916.

LLOYD GEORGE

Robert Minor
Liberator. Dec. 1920.

**Fig. 20. "'Having Made the World Safe for Democracy,
We Must Now Settle the Irish Question."**

Robert Minor
Masses. July 1916. **Fig. 21. "Army Medical Examiner: 'At Last a Perfect Soldier!'"**

who saw them." Minor always drew with complete commitment.
Freeman once watched him sketch, on his stomach, grimacing as
he drew prostrate bodies: "The artist became his subject." Minor's
style, Freeman felt, was "so vivid, so mighty in its simple masses"
that it created a school of imitators: Fitzpatrick of the *St. Louis
Post-Dispatch,* Rollin Kirby of the Scripps-Howard Syndicate,
and Fred Ellis and Jacob Burck of the *Daily Worker* and *New
Masses.*[18]

But these attributes of Minor's work are properly characteristic
of his *Masses* tenure, when as an anarchist he depicted a sense of
bold, albeit uneven, struggle, by focusing conflict in the center
of his pictures by converging lines toward the center. This is quite
different from his simple use of space in the center on the *Post-
Dispatch.* Minor's whole method of composition was much more
sophisticated and artistic on the *Masses,* because he used all sorts
of new contrasts; in "In Georgia," for example, he counterposed
delicate human forms against massive, blocklike crosses, and
arranged the crosses at different angles. The striking contrasts are
derived not just from converging lines. On the *Post-Dispatch*
there was just a straightforward view; on the *Masses* lines came
diagonally. Minor achieved dramatic contrasts with volumes as
well—such as the fat versus the thin in "Either Platform Will Do"
(Figure 22).

But "Either Platform Will Do" is exceptional in one respect
and is therefore more like his later *Liberator* work. There is less
convergence toward the center; the cartoon is more balanced.
Lines, forces, and the theme are balanced because the subject of
the cartoon is not a simple conflict of good versus evil, as in
"Pittsburgh," but is more specifically political. However, "Either
Platform Will Do" is typical in its use of expressive lines. That is,
in his effort to simplify for dramatic effect, Minor used the
device of contrast through lines during his *Masses* period. Here
in this cartoon the stomach of the priest is contrasted with the
shoulder of the capitalist, the round hat and jaw are contrasted
with the pointed hat and jaw.

"Pittsburgh" is the unusual style and "Either Platform Will
Do" is the more typical in another sense. The former is so

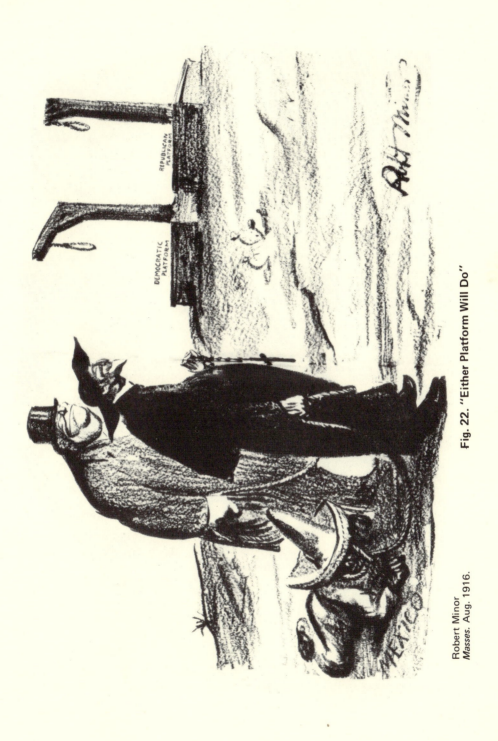

Robert Minor
Masses. Aug. 1916.

Fig. 22. "Either Platform Will Do"

Manichean that social types cannot be developed; in the latter, capitalist and cleric are seen as two forms of political evil—fat banker, thin priest, concave and convex. There is contrast but no conflict. The magnate and priest are not opposed but are two sides of a coin. The Mexican with the rope in "Either Platform Will Do" would ordinarily be the center of conflict. In this cartoon there is no conflict on the political level, but rather political stasis, for the conflict is controlled. Minor almost always drew two social types. The distinction in "Either Platform Will Do," "Army Medical Examiner," and more commonly in his *Liberator* work, was that the contrasting elements were not the conflicting elements. The conflict was minimal.

As a communist on the *Liberator,* Minor had various themes to illustrate. One must look closely to understand his *Liberator* cartoons. The ideas that he wanted to express were more intellectual than before and he exhibited less moral outrage against the idea of oppressor and oppressed. Also, the captions as well as the background (absent in "Pittsburgh") became important; in "On the River Styx" (Figure 23), for example, one must notice the burning Capitol in the background to be able to understand Harding. Minor's later *Liberator* cartoons illustrated Communist party homilies: the plight of the farmer in "Evolution of the American Peasant" (Figure 24) and the soldier in "Ghost of the Dead 'Hun'" (April 1922); the oppression of the open shop in "Back to the Galleys" (May 1921); and the conservatism of the AFL in "'For God's Sake, Sam'" (Figure 25).

As an anarchist on the *Masses* , Minor's drawings were, as already noted, almost Manichean in their depiction of the struggle of good and bad. He was the *Masses* anarchist rebelling against all oppressive forces, but the struggle was always overwhelmingly weighted in favor of the forces of evil. On the *Liberator* Minor was the communist concerned with applying the Communist party program to the United States. As conviction became refined into ideology, so did his art. He became programmatic in "'For God's Sake, Sam,'" telling the viewer that labor should join the Farmer-Labor party. In attacking Samuel Gompers in this cartoon, Minor was thus sectarian

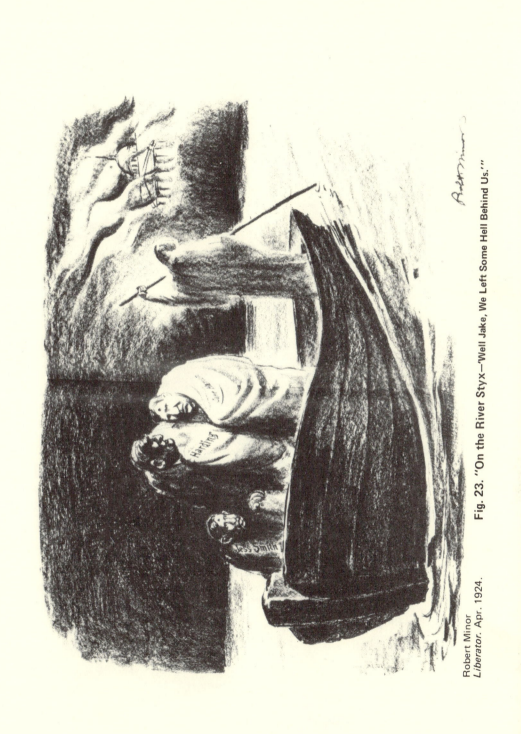

Robert Minor
Liberator. Apr. 1924.

Fig. 23. "On the River Styx—"Well Jake, We Left Some Hell Behind Us.'"

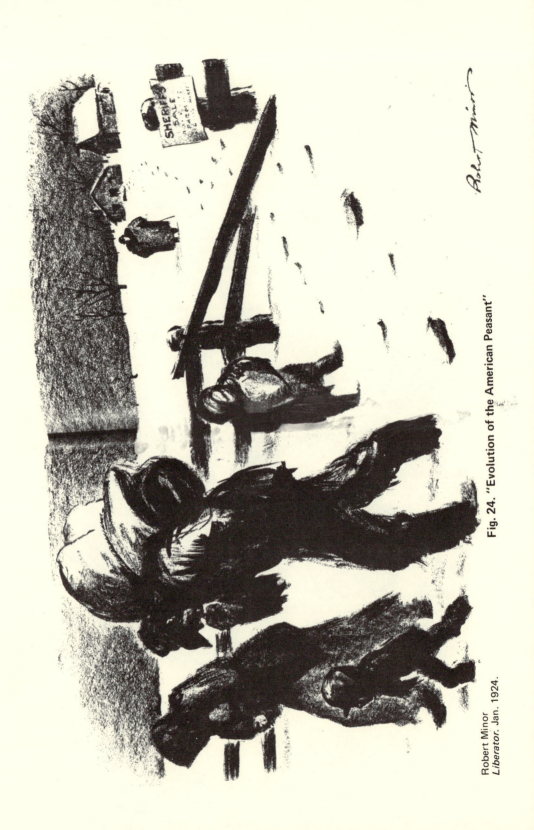

Fig. 24. "Evolution of the American Peasant"

Robert Minor
Liberator. Jan. 1924.

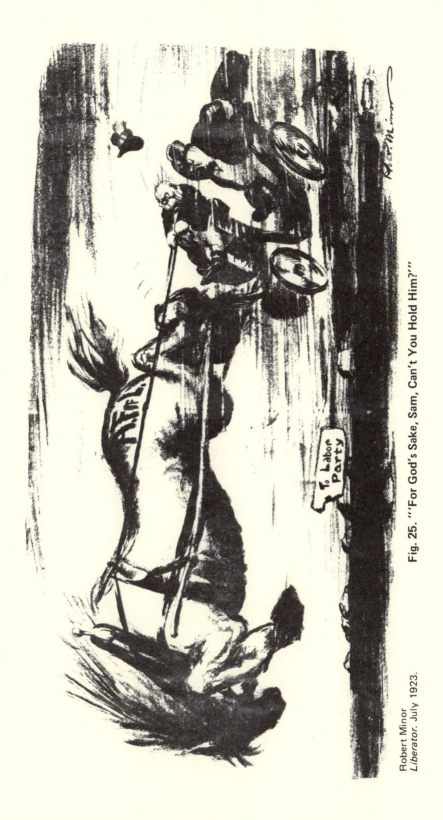

Robert Minor
Liberator. July 1923.

Fig. 25. "'For God's Sake, Sam, Can't You Hold Him?'"

in supporting the Communist party line, but his *Masses* drawings followed no particular line, being simply anticapitalist and pro-labor. The *Masses* in general supported the labor movement's struggles, but the *Liberator* was more concerned with specifically implementing a communist program in the United States.

Minor, as a *Masses* cartoonist, universalized the fight against oppressive forces, focusing on both the struggle for social and personal emancipation, and on the liberation of the proletariat from labor (in "Pittsburgh"), and the individual from censorship (in "O Wicked Flesh!" Figure 26). One could almost understand his cartoons without looking at the captions. The pictures almost spoke for themselves, almost said everything. The themes, as in "Pittsburgh" and "O Wicked Flesh!," were universal. One needed only to place and date them. But in the *Liberator* Minor was more concerned with the characterization of particular people and their emotions; the conflict between good and evil was less the stark focus of his work. Therefore in " 'Having Made the World Safe for Democracy,' " Lloyd George's face is expressive of individual emotion. That is, Minor on the *Liberator* drew people as particularized and concrete, as he had done as a newspaper cartoonist before he joined the *Masses*.

Minor's *Post-Dispatch* and *Evening World* cartoons did not feature dramatic conflict, and the framework of the cartoons was still irony within the established political system. It was clear in the *Masses* cartoons that evil had won and that Minor was displaying outrage at this fact. But in the *Liberator* cartoons there was no winner or loser, although there is the feeling of conflict and a historical sense of struggle. In other words, the later cartoons depend on theory, and the theory is the Marxist-communist view of the world. The earlier cartoons, insofar as they are dependent on theory at all, reflect the American mind, the American way of looking at the world. The middle cartoons express moral outrage— the conflict of evil triumphant over good—and the forces are right there in immediate conflict.

Thus, Minor's themes changed, being more libertarian on the *Masses* than on the *Liberator*. The artistic devices by which he

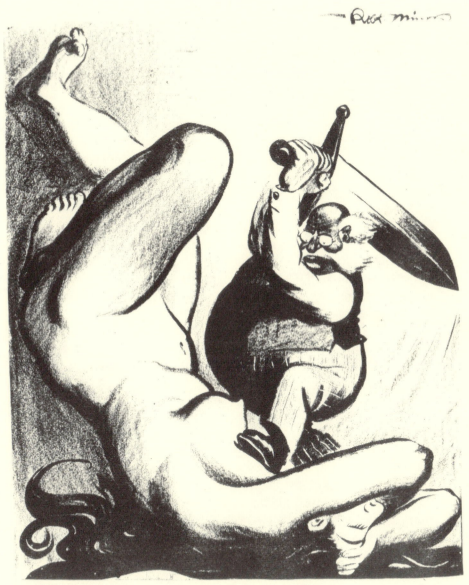

Robert Minor
Masses. Oct.-Nov. 1915. **Fig. 26. "O Wicked Flesh!"**

achieved this effect also changed. On the *Masses* Minor relied on heavy contrast and, to a lesser extent, on lighting and shade. But he relied on nothing else. Typically, contrast is found between a victim, chained or roped, drawn concave with delicate, almost serpentine, curved lines; and a victimizer, convex, with a mass expressing roundness, highlighted by the use of shading. "In Georgia," "O Wicked Flesh!" and "Either Platform Will Do" are good illustrations of such contrasts. That is, he achieved contrast through his delicate, flowery lines used in opposition to either some hard and linear or round and fat form: either a crucifix or a fat capitalist. Minor always contrasted massiveness, emphasized by shading, with fragile lines.

"O Wicked Flesh!" is a notable exception in that here the victim is also massive, so massive that the rotund victimizer, Comstock, is insignificant, like an insect attacking a large inde- structible element. This is curious; before "O Wicked Flesh!" Minor's victims were delicate and needed protection. Here his woman is indestructible—a kind of elemental force before Comstock the pest. In his later *Liberator* period, Minor, as in "'Having Made the World Safe,'" still derived a magnificent effect from serpentinely curved lines but added an element of darkness.

"Evolution of the American Peasant" is representative of Minor's *Liberator* work. On the *Masses* he used massiveness expressively; in this cartoon he used darkness expressively: the peasants are dark figures with clouded faces. His previous victims were not shadowy, but in "Evolution" his tenant farmers are victims of the night, giving one the feeling that these are people up against tremendous obstacles. Minor thus shifted somewhat from seeing people as the victimized to seeing them as active agents of social change in an almost overwhelming struggle for survival. They now became underdogs more than victims, depicted without the tremendous force evident in earlier *Masses* drawings which contrasted a strong capitalist and a weak worker.

This suggests why Minor's art changed on the *Liberator* when he became a communist and why he eventually gave up art for politics: his artistic sensibility inclined him to portray workers

as victims but communist thought argued they were active, rebelling agents. He chose ideology over his artistic soul, which fed on identification with the underdog. As a Communist party expert on the Negro, he maintained this mentality in his later preoccupation with blacks. Becker, Sloan, and Minor each identified with the downtrodden and depicted them sympathetically in their cartoons. Sloan, with his reformist perspective, saw the exploited poor as totally helpless, and so did Minor— who, however, was dialectical enough an artist to use contrast in his drawings to portray the rulers of men as the cause of the plight of the poor.

Minor's political hegira to Moscow began in 1918 when he read John Reed's reportage of the October Revolution in Russia. He left for Russia in March 1918. Minor, who had never read a word by Lenin, and by now definitely hard of hearing, arrived in Moscow during the Civil War while foreign troops, soon joined by American soldiers, maneuvered about Russia. His posters and leaflets distributed around Archangel asked United States and British troops not to fire on Russian workers. Minor himself spoke to Allied soldiers over a megaphone.[19]

Minor came to the USSR as an anarchist believing that all the world's socialist parties were opportunistic, and that, since all states were tyrannical, all power should reside in the unions. As Christopher Lasch puts it,

> Minor, like so many anarchists, had welcomed the Bolshevik revolution as the triumph of man over the state, and set out for Russia . . . with the highest expectations. He was immediately and cruelly disillusioned by everything he saw. After nine months in Russia he concluded that the Soviet state was more despotic, more arbitrary, and more ruthless than the Tsarist tyranny. An interview with Lenin in January, 1919, capped his disappointment; Lenin, he thought, was willing to compromise with capitalist imperialism even to the point of introducing capitalistic techniques into Soviet Russia.[20]

After this first foreign press interview with Lenin since the seizure of power, Minor wrote three stories which eventually appeared in the *New York World*. In his first dispatch he men-

tioned Lenin's desire for peace. But Minor dwelled on the restoration of capitalism in the Soviet Union:

> The main fact in the new situation [bourgeois in the Soviet government] is that the so-called nationalization of Russian industry has put insurgent industry back into the hands of the business class, who disguise their activities by giving orders under the magic title of "People's Commissaries." That is the only title that commands obedience.[21]

Lenin credited the American Marxist Daniel de Leon with the conception of Soviet government, saying "Industrial unionism is the basic state." But Minor wrote, "There is no more industrial unionism in Lenine's [sic] highly centralized institutions than in the United States Post Office," and that the process of nationalization had aroused the strong opposition of the "anarchist-syndicalists."[22]

On leaving the Kremlin after having interviewed Lenin, Minor watched as "two smart limousines drew up and deposited several well dressed men of the business type. This class had been lying very low only a few months ago," but now managed industries with "the iron discipline of the army under red flags." In his second article Minor described the Soviets as once the "spontaneous expression of rebellion against the old order" by "thousands of untheoretical minds, trying to manage affairs without a Government," but now molded by the Bolsheviks "into a shape bearing considerable resemblance to an ordinary congress." Minor's dispatches had great impact on the American liberal press reaction to the new Soviet regime and the question of American intervention. But, Lasch points out, "Minor deplored the return of order and discipline; [liberal] anti-imperialists welcomed it."[23]

In early 1919 Minor witnessed the Spartacist uprising in Berlin, which he felt was betrayed by the German "Majority Socialists." In Dusseldorf, then under a soviet, Minor propagandized the Allied troops across the Rhine. Then, at a railroadman's meeting in Paris, he urged a strike against munitions shipments to White Russian armies. In June he was questioned by

French police, turned over to the United States army, and put
into solitary confinement. After about a month he was released
and learned he had been charged with treason for promoting
Bolshevik propaganda among American soldiers.[24]

A year later Minor returned to the Soviet Union. In Moscow
he apparently saw Emma Goldman and Alexander Berkman,
who were rapidly being disabused of their enthusiasm for the
Soviet experiment, though it is unclear whether they then
conveyed their disillusionment to Minor. When Minor returned
to the United States, he decided, as he wrote in "I Change My
Mind a Little" (*Liberator*, October 1920), that his indictment of
the new Russian government was wrong. Minor did not change
his mind overnight. In July 1920 he wrote Tom Mooney that
the deterioration of the International Workers' Defense League's
(IWDL's) campaign for Mooney's and Warren K. Billings' release
was attributable to "the cause of the rotting of every organiza-
tion that ever man's hands put together—the building of a
burocracy [*sic*]." The IWDL should have tied the Mooney case
to a call for "Hands Off Russia" and a general strike at home to
free the prisoners, instead of allowing "criminal attacks on the
Russian workers' republic."[25] Thus, by July 1920 Minor defended
the "workers' republic" which he had ridiculed as a sham in
January 1919. But as a good anarchist he still attacked bureauc-
racy and advocated the general strike.

In October, with "I Change My Mind a Little," Robert Minor
the anarchist converted to communism and from that time
devoted himself to his role as political organizer, artist, writer,
and literary critic in the American Communist party. To
Christopher Lasch, "I Change My Mind a Little" failed to explain
reasonably "exactly wherein" Minor believed himself to be
wrong. Nor did Minor withdraw his previous allegation that the
Bolshevik state was the world's most dictatorial. To Lasch, Minor
had "slipped mysteriously beyond the boundaries of the ordinary
world in which such questions as how a dictatorship can advance
the cause of freedom, and how wars, however 'revolutionary,'
can lead to world peace, are presumed to have reasonable
answers."[26] Actually, a close study of "I Change My Mind a

Little" provides a reasonable explanation for supporting the
Soviet Union and communism. Minor said that since returning
from the USSR he realized "there is something more important
than to save Soviet Russia. It is to *understand* Soviet Russia."
His misunderstanding of Soviet Russia had resulted in objections
to the "Labor Republic," objections which he now repudiated.
He had formerly thought Lenin employed anarchist tactics only
during the Revolution, but having won, concentrated all power
on "an iron central authority." This was effected by repression
and by alliance with the bourgeoisie of Russia and other coun-
tries. The Revolution became a form of bourgeois "State Social-
ism" enforced by a bureaucracy and the Tsarist-officered army.[27]

So believing, Minor continued, he made a speaking tour of the
United States, learning that the "working masses" wanted, more
than the saving of Soviet Russia, an understanding of it.

> Slowly I began to sense in the Labor masses a current as profound
> as the tides of the sea. I was bothered with the elusive impression
> that a great natural law was at work which I did not understand.
> It was plain that the Russian Revolution had set this current in
> motion, and that its form was pre-determined somewhere in the
> origin of the race. . . . There couldn't be anything the matter with
> a natural law, so I thought there must be something the matter
> with me.[28]

He felt something was lacking in his perception of the Revolution,
so he settled to read three volumes of *Das Kapital* and Lenin's
"State and Revolution." According to him, *Das Kapital* outlined
the program followed by the Bolsheviks to that time. Guided by
Lenin's quotations, Minor indulged in prolonged reading of Marx,
Engels, and the anarchists, finding the "Communist Manifesto"
an outline "in complete harmony" with 1917 Bolshevik tactics.
He found that Engels "by cold scientific method" dissected the
state's function—protecting private property—whereas the anarch-
ists showed no understanding of the state.[29]

The Russian Revolution would have failed had not the Bolshe-
viks "suppressed the bourgeoisie with . . . brute, police force.
And, without kidding ourselves, that is simply and plainly a
State, no matter what we may call it." Marxism "calls for a

transitional period of the Dictatorship of the Proletariat." Compared with the anarchist conception of soviets "we see Lenin striking straight for a non-State society with a clear program for getting it more quickly than any other had ever dared hope." The Bolsheviks suppressed the anarchists to maintain "unity of action" necessary to win the Revolution. "I only wish now that I had been subject to 'party discipline' when [as a *World* correspondent critical of the USSR] I made a certain journalistic blunder."[30]

It must be seen, said Minor, that "Communism is impossible where a State exists." The proletarian dictatorship, on the other hand, will last only "as long as there is a bourgeois with a gun or a hope." Minor did not know this before, he explained, because he had entered socialism naively through the Socialist party, which was so revisionist that he was naturally drawn to the radical anarchist side of the SPA. Maybe, said Minor, we are tainted by "a faint trace of the ideology of priestcraft" in following the anarchists' "old metaphysical style of moralizing." Then, "What strange power has Lenin? Why does every adversary, one by one, fall before him? . . . The answer is that Lenin is a scientist in an unscientific world."[31] Thus, contrary to Lasch's opinion, Minor had not "slipped beyond the boundaries of the ordinary world," but like most socialists all over the world came to regard the USSR and Lenin as the logical result of Marxist theory.

To Theodore Draper, "I Change My Mind a Little" is "intellectually incredible and psychologically fascinating. Since Minor had no political finesse, he put down his thoughts with unashamed and disarming naivete." To Minor's statement that Lenin succeeded because he was a scientist, Draper responds: "In a previous age, Minor might have venerated Lenin as a prophet or even as a wizard. In the twentieth century, he worshipped Lenin the Scientist," seeking, like Dell, Eastman, and Lincoln Steffens, "something in the 'science' of communism which they did not have in themselves. What really captivated them was the mysticism . . . because it substituted for older mysteries the mysteries of science." The identification of communism with science was, Draper argues, a way of paying tribute to the success of the

Russian Revolution. In 1918, when the Revolution was unde-
cided, Minor was unimpressed but by 1920 all radicals had to
choose between their own "frustrating little movements" and
the only successful revolution in the world. Minor still believed,
as an anarchist, that the dictatorship of the proletariat was like
any other State—an instrument of oppression—but his reading
convinced him it would wither away. Draper concludes:

> Minor is a study in extremes. A truly gifted and powerful
> cartoonist, he renounced art for politics [not until 1926]. He
> made this gesture of total subservience to politics after years
> as an anarchist despising and denouncing politics. But he could
> not transfer his genius from art to politics. The stirring drawings
> were replaced by boring and banal speeches.[32]

In reply to these remarks, it might be argued that, like many
students of socialism from the later Eastman to the present,
Draper has a very narrow conception of what a science is.
"Science" typically means "empirical science," pragmatic,
positivistic, purportedly antimetaphysical, relying for the truth
of its hypotheses on the observation of repeatable and control-
lable events. This view of science is clearly an important one, but
there is no reason to suppose it has to be the only one. The
dogmatic acceptance of this view has led many non-Marxist
scholars to reject Marxism as "unscientific" and "mystical."
But if Marxism is rejected on such grounds, then the greater
part of bourgeois political and socio-economic sciences, and
perhaps a certain part of natural science as well, will have to be
rejected on the same grounds. Indeed, a relatively small part of
any purportedly "scientific" enterprise will ever live up to the
empiricists' expectations. Thus, if we refrain from ideologically
and persuasively defining Marxism out of the realm of scientific
legitimacy, there is no reason why we should not accept it as a
genuine and comprehensive scientific hypothesis. And while
Minor's seemingly uncritical acceptance of this hypothesis might
justifiably be regarded as naive, it is surely no more naive than
the non-Marxist scholars' uncritical acceptance of empiricism.

Joseph North explains Minor's switch in this way. In the

USSR for the first time, Minor saw chaos in factories under worker control. Wobblies and anarchists from other countries then in the Soviet Union complained to Minor that the dictatorship of the proletariat was really the replacement of Tsarist with Bolshevik despotism. Of Minor's first interview with Lenin, North only says they discussed the American labor movement. Back in the United States Minor began speaking in support of the Soviet Union but sensed, as he wrote in "I Change My Mind a Little," that the crowds wanted more than a description of the revolution. So he spent hours comparing Marx and others with anarchist writers, deciding Lenin's program would most efficaciously bring about the classless society. North disposes of the question by concluding that "once he saw that Marxism was a liberating science, he joined the Communist movement, and afterward became a leading member of the Communist Party until his dying day, thirty-two years later."[33]

Theodore Draper treats Minor's conversion as effect and cause; that is, Minor became a communist because of psychological reasons—a sort of quest for the religious experience—and because of the external political situation in the United States. Where else could a left wing American socialist go in 1920? The Socialist party of America had irrevocably split and the IWW was in serious decline. Given the decline of American socialism and the reality of the Soviet Union, the acceptance of communism by an American socialist in 1920 is reasonable.

The problem with explanations like Draper's is, first, that they seek underlying motivation and outward behavior but ignore ideals, the conscious idealism of a man such as Robert Minor. Second, in explaining Minor's conversion, no writer notes that only prior to World War I could an artist in the United States survive in the market as a political socialist. In 1910 Minor could say yes to Mark Sullivan; he was a member of the Socialist party. But during World War I, as Art Young also discovered, this was no longer possible: as the American government edged toward intervention, with the press behind it, socialists moved into opposition. One must make one's choice. Minor took the bull by the horns and made his decision.

Minor argued later that in the art market only "those [artistic] capacities which are adaptable to the interests of Capital are developed into the artists' professions. The more sensitive—the more able—artists tend to chafe under . . . this prostitution . . . [because] The impulse of the artist is the hunger to bring incoherent things into focus with a unifying concept." Even if the commercial artist remains "sleek and witty," Minor said, he is still a "flatulent mock-artist." Both capitalist and communist artists are "propagandists," for "art is an indispensable weapon in the class struggle." The difference, however, is the "freedom from prostitution, and the positive value of a . . . unifying concept of the universe" offered only by the communist press.[34]

Between Joseph North, who sees Robert Minor as "artist and crusader," and Theodore Draper, who emphasizes Minor's servility to the party line and bureaucratic role, emerges a large gap, bridgeable only by a profile covering Minor's role as both party functionary and activist. But overall, Minor appears much more the activist than bureaucrat, a person moving with zest rather than with the calculated strategy of one enmeshed in the bureaucratic web. He seems rather more unconcerned with, than a slave to, party ideology; more involved in the fight for immediate social justice in particular instances than the long-range implications of the Communist party's position on a given issue. Ideologically, Minor should be characterized as consistently believing that workers and the minority poor were the agencies of social change, though at various times the party and Minor supported different groups and organizations as best representing the true interests of labor and ethnic minorities.

It is difficult to ascertain whether, in Communist party debates, Minor led arguments, was persuaded to what became the official position, or simply followed the emerging party line. This is an important question because one of the standard statements about Minor is that after he stopped being a creative artist he became a political hack with no creativity or originality. And that, if true, would be a fact requiring explanation. It can only be pointed out that the evidence is limited and points in

both directions.[35] Anyone who draws a firm conclusion about
Minor as party official without looking at all the evidence is,
of course, not being fair to the facts.

In explaining Minor's decision to give up art, all that the
known evidence (except for the changes in his cartoon style)
warrants are certain conjectures and speculations. However, the
most plausible explanation for the movement in Minor's political
development is that he was an artist with a passion to make
political points by using art as a vehicle; finally the passion became
so great that being an artist who merely commented on the times
became dissatisfying. That is, he became dissatisfied with the
politics of commentary. Yet, it is most difficult to ascertain the
specific reasons for his dissatisfaction. Perhaps he did not have
sufficient respect for the artist, because artists, from the point of
view of the Communist party and of the artists themselves, were
instruments for realizing some other non-artistic political aim.
Minor as a communist cartoonist could have been pressured by
the feeling that he should, in accordance with the party view,
reflect proletarian life. This was contrary to all his artistic
impulses. He tried to reflect but he could not conceive of his
work as having value in itself and so he gave it up. One cannot
just say it was Stalinism—being a party hack—that killed him.
The question was the much deeper one of how he saw the value
of his own art. The party did not, so to speak, slit his artistic
throat; Minor killed himself.

It appears that this alienation of artistic powers was a recent
development, occurring in Minor's own lifetime. Therefore,
radical artists did not conceive of themselves as opposing their
alienation and exploitation *as artists.* They saw themselves acting
in their interests for all sorts of other reasons—in Minor's case,
as a communist.

From 1921 to 1924, Minor served as an editor of the *Liberator*
and regularly contributed writing and art to it and to the party
magazine, *Workers Monthly*, as well as cartoons to Art Young's
satirical magazine, *Good Morning.* Ideas for Minor's cartoons
and articles were often taken from his extensive travels. He was
forever optimistic. He believed that co-operatives would work

with organized labor, the IWW would not die, and that growing
strikes indicated growing worker power.[36]

Minor was better at drawing than journalism, but there is a
fine line between cartooning and journalism. His writing was
a different side of the same coin, was not "banal and boring,"
and showed the same stark contrasts as his illustrations. In "Man,
X His Mark: Comment on an Exhibit of Drawings by Boardman
Robinson," Minor revealed what compromise with the art market
costs and what radical art should be.

> The pictures that we see are the fake Mark of Man. . . . Look
> at these pictures in the Daily Lie, in the Weekly Smirk, in the
> Monthly Cash—they are printed with the pus from the sores
> of Job . . . holy, sweating bones and muscles gone from out
> of them. What conception forewent the birth of these pictorial
> abortions? . . . $185 per week. A Buick. A flat on Riverside.[37]

But with Boardman Robinson's pictures, mankind speaks in
"bleak white and desperate black, struggling in a frame as man
struggles on the world."[38]

Minor could not remember exactly what Robinson's pictures
were about—"they are all about the same thing. . . . Here is
Winter, proven guilty of the murder of Summer, here's hope
balanced against despair, life struggling with death." But then,
he added, "That's all that any real picture is about. The fight
of forces. That is the only theme an artist ever knew." Today
"the screaming forgeries on all sides confuse us," but someday
things will be better:

> When the race draws as a whole, individuals' names will no
> longer be signed to pictures. In general it is because men trade
> with their art that they put their trade-marks upon it. The prosti-
> tute must mark his door for further business. Out of this, I think—
> this life of copyrights and hold-backs—the habit of—and necessity
> for—individual signatures comes into art.[39]

In late 1922 when the faltering *Liberator* was turned over to
the Workers party (at Minor's request but with the consent of the
staff), Minor and Freeman as the magazine's executive editors
moved the *Liberator* to party headquarters on East 11th Street,

away from Greenwich Village and into a working-class neighbor-
hood. From 1920 to 1933 Minor was usually a member of the
party's Central Committee, and as such became a close friend
of Charles Ruthenberg, a founder of the American Communist
party, William Z. Foster, Alexander Trachtenberg, and others.
In 1921 and 1926 Minor was one of the American representatives
to the Comintern, while his wife, Lydia Gibson Minor, was an
American recipient of secret Comintern messages. From an old
New York family, she was in the women's rights movement. But
she contributed poems to the *Masses* for its art, not its socialist
message. She also contributed Gauguin-like Polynesian drawings
to the *Masses*. When she joined the *Liberator*, however, her art
became political.[40]

In New York the Minors had resided at her Croton-on-Hudson
estate. After the Workers party headquarters were moved to
Chicago in 1923, the Minors lived in an apartment in the black
South Side. Minor, a party leader in Negro work, began speaking
on South Side streets. For five years he headed the Negro
Department of the Central Executive Committee and led a brief
flirtation with the Garveyites in 1924. Soon Minor concluded
that Garvey failed to develop the revolutionary potential of the
black masses. He hoped through the 1920s that blacks would
merge with "the advanced section of the labor movement."[41]

Minor helped draw up the Central Executive Committee
resolution for a labor party in 1922. He found less time to draw
because, as his biographer says, "He decided [in 1926] that he
could not be a political leader and a cartoonist simultaneously."
Minor's friend, the musicologist Lawrence Gellert, explained
that "Bob Minor gave up his brush . . . because he felt he had to
get direct action as an organizer. And we lost a first class artist
for a pedestrian politico." Surprisingly, the Communist party
recognized Minor's talent and tried to get him to spend more
time on the drawing board than in direct political work. Appar-
ently, it was Minor alone who decided he could not do both.
According to Joseph Freeman, it was because Minor was "a man
whose temperament requires complete concentration," that he
"abandoned art for action. The choice and the reasons for it

were entirely his own; if these be an enigma, that enigma is personal." So Minor continued to speak and write and returned to New York in 1928 as *Daily Worker* editor. To young communist artists such as Joseph Freeman, John Reed and Robert Minor served as examples of men who took the "extreme solution" to the problem of art and politics—that of abandoning art for the benefit of the Communist party.[42]

When the *Daily Worker* was founded in 1924, Minor tried to employ the writing, printing, and distribution techniques of the commercial press and spent long hours writing most of the editorials. When the depression came, he became active in the party's unemployment councils. In March 1930 he and other party leaders, including William Z. Foster, were arrested during a massive march for the unemployed; Minor received a six-month to three-year sentence. In prison he collapsed from appendicitis and was released in an ambulance. He spent more than a year recovering at his wife's estate in Croton.[43]

When Minor returned to the *Worker*, he helped organize the International Labor Defense (ILD), which uncovered perjured testimony in the Scottsboro case and which helped obtain the release of the nine black defendants who had been convicted of rape and sentenced to death. Later, Minor headed the ILD in Gallup, New Mexico, where striking miners were involved in bitter labor struggles with the Gallup-American Coal Company. He and an ILD attorney were kidnapped and abandoned in the desert but Minor remained in Gallup to organize a defense committee.[44]

During the Spanish Civil War, Minor went to Spain as correspondent for the *Daily Worker* and other left wing periodicals. His daily dispatches argued, in typical Popular Front rhetoric, that the Civil War was analogous to the American experience in the 1860s—a struggle not between fascism and communism but a war to save democracy. In Spain, Minor was apparently also a political commissar, for at the front he made many speeches on the world political scene to the American Abraham Lincoln Brigade, though by then he was nearly deaf. He returned to the United States in 1938 to rally popular support for the Spanish Republic.[45]

When Pearl Harbor was bombed, Minor was acting secretary of
the Communist party, a post he had held since 1939. He
constantly advocated a "Second Front" in Europe. But toward
the war's end, in 1945, the party line reversed, and the Commu-
nist party opposed coalition. When this was formalized at the
party's Extraordinary Convention of 1945, Minor recognized he
had been too slow in perceiving imperialist forces at work in
the war against fascism and immediately recanted.[46]

Shortly after the convention, Minor, at sixty-one, requested
assignment to the South, where he was made southern editor for
the *Daily Worker*. When a "race riot" broke out in February
1946 in Columbia, Tennessee, and the national guard was called
in, Minor again searched for the facts himself. He ascertained
that the initial incident was provoked by whites and that the
magistrate had participated in a 1933 lynching. He wrote another
pamphlet, "Lynching and Frame-up in Tennessee."[47]

Minor suffered a coronary occlusion while working for the
legal defense of party General Secretary Eugene Dennis, whom
the House Un-American Activities Committee (HUAC) had
voted in contempt after Dennis had refused to testify. While
bedridden, Minor started his autobiography. Though confined
to his house when the entire party National Committee was
arrested in 1948, he wrote many memoranda and followed the
trials closely from 1948 through 1951. In early 1952 he died.
Supposedly, one of his last utterances was "I'll write Steve
[Nelson, imprisoned] in the morning." Lydia Gibson Minor put
up their estate as bail for the indicted communist leaders.[48]

To the end, Minor remained a party stalwart. Eastman, reflect-
ing on his conflict with American communists over Trotsky in
the late 1920s, said that in 1927, when he was living across from
Minor in Croton, his old *Masses* and *Liberator* colleague pointedly
ignored him, and once, in Floyd Dell's living room, refused to
shake hands or speak. "Only the strict active Communists, the
party militants and finished bigots like Bob Minor, then regarded
the barrier against me as absolute."[49]

Yet, in 1921 on the *Liberator*, during a brief period when the
Liberator was put out jointly by Minor, Dell, and Claude McKay,

Minor's reply to Eastman's complaint that the April number was
"surrendering to Greenwich Village studio art" was that

> a monthly magazine cannot carry cartoons that are of the same
> value only as daily newspaper cartoons. . . . to be available for use
> in the Liberator, a cartoon must contain either extraordinary
> "literary ingenuity" or else a distinctive artistic value. . . . I am
> going to make the double[-page] cartoon this month, so I suppose
> the coming issue will be vulgar-realistic enough to suit you.[50]

But in 1925, Eastman added, Minor attacked him "from the other
side of this question" concerning Stalin, Minor now calling East-
man a bohemian dilettante.[51]

How can one explain Minor's willingness to follow the Com-
munist party line for over thirty years? He was a forceful
personality, a tremendously talented and successful artist, who,
out of moral conviction, cut himself loose from the commercial
art world. Compared with Becker, Chamberlain, Sloan, and
Young, Minor was by far the most political artist. After throwing
up his professional career, his willingness to be dominated
by the party for the rest of his life may have been due to a deep
need for a new anchor in life. At all times he identified with the
party's official position, and worked for the needs of the working
class and especially the minority poor.

A personal revolt of this kind is the rebellion of an individual
against larger institutions. First, it is against institutions involved
in the art market—for example, against employers and gallery
dealers. Second, it is against certain kinds of fixed traditions in
art, traditions that every art student encounters while learning an
art that may not be suitable for his purposes. Third, it is typically
(especially in the case of a man like Minor who was not initially
wealthy) the rebellion of an individual who only has his artistic
skills to rely on and needs money to survive. And this money is
usually earned through work in art. Thus, the struggle to find
an art form that both expresses what the artist wants to say and
can be marketed is a completely innervating struggle, a struggle
which must be waged without the support of institutions com-
parable to labor unions or professional associations which have

a history and tradition of resistance. To Minor, who always held that the real struggle was political, the Communist party was the only alternative open to him.

NOTES

1. North, *Minor*, pp. 11-12, 16-17, 27-29, 33-34, 36, 39, 40-43. Robert Minor, "How I Became a Rebel," *Labor Herald* 1 (July 1922): 25. Philip Sterling, "Robert Minor; The Life Story of New York's Communist Candidate for Mayor," *Daily Worker*, September 11, 1933, p. 5. Orrick Johns, "Robert Minor, The Man," *New Masses* 12 (August 28, 1934): 16. Draper, *Roots*, p. 121. On p. 418, note, Draper characterized North's biography as "almost a *reductio ad absurdum* of Communist hagiology. For most of his Communist career, Minor was a slavish follower, first of Lovestone, then of Browder, both of whom he betrayed. Neither Lovestone nor Browder are ever mentioned in this book." North, a *New Masses* editor, *Daily Worker* correspondent, and friend of Minor, wrote with the collaboration of Minor's widow Lydia, who provided Robert Minor's autobiographical notes and correspondence. North failed to discuss Minor's 1919 dispatches from the Soviet Union critical of the Bolsheviks from an anarchist viewpoint, his second trip to the USSR in 1920, or, with one exception, his position in Communist party factional fights.
2. Johns, "Man," p. 17. North, *Minor*, pp. 44-49. Quote from Robert Minor to Gil Wilson, October 6, 1935, Gil Wilson Papers.
3. Draper, *Roots*, p. 122. Johns, "Man," p. 18. North, *Minor*, pp. 52-53, 55.
4. North, *Minor*, pp. 55, 277, 279-280. (Quotes 1-2 from p. 280.) Quote 3 from Robert Minor, "1907—St. Louis," p. A(2)-1 [manuscript], Robert Minor Papers, Butler Library, New York. North, *Minor*, p. 53, claimed Minor joined the SPA in 1907, as did Johns, "Man," p. 17, and Draper, *Roots*, p. 122. Minor said he joined in 1908 in "Rebel," pp. 25-26, in 1907 in "1907—St. Louis," p. EE-1, Robert Minor Papers. The reference to the *Appeal to Reason* is in Johns, "Man," p. 18.
5. Philip Sterling, "Robert Minor: The Life Story of New York's Communist Candidate for Mayor," *Daily Worker*, September 12, 1933, p. 5. North, *Minor*, pp. 53, 55. Quotes from Johns, "Man," pp. 16-17.
6. North, *Minor*, pp. 57-58.
7. Ibid., pp. 60-61.
8. Ibid., pp. 61, 63-64. (Quotes from pp. 63-64). Johns, "Man," p. 18.

9. North, *Minor*, p. 66. North said Minor worked for the *World*. Draper, *Roots*, p. 418, note, stated correctly that it was the *Evening World*, a separate newspaper under the same publisher. In "Rebel," p. 26, Minor explained that he was first hired by the *World*. But because he refused to draw cartoons linking the anarchists Alexander Berkman and Emma Goldman to a bomb explosion, he was "reduced" to the *Evening World*.

10. North, *North*, pp. 68-69. Draper, *Roots*, p. 122.

11. Quote 1 from *Minor*, "Rebel," p. 26. North, *Minor*, pp. 70-71, 73. (Quote 2 from p. 73.) In "Rebel," p. 26, Minor said he quit the *Evening World* before joining the New York socialist daily, the *Call* (1908-1923), to "make revolutionary cartoons."

12. North, *Minor*, p. 74. Quote 1 from Emma Goldman, *Living My Life*, one vol. ed. (New York: Garden City Publishing Company, 1934), p. 567. Quote 2 from Philip Sterling, "Robert Minor: The Life Story of New York's Communist Candidate for Mayor," *Daily Worker*, September 15, 1933, p. 5. Johns, "Man," p. 18.

13. Robert Minor, "The Paintings of William Sanger," *Liberator* 3 (January 1920): 43.

14. North, *Minor*, pp. 74-75. Robert Minor, "A Letter from Bob Minor," *Masses* 8 (March 1916): 18. Quote 2 from Sterling, "Minor," September 15, 1933, p. 5.

15. North, *Minor*, p. 76. Interview with K. R. Chamberlain, August 10, 1966. Eastman also remembered Minor on the *Masses* as a committed anarchist. "New Masses," pp. 296-297.

16. Johns, "Man," p. 17. Perhaps the white victim in "In Georgia," similar in appearance to Jesus in "Billy Sunday Tango," is Leo Frank, a Jew accused of a sex murder and murdered in 1915 by a Georgia mob.

17. North, *Minor*, p. 125.

18. Freeman, *Testament*, pp. 303-304, 319.

19. North, *Minor*, pp. 98, 100. Johns, "Man," p. 18. Sterling, "Minor," September 15, 1933, p. 5.

20. North, *Minor*, p. 103. Young, *Young*, p. 387. Christopher Lasch, *The American Liberals and the Russian Revolution* (New York: Columbia University Press, 1962), pp. 149-150.

21. Robert Minor, "Lenine Is Eager for Peace, He Tells *World* Man; Asks 'When Will Revolt Reach U. S.?,'" *New York World*, February 4, 1919, pp. 1-2.

22. Minor, "Lenine Is Eager for Peace," p. 2.

23. Ibid.; Robert Minor, "Lenine Overthrew Soviets by a Masked Dictatorship; Bourgeoisie Gain Power," *New York World*, February 6, 1919, p. 1. Lasch, *Liberals*, p. 152. North, *Minor*, pp. 110-111.

24. Robert Minor, "The Spartacide Insurrection," *Liberator* 2 (August

and September 1919): 22-25, 31-39; Robert Minor, "I Got Arrested a Little," *Liberator* 2 (December 1919): 28-29, 31-38. Sterling, "Minor," September 15, 1933, p. 5. North, *Minor*, pp. 112, 114, 116. Apparently, Minor was never tried for treason.

25. Richard Drinnon, *Rebel in Paradise: A Biography of Emma Goldman* (Chicago: University of Chicago Press, 1961), p. 238. Goldman, *Life*, pp. 731-755. Robert Minor to Rena Mooney [Tom Mooney's wife], July 16, 1920, Thomas Mooney Papers, Bancroft Library, Berkeley. Mooney, Billings, and others were charged with bombing a 1916 San Francisco "Preparedness" parade. On April 20, 1919, Minor wrote Eastman that "as soon as the men who rule Homestead and East Pittsburgh and Ludlow [,] Colorado, begin to rule the Urals and the Volga . . . it will be [as] necessary for the [American] working class to . . . understand Lenin as it is needful that they understand Gompers." Max Eastman Papers, Lilly Library, Bloomington, Indiana.

26. Lasch, *Liberals*, p. 155.

27. Robert Minor, "I Change My Mind a Little," *Liberator* 3 (October 20): 5.

28. Ibid., p. 6.

29. Ibid., pp. 6-7.

30. Ibid., pp. 7-8.

31. Ibid., pp. 9-11.

32. Draper, *Roots*, pp. 124-126.

33. North, *Minor*, pp. 103-105, 118-119, 121-124.

34. Robert Minor, "Art as a Weapon in the Class Struggle," *Daily Worker*, September 22, 1925, p. 5.

35. The Robert Minor Papers at Butler Library include clippings, manuscripts, and cartoons but no letters. The whereabouts of the correspondence remains a mystery. Minor's biographer, Joseph North, who used the Minor correspondence, said that he did not know what became of the letters. To author, June 10, 1970.

36. Robert Minor, "A Yankee Convention," *Liberator* 3 (April 1920): 28-34; Robert Minor, "The Great Flop," *Liberator* 3 (May 1920): 20-22; Robert Minor, "Palmer and the Outlaws," *Liberator* 3 (June 1920): 5-12.

37. Robert Minor, "Man, X His Mark: Comment on an Exhibit of Drawings by Boardman Robinson," *Liberator* 5 (April 1922): 20.

38. Ibid., p. 21.

39. Ibid.

40. Freeman, *Testament*, p. 309. Sterling, "Minor," September 15, 1933, p. 5. Draper, *Roots*, pp. 338, 450, note; Theodore Draper, *American Communism and Soviet Russia: The Formative Period* (New York: Viking Press, 1963), pp. 169, 207. North, *Minor*, pp. 142-143. Lydia Gibson also contributed political cartoons to the *Workers Monthly* (1924-1927) and the *Daily Worker* (1924-1968).

41. Lawrence Gellert to author, August 2, 1968. Draper, *Communism,* pp. 89-90, 330-331. North, *Minor,* pp. 152, 158. Sterling, "Minor," September 12, 1933, p. 5. Robert Minor, "The Black Ten Millions," *Liberator* 7 (March 1924): 7, 15-17; Robert Minor, "The Handkerchief on Garvey's Head," *Liberator* 7 (October 1924): 20-25; Robert Minor, "The First Negro Workers' Congress," *Workers Monthly* 5 (December 1925): 68-73; Robert Minor, "Death or a Program!," *Workers Monthly* 5 (April 1926): 270-273, 281; quote from Robert Minor, "After Garvey—What?," *Workers Monthly* 5 (June 1926): 363-365; Robert Minor, "The Negro and His Judases," *Communist: A Magazine of the Theory and Practice of Marxism-Leninism* 10 (July 1931): 632-639.

42. North, *Minor,* pp. 167-168. Lawrence Gellert to author, July 11, 1968, September 7, 1971. Freeman, *Testament,* pp. 302, 307-308. Joseph North and James S. Allen, Minor's colleague in the Negro Department, said Minor never elaborated on his decision to give up art. December 22, 23, 1970, interviews. However, Gil Wilson recalled that in the 1930s Minor privately expressed doubts about the artist's role as an organization man. To author, May 4, 1970, June 14, 1970. Minor's last cartoon was in the November 12, 1926 *Daily Worker.*

43. North, *Minor,* pp. 169-173, 177-179, 181-185. Benjamin Gitlow, *I Confess: The Truth About American Communism* (New York: E. P. Dutton & Co., 1940), pp. 478-479. The *Daily Worker* superseded the *Worker.* The *Daily Worker* moved to New York in late 1926, appeared as the *Worker* after 1955, and was superseded in turn by the *Daily World* in 1968. See Walter Goldwater, *Radical Periodicals in America, 1890-1950,* 2d ed. (New Haven: Yale University Press, 1966), pp. 10, 46. Minor was arrested in 1927 while speaking at a Wall Street "Hands Off Nicaragua" rally, was clubbed in 1929 at a Food Workers Industrial Union protest and at a 1930 unemployment demonstration, arrested in 1933 leading a Furniture Workers Industrial Union picket line and at a 1938 demonstration. North, *Minor,* p. 170. Sterling, "Minor," September 15, 1933, p. 5. "Communist Riot, March, 1938," Amos Pinchot Papers. In 1929, when the socialist Morris Hillquit brought a criminal libel suit against the editors of *Freiheit* (the communist Yiddish language daily) and the *Daily Worker,* Minor was among those briefly jailed. Melech Epstein, *The Jew and Communism: The Story of Early Communist Victories and Ultimate Defeats in the Jewish Community, U.S.A., 1919-1941* (New York: Trade Union Sponsoring Committee, 1959), pp. 139-140. In a letter to Tom Mooney, Minor apologized for delays in corresponding, adding "Saturday I was jailed in a picketing scrimmage for a few hours, but forced to spend a lot of time also in the courtroom," March 10, 1936, Thomas Mooney Papers.

44. North, *Minor,* pp. 194-198, 212-213, 215-216, 219.

45. Ibid., pp. 222, 225-227, 237, 239. Steve Nelson, *The Volunteers: A*

Personal Narrative of the Fight Against Fascism in Spain (New York: Masses & Mainstream, 1953), pp. 118-120. George Morris, "Spanish Republic Gains Strength, Minor Tells Communist Convention," *Daily Worker*, May 23, 1938, pp. 1, 4.

46. North, *Minor*, pp. 249, 251, 254, 256. As with Jay Lovestone in 1929, Minor supported the party's ouster of Earl Browder in 1945. Draper, *Communism*, pp. 423-431. Irving Howe and Lewis Coser, *The American Communist Party: A Critical History, 1919-1957* (New York: Praeger, 1962), pp. 169-173, 443-445.

47. North, *Minor*, pp. 257-262. Robert Minor, "Lynching and Frame-up in Tennessee" (New York, 1946). Minor wrote a great deal in the 1940s. In addition to "Lynching and Frame-up," other pamphlets were "Free Earl Browder!" (New York, 1941); "One War: To Defeat Hitler" (New York, 1941); "Our Ally: The Soviet Union" (New York, 1942); "The Year of Great Decision, 1942" (New York, 1942); "Invitation to Join the Communist Party" (New York, 1943); "The Heritage of the Communist Political Association" (New York, 1944); "Tell the People How Ben Davis Was Elected" (New York, 1946).

48. North, *Minor*, pp. 268-271, 273-275, 280-281. (Quote from p. 281.) Lawrence Gellert to author, August 2, 1968.

49. Eastman, *Love*, pp. 491, 533. Minor claimed that "the little buzzard of Trotskyism began to hatch in the arm-chair of the former chief editor [of the *Liberator*] —but this bird was smothered in its nest." "The Great Quarter-Century," *New Masses* 21 (December 8, 1936): 18.

50. Robert Minor to Max Eastman, April 8, 1921, Max Eastman Papers.

51. Eastman, *Love*, p. 236.

4
John Sloan

John French Sloan (1871-1951) was born in Lock Haven, Pennsylvania, but grew up in Philadelphia. His father, John Sloan said, was "a total wreck in business" and struggled as a traveling salesman, suffered a nervous breakdown, and finally lost the stationery store in which he had been established by his wife's family. When his father lost the store, Sloan, then sixteen, had to quit school and start working to support the family. He started as an assistant cashier in a book and print store, and found he could sell his own drawings and cards at the store.[1]

In 1888, at sixteen, Sloan taught himself to etch, at first by copying Rembrandt and selling the etchings at the bookstore. Sloan then moved on to a "fancy goods" store designing Christmas cards, match-boxes, and book marks. At this time he saw himself as an illustrator, not as a painter. He worked patiently on everything he undertook, saying years later, "The reason I accomplished more than some of the other artists of my generation was that I had less talent than they did and so I had to work harder." As an illustrator, Sloan thought highly of the work of Forain, Steinlen, and Boardman Robinson.[2]

In 1892 Sloan began work on the *Philadelphia Inquirer* doing headings for the Sunday section and illustrations for the women's section. In his spare time he attended the Pennsylvania Academy where he studied under Thomas Anshutz, the disciple of anatomist Thomas Eakins. The same year he initiated a long friendship

with the philosophical anarchist Robert Henri, who had also studied under Anshutz. In 1895 Sloan joined William Glackens and George Luks as rapid-sketch artists on the *Philadelphia Press.* Sloan, however, worked slowly and did few reportorial drawings. He was happy that the editors allowed him to draw "out of his head." Together with Everett Shinn (who was not on the newspaper), these men comprised Henri's informal group, later labeled the "Ash Can" school. As its members one by one lost their *Press* jobs to cameramen, they migrated to New York between 1896 and 1904, Sloan arriving last when the Sunday supplement for which he drew was replaced in 1903 by a syndicated edition. But he had no love for newspaper work, once saying, "if there is any way to be 'out of the world,' it is to work on a newspaper . . . and [be forced to] discount most of the news because you know how much of it is colored by editorial policy."[3]

Sloan was receptive to Henri, who gave him a copy of Bakunin's *God and the State*, helping him to break with his Episcopal upbringing and to develop "a strong suspicion that all government was bad and subject to corruption." Henri not only preached politics to Sloan, but urged him in 1897 to take up serious painting and to include all types of subject matter. Though Henri was doing mostly portraits, he encouraged his group to paint "pictures" or "memory impressions" from everyday scenes. Sloan did portraiture from 1898 to 1903, but in 1898 he also began to paint Philadelphia street scenes and landscapes.[4]

In 1902 Sloan began a series of etchings for the novels of Charles de Kock; three years later he started a "city-life" series. Though he did exhibit paintings with the "Eight" in 1908 and was in the 1910 Exhibition of Independent Artists, not until 1943 could he live from his work alone. He survived financially from 1903 to 1910 mainly by mailing "word-charade" puzzles to the *Press*, aided by occasional popular magazine illustrations in *Scribner's, Everybody's, Munsey's, Collier's, Harper's Weekly,* and the *Saturday Evening Post.* These drawings were mostly illustrator's work; that is, they were story illustrations rather

than cartoons. By 1910 Sloan lived by doing free lance illustration and by 1916 from teaching at the New York Art Student's League.[5]

In 1901 John Sloan married Anna Wall, known as Dolly. He called her a "lonesome frightened little girl," for she had been boarded by nuns from the age of fifteen to nearly twenty, but she had drunk heavily starting at fifteen and attempted suicide several times. During Sloan's active socialist phase, he so influenced Dolly that she became a hyperactive party worker. His sympathy for the downtrodden, especially female alcoholics, was deepened by his wife's condition. He once watched a drunken woman in Madison Square offer a stern policeman a drink and later lamented: "It makes a knife go right through me whenever I see one of them, alone and exposed to trouble. I am reminded that Dolly might [have been] in their same situation if I had not looked after her."[6]

In Sloan's painting, "Sixth Avenue and Thirtieth Street" (1907), he depicted a drunken woman. The painting was probably the outgrowth of this diary observation:

> Walked today, and, at a distance, shadowed a poor wretch of a woman on 14th St. Watched her stop to look at billboards, go into Five Cent Stores, take candy, nearly run over at Fifth Avenue, dazed and always trying to arrange hair and hatpins. To the Union Square Lavatory. She then sits down, gets a newspaper, always uneasy, probably no drink as yet this day.[7]

After studying a neighborhood, day or night, and waiting, as Helen Farr Sloan put it, for a "human incident" to give him the "final" idea, Sloan painted in his studio from memory, aided only occasionally by a sketchy drawing. He said the "social evil—evils? shall I say—goad thee, to paint." Sloan's people are in the foreground of "uncompromising commonplace: the sidewalks of New York, a gloomy downtown barroom, a woman wearily hanging out wash from a tenement fire escape. But his background was often mysterious, and he invested the dreary prose of everyday life with the touch of romantic lavishness."[8]

Thus, along with social sympathy Sloan always displayed a

romantic urban nostalgia which is significantly absent in Maurice Becker, who grew up in the slums. Sloan reflected that his feeling for New York was a "nostalgia for the New York of the days before automobiles and prohibition." The hurried pace of urban life through the years impeded Sloan's search for impressionistic subject matter. Years later, sitting in Bryant Park in 1944, he commented that "the city is spoiled for me now by the automobiles. You can't see a street or a place or an incident without a mass of cars rushing by or being parked all over the place. The subways are full of splendid material, but the people move out of the trains so quickly."[9]

Sloan's pre-World War I painting documents his attachment to the city as dark-palleted and gloomy but intimate, as in the canvasses "Wake of the Ferry No. 2" (1907), "The Haymarket" (1907), and "McSorley's Back Room" (1912). His friend, John Butler Yeats (father of the poet William Butler Yeats), referred to Sloan's "mountain gloom," yet "richly coloured darkness." Of the Jersey Ferry evoking "Wake," Sloan later wrote, "Optimistic people go to the front of the boat, the depressed," whom he chose to paint, "stand in the stern." "Gray and Brass" (1907) is exceptional in its anger, though still impressionistic, growing out of "an idea which crossed me yesterday," namely, an actual incident: "a brass-trimmed, snob, cheap, 'nouveau riche' laden automobile passing the park."[10]

In painting and drawing the city, Sloan developed a sense for the unique character of a neighborhood, though he focused on the "quaintly humorous" rather than the pessimistic aspects of a locality. He commented on his usual after-dinner walk, "ending up" once on Eighth Avenue, that "the avenue life is different in each case. Sixth, tenderloin, fast. Eighth, neat lower class, honest. Third, poor, foreign." Sloan's favorite New York excursion was the area of West 14th Street and lower Sixth Avenue— the Tenderloin, setting for "The Haymarket" (a Sixth Avenue underworld dance hall) and "Sixth Avenue and Thirtieth Street." He said years later of "Sixth Avenue": "This canvas has surely caught the atmosphere of the Tenderloin; drab, shabby, happy, sad, and human."[11]

 Sloan wrote that East Side tenement urchins manifested
"happiness rather than misery in the whole life. Fifth Avenue
faces are unhappy in comparison." Fellow painter and critic,
Guy Pène duBois, considered Sloan's work "satirical about Fifth
Avenue and dangerously near to romantic about Sixth. His
Fifth Avenue people give you the feeling that they have just
moved over from Sixth and made themselves funnier . . . by the
addition of more exaggerated clothes and manners; have moved
out of reality into a world of fiction." But Sloan's work is not
even that critical. If he perceived the happy poor romantically,
he failed consistently to satirize the rich. It is apparent that he
was totally ambivalent in dealing with class distinctions. While
shopping with Dolly on Fifth Avenue, they were "entertained at
great expense by some of the wealthiest people in New York who
showed us their gowns and gay hats and automobiles and car-
riages and servants, all of which display we enjoyed much."[12]
 Thus, John Sloan the observing genre painter and illustrator
lived a curious duality: although he observed that East Side
children exuded "happiness rather than misery in the whole
life," at the same time he wrote: "Crowds of children merry-
making always make me sad, rather undefined in origin—perhaps
it is the thought of this youth and happiness so soon to be worn
away by contact with the social conditions, the grind and strug-
gle for existence—that the few rich may live from their efforts."[13]
 As a social-minded person, however, John Sloan was more
astounding, for in describing the feathered streetwalker inspiring
"The Haymarket" he saw her not as a victim of economic
circumstance but as "some wild creature of the night." And the
Bowery (on the Lower East Side)—"The Bowery, that name! so
romantic to the youth of towns in the U. S. . . . so dull and dark
and safe and slushy." Of the East Side he said, "Life is thick!
colorful. I saw more than my brain could comprehend, a maze of
living incidents—children by thousands in the streets and parks."[14]
 As Sloan could not commit himself totally to a socialist view-
point, his painting and illustration failed to restructure the tene-
ment world, the "maze of living incidents" his politics supposedly
opposed. It seems that he was insufficiently alienated from

American political life to travel more than six or eight uncertain years as a democratic socialist.

> His interest in liberal crusades, in social reform, in the *Masses*
> was an outgrowth of his sympathy for people. . . . But even in
> his sympathy he remained always the spectator, standing
> slightly apart. . . . His art, like that of all of the Ash Can school,
> lacked militancy; the most one finds is a jibing satire of
> pretension and snobbery. It was perhaps fortunate, therefore,
> that Sloan never attempted to convert his art into a weapon for
> socialism, for he was neither intellectually nor artistically capable
> of so complex a statement. The measure of his greatness is in the
> warmth of his reporting. Whenever he strayed outside the specific
> limits of his talent, his art suffered.[15]

In addition, Sloan never developed class hatred. Robert Minor would not have counseled art students, as Sloan did, to "draw with human kindness. It is easy to make caricatures or cartoons that show dislike for something. The great artists like Hogarth or Goya, who started out with indignation against some evil, always had in mind a concept of the dignity of human beings."[16]

Rarely was Sloan more than temporarily alerted to social injustices. He painted "Scrubwomen in the Old Astor Library" (1910), picturing the happy poor, one on her knees, two carrying buckets, all smiling. "These jolly strong-arm women in the golden brown and musty surroundings of thousands of books aroused a strong urge to fix them on canvas."[17] But if John Sloan failed to develop a truly radical perspective on American social conditions, he was repulsed by his own "grind and struggle for existence" in the art market.

Despite inconsistencies, from his arrival in New York in 1904 Sloan showed increasing concern with social problems, and after 1908 his diary, as Van Wyck Brooks noted, "bristled with notes" exclaiming social consciousness. Typical was his approval of William Butler Yeats' Irish Players didactically explicating "religion and the other great beast that sucks the blood out of all of us—property." In Philadelphia Sloan hardly noticed the Homestead Strike of 1892 or the Great Northern and Pullman Strikes and jailing of Eugene Debs in 1894. But by 1909 Sloan was

describing the United States as "the plutocracy's government," the churches as perverters of "the intentions of that great Socialist Jesus Christ. He was a revolutionist. The Church backs the Exploiters by preaching content to the victim."[18]

In 1909 Sloan began occasional contributions to the *Call*, and the next year sold a few story illustrations to the *Coming Nation*. Meanwhile, Dolly helped organize the intellectual Socialist party Branch One, which they joined, Sloan declaring "Now we are 'Reds.'" For a few years the Sloans were active socialists. In 1910 and 1911 Dolly Sloan was secretary of their local branch and both were delegates, rather bored ones, to the city convention. They handed out literature in Battery Park and in a May Day demonstration at Union Square. Dolly helped organize housing for children of the 1912 Lawrence, Massachusetts, textile strikers. After voting for Bryan, in 1908, Sloan wrote, "I am of no party. I'm for change—for the operating knife when a party rots in power." Even so, in 1910 and 1913 he ran (unsuccessfully) for state assembly and in 1914 for a judgeship on the Socialist ticket. As late as 1917 the Sloans were on the New York committee of the International Workers Defense League, established to free Tom Mooney.[19]

For socialist literature Sloan seems mostly to have read the *Call*, but compared with Becker, Minor, and Young he had almost no theory. He attended many lectures, however, and followed the news closely, becoming excited by the violent Philadelphia carmen's strike in 1910 and interpreting American troop movements on the Mexican border in 1910-1911 as the policy of the "Money Kings" puppeting "the beast Díaz." Sloan thought the anarchists, IWWs, and Italian Socialists were "wild Indians" and touchily argued with Bill Haywood of the IWW when Haywood attacked Branch One. But after the successful IWW-led Lawrence strike of 1912, Sloan became sympathetic to the left wing of the Socialist party and "straight real 'Industrial Unionism.'"[20]

Sloan tried repeatedly and unsuccessfully to convert his old friend William Glackens to socialism. And when illustrator Rollin Kirby said he could not understand how Sloan or any artist could be socialist, Sloan replied that "no man could do good work and

not be," adding to his diary, "Poor Kirby . . . with his nose to
the most tiresome grindstone of making money by average
illustrating." To Sloan and each artist in this study socialism
was an alternative to what Sloan contemptuously called "making
a living," the debilitating process whereby "persons are warped,
maimed, coarsened, contaminated, defiled, to various degrees
by the fight with starvation."[21]

Sloan's interest in socialism was partly aroused by the punish-
ment he saw meted out to the poor by their immediate superiors—
police and magistrates—on his strolls in search of paintable
incidents. On Eighth Avenue he watched as a drunk was arrested
and handcuffed to two policemen. "Something he said, apparent-
ly, angered one of the 'cops.' He stopped, turned and with brutal
deliberation planted a blow with his white gloved hand square
between the poor 'drunk's' eyes—both wrists held, mind you!!
I felt mad enough to go along and report it, but I didn't." Evening
walks led Sloan to the Jefferson Market Night Police Court for
women in Greenwich Village. On one visit, watching "the 'poor
things' served with snap justice"—exorbitant fines and/or im-
prisonment for petty offenses—he wrote, "My heart melted one
minute and grew red hot the next." Later that night he ran into
Arthur Ruhl of *Collier's,* "and being full of rancor of what I had
felt in the Night Court" but always fearful of seeming the fanatic,
"I shot a lot of Socialistic (I suppose) resentful noticings of mine,
at him. I suppose he thought me a radical fool."[22]

Although Sloan gave up on active socialism as a remedy for
poverty in 1914, he remained in theory a democratic socialist,
maintaining sympathy for the downtrodden. In 1907, after
turning down "a poor rum soaked bum" who had asked him for
money, Sloan "regretted it and slunk home feeling below cost."
Helen Farr Sloan said that in teaching at the Art Student's
League of New York (1916-1930; 1935-1937), "to illustrate his
thoughts on society, the most essential things he had to say to
his students centered about the importance of human kindness."
Charity, not a workers' republic, was the essence of Sloan's
socialism. Thus, it was Eugene Debs' humanism that appealed
to him above all. He considered Debs "one of the most Christ-

like men I had ever met. He would share his clothes or his last
crust of bread with any man who was poorer than himself."[23]

Sloan's pre-World War I conception of socialism was vague,
but the doctrine seemed the self-evident solution to the social
problem. As he recalled in 1950,

> We all felt that we were part of a crusade that would help to
> bring about more social justice at home and prevent the out-
> break of world war. . . . We did not have any doctrinaire ideas
> about running the world. Every time we went to a meeting,
> the speakers would talk about . . . more justice without
> getting the world into the tyranny of some huge bureaucracy.[24]

Sloan was puzzled by the absence of class consciousness among
American workers. After reading Debs' 1908 platform, he could
not "understand why the workers of the country were so disin-
terested or intimidated as not to vote en masse for these princi-
ples." Sloan saw socialism as a natural response to human
suffering, and "never knew about the history or theory of
socialism. I took it on faith. . . . It was that way with most of
us who were artists working for the cause." As a remedy for
deprivation, what appealed to Sloan in socialism was "the general
idea that the natural resources of the land belonged to the people
and should not be used for the benefit of any one class—that is
what struck me as an artist—a human being with concern for the
welfare of the people."[25]

But total commitment to wrest control of "the natural
resources of the land" from the few for the many was a step
Sloan avoided. Once he remarked that Herman Bloch, *Call* art
editor, "speaks of a man being religiously interested in his work.
This may mean well but does not sound 'healthy' to me." Sloan
never repudiated the feasibility of socialism by the ballot, but
always distrusted the concept of socialism as a way of life,
thinking this analogous to a secular religion. In later years, though
he lamented the failure of socialism, as he conceived the idea, in
the Soviet Union, Sloan criticized the USSR for establishing a
"religious system with saints and inquisitions." After hearing a
friend, in 1909, fervently advocate socialism, he agreed "the

movement is right in the main," but "I am rather more interested
in the human beings themselves than in the schemes for better-
ment."[26]

Sloan was interested in people as a reporter would be, who
would "rather wonder if they will be so interesting when they
are all comfortable and happy." Reacting elliptically, as always,
to the concept of social reconstruction, he wondered if the
creative artist would suffer under socialism. "Will the great mass
of the workers," he queried in his diary,

> when they find the power of the united vote, stand for
> differences in the rewards between their ordinary labor and
> mental labor? Of course all will have every necessary [sic]
> to existence, and comfort—but should not the higher faculties
> have some higher reward? Or is this feeling in me, only a
> surviving view of the present upper class feeling?"[27]

Nevertheless, before World War I, Sloan was certainly pleased
over what he perceived as the imminence of socialism in the
United States. He felt the Philadelphia General Strike of 1910
represented "the first throbs of the Great Revolution. I'm proud
of my old home—cradling the newer greater Liberty for America!"
But excited as Sloan was by the prospects of socialism, he still
could not deny his reservations about political activism. While
attending a night rally in Battery Park and handing out the
socialist weekly *Appeal to Reason*, he sensed "a serious kind of
humor about such an affair and it seems curious that I have gone
into it. And yet it surely is better than to paint pandering pictures
to please the ignorant listless moneyed class in the U. S."[28]

As early as 1906 Sloan had considered establishing a satirical
magazine, to be called the *Eye*, and when the *Masses* was revived
by Max Eastman in December 1912, Sloan began contributing
and got Henri and Bellows to do so as well. Sloan's cartoons,
though only a small percentage of his total graphic work, are
a major element in the *Masses* message. He not only contributed
but helped supervise make-up and solicited financial contributions.
For over three years Sloan devoted much of his time to the
magazine. "The night the first copy of *The Masses* [under

Eastman's editorship] came out," he recalled, "I sold seventy-eight copies. It was at a Suffrage parade. I went up to people, sometimes got on the running board of a car, saying, 'Buy it. It will be worth ten dollars some day.'" According to Eastman, Sloan, who put out the July and August 1913 issues, "loved *The Masses* and would waste time on it in the same childish way I would. We were potentially, I always felt, a perfect team. But he had sense enough to know that his real work lay elsewhere." Eastman remembered seeing "Sloan at a *Masses* meeting, holding up a drawing by Stuart Davis of two sad, homely girls from the slums of Hoboken, and proposing the title: 'Gee, Mag, think of us bein' on a magazine cover!' That formed our June[1913] cover, which was much commented upon. It was realism; it was also revolt."[29]

Sloan enjoyed the freedom provided by the socialist press to deal with subjects "of a human nature sort and offer right good chance to make pictures. Which is just what is not true of most of the paid illustration of the magazines of the day." Sloan felt that with the *Masses* he had "cut loose from a sort of tight type of illustration current at the time." Actually, his *Masses* drawings are not stylistically different from his earlier free lance work. The genre differs in that the *Masses* illustrations are cartoons and the earlier drawings are simply illustrations. Sloan's graphic style had matured by 1905 and changed very little afterward.[30] His drawings were detailed. Whereas Minor featured a few massive, sharp contrasts, Sloan, as in "The Net Result As Seen on Broadway" (Figure 27) which depicts two translucently clad prostitutes, drew many detailed contrasts; in this instance he compared the two girls' arms and feathers, and the sash of one with the purse string of the other. He focused on the small ironies of life, as he did in "The Extreme Left" (Figure 28), which shows a corpulent sedentary woman criticizing inaction.

Around 1914 Sloan began to rely more on facial expressions than on the general scene to show ugly temperament. Before 1914, although emotion was manifested in the person, it was also expressed in the overall situation. After 1914, in an attempt to go beyond impressionism, psychological aspects became an

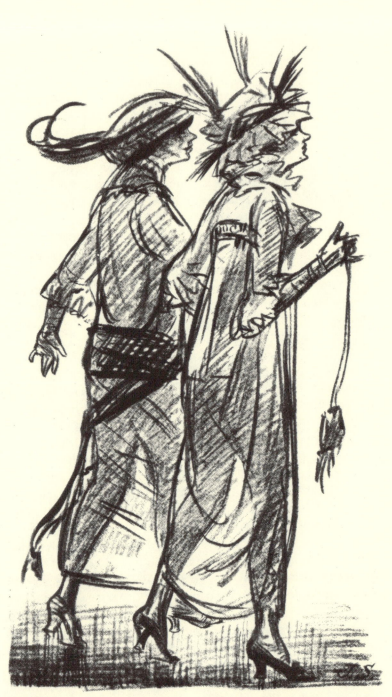

John Sloan
Masses. Aug. 1913. **Items From a Department Store's Newspaper Advertisement—**
Net Undervests. . . . $1.50 Net Petticoats. $4.00
Net Combinations . . $3.50 Net Dresses$30.00
Fig. 27. "The Net Result as Seen on Broadway"

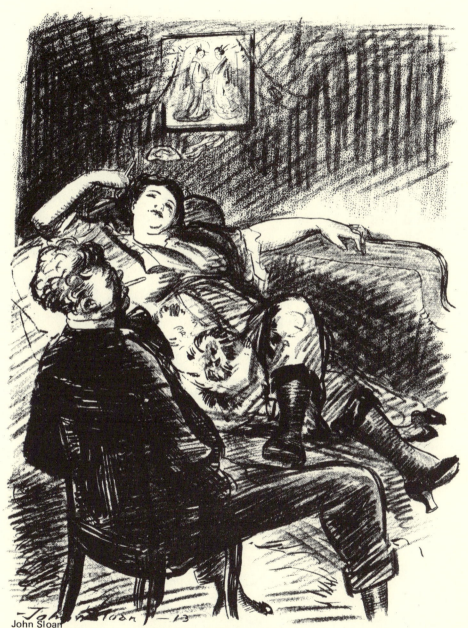

John Sloan
Masses. Sept. 1913. Fig. 28. "The Extreme Left.
'Why Don't Those Strikers DO Something—Let a Few of Them Get
Shot, and it'll Look as if They Meant Business.'"

integral part of the situation. This is seen in comparing
"'Circumstances' Alter Cases" (Figure 29), in which facial
expressions are significant but still stylized in their emission
of disdain and poverty, with "Mid-Ocean" (Figure 30), in which
attention is drawn to faces evoking sated, indolent boredom.
Originally, Sloan's drawings were semi-impressionistic street
scenes. By 1914, he grew personally dissatisfied, due to the
limitations of his art which were made apparent to him in the
Armory Show, and the disintegration of world socialism in
the First World War. Thereafter, he felt it necessary (apparently
not consciously) to include a psychological component in the
scene.

Sloan's drawings can be described as sketchy, yet detailed,
with ample use of shading. For contrasts, typically illustrated in
"The Unemployed" (Figure 31), he used the play of light instead
of masses and volume, as did Minor and Young. In this respect
Sloan had a painter's style, whereas Minor and Young relied little
on light and shade. But except for the introduction of a psycho-
logical element into his *Masses* work from 1914 to 1916, there
was no change in Sloan's overall style of illustration.

His political illustrations were usually satires, parodies of
actual incidents, of individual people, not social types. His
caricatures treated the rich as crude and wasteful but not
exploitative. He said of his intention in painting one of his rare
satirical canvasses, "Grey and Brass," that it was "to bring out
the pomp and circumstance that marked the wealthy group in
the motor car." The conflict between capital and labor that
characterizes Becker's and Minor's cartoons is absent in Sloan's.
Typical of Sloan's work is "Entertaining the Buyer" (Figure 32).
The two businessmen are gauche but not cruel. Sloan's forte was
catching the wealthy, particularly the nouveau riche, at leisure.
As in "Mid-Ocean," Sloan "would have people shorn of those
masques by which they erect class distinctions or are enabled,
when snobs, to more bravely face the world."[31] "The Consta-
bulary" (Figure 33), although rather static, is the exception to
his usual snapshot, surface incidents. He creates tension
and highlights internal conflict between policemen on chargers

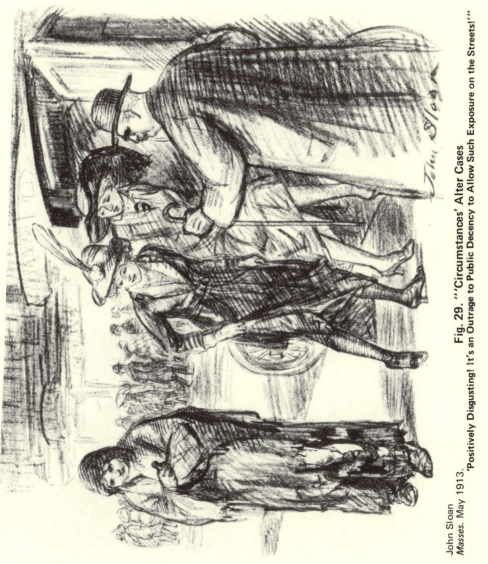

John Sloan
Masses. May 1913.

Fig. 29. "'Circumstances' Alter Cases
"Positively Disgusting! It's an Outrage to Public Decency to Allow Such Exposure on the Streets!'"

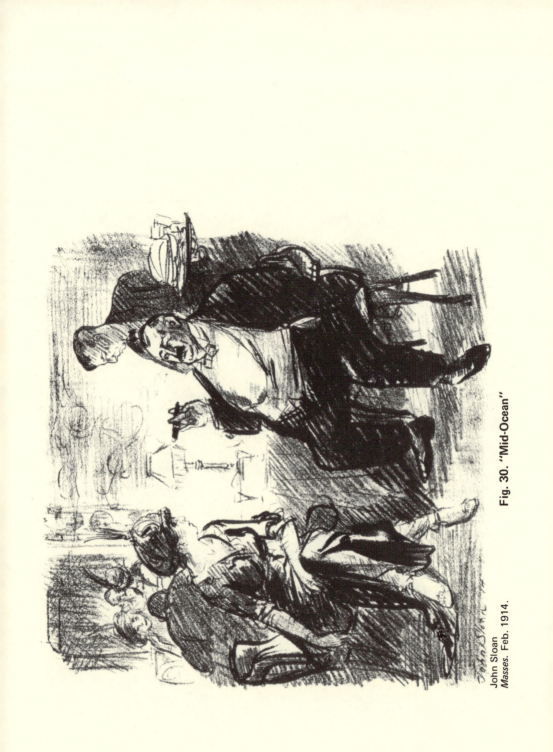

John Sloan
Masses. Feb. 1914.

Fig. 30. "Mid-Ocean"

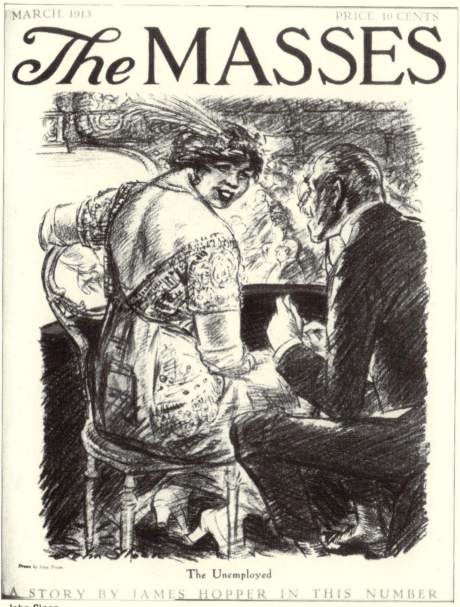

MARCH, 1913 PRICE 10 CENTS

The MASSES

The Unemployed

A STORY BY JAMES HOPPER IN THIS NUMBER

John Sloan
Masses. Mar. 1913. **Fig. 31. "The Unemployed"**

John Sloan
Masses. June 1914. **Fig. 32. "Entertaining the Buyer**
 A Factor in the High Cost of Living"

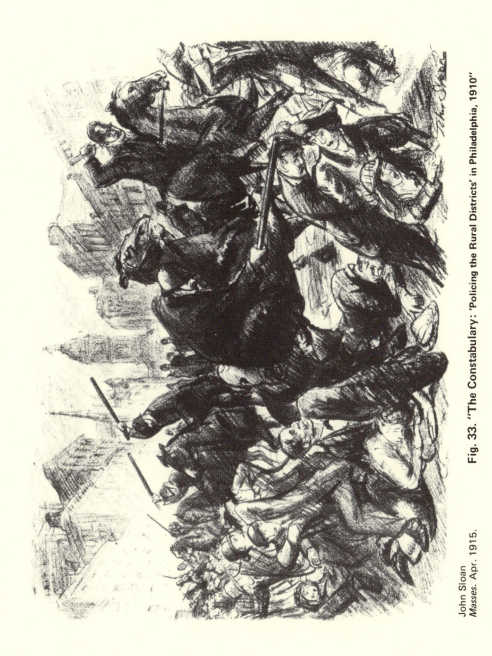

John Sloan
Masses. Apr. 1915.

Fig. 33. "The Constabulary: 'Policing the Rural Districts' in Philadelphia, 1910"

with raised clubs angled one way and the huddled, frightened
crowd another.

Sloan drew few workers, preferring alcoholics and prostitutes.
He did treat working people in "The Return from Toil"
(Figure 34). It is surprising that Sloan, a socialist, drew these
subjects, whom he frequently called "little shop girls," as though
their workaday lives were fun, even a lark. Even the prostitute
in "The [Jefferson Market] Women's Night Court" (Figure 35)
is depicted rather elegantly and not as though her life were
scarred by a degrading occupation. Sloan, however, could have
justified such scenes by saying that the subject matter for a
socialist illustrator is the common life of the common people.
But Walter Benjamin points out that the depiction of everyday
life reproduces the patterns of that life, and therefore is not
radical art. That is, such depictions create a sentimental gloss of
such life.[32] True, they concentrate on the life of ordinary people,
but they sentimentalize their lives by picking out only particular
moments—for example, working girls laughing after a hard day
at work—as representative of their workaday lives.

Sloan sentimentalized working and under class life in this
way, whether drawing approvingly as in "The Return from
Toil" or disapprovingly as in "The Women's Night Court." He
appealed to and reinforced certain sentiments in his reading
audience—the idea of eternal spring in one drawing, and arbitrary
justice in the other. These sentiments, however, are part of the
structure of oppression and should have been attacked rather
than reinforced by a socialist illustrator. Even the disapproving
"Women's Night Court" only says that the system of justice is
hypocritical; it fails to say that the basic values of society are
wrong. Art Young, too, pointed to hypocrisy, but as a political
cartoonist rather than as an illustrator, as Sloan did. Young went
further and pointed out not merely the hypocrisy but the total
irrationality and absurdity of the established system.

The presupposition here, in criticizing Sloan, is that the truth
is more than a camera-like repetition of daily life, that it lies
below the surface. Thus, the effective radical cartoonist does
not merely show what is; he shows that there is opposition to

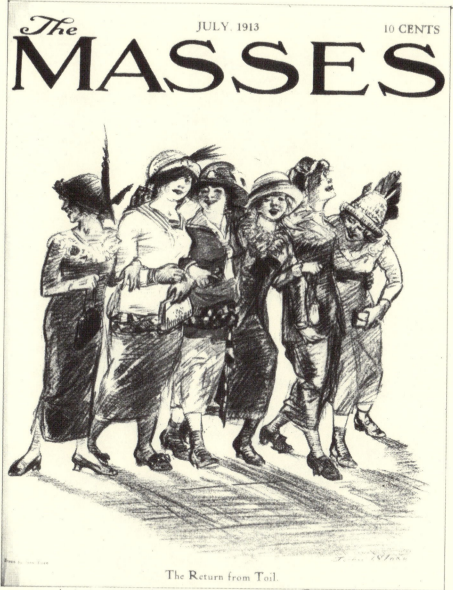

The Return from Toil.

Fig. 34. "The Return From Toil"

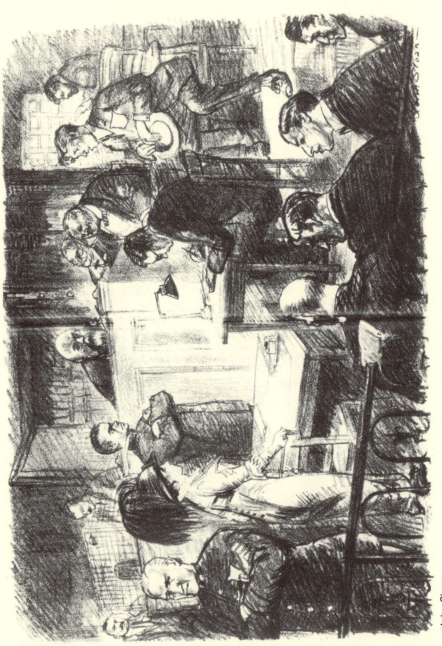

John Sloan
Masses. Aug. 1913.

Fig. 35. "The Women's Night Court. Before Her Makers and Her Judge"

what is, even if what is shown is commonplace life. Repetitive daily social life seems natural and fixed to the media audiences. This ignores the fact that these daily cycles (happiness in "The Return from Toil") are part of a larger social-political framework which is full of contradictions and oppositions to daily life. The effective radical cartoonist points to the contradictoriness of the overall framework by at least showing minor contradictions in daily life; for example, perhaps, bags under the tired eyes of laughing girls returning from work.

Sloan had a peculiar interest in large women, as in "Isadora Duncan in the 'Marche Militaire'" (*Masses*, May 1915) and the reclining figure in "The Extreme Left." His prostitutes are curiously thin; typical is the delicate girl in "The Women's Night Court." Although Sloan had a proclivity for drawing girls and women, even underworld types hustling to survive, he drew them as innocent and joyful, as in "At the Top of the Swing" (Figure 36). But he could also make his point sharply whenever aroused to do a genuine political cartoon. Striking coal-miners in Ludlow, Colorado, whose families had been attacked by the National Guard, inspired him to do the June 1914 cover drawing for the *Masses* (Figure 37). He achieved a sharp effect by drawing with firmer lines and giving a more dramatic focus to his composition.

Sloan's favorite painter was Rembrandt for "simon-pure realism—more real than nature," and it would be easy to say that Sloan himself failed to transcend natural appearances.[33] But he did not seem interested, generally, in transcending natural appearances. What he sought to do was to look within everyday life for indicative scenes of rebellion or coercion, or scenes that would reveal the stresses, strains, and contradictions that are really there, latent, beneath the surface of daily life. Selecting indicative scenes of daily life was the only critical act Sloan undertook. He showed certain specific, not unusual, characteristics of victims of the established political-economic system, as the prostitute in "The Women's Night Court" before hypocritical petty officialdom.

But selection by itself is not enough. In merely portraying

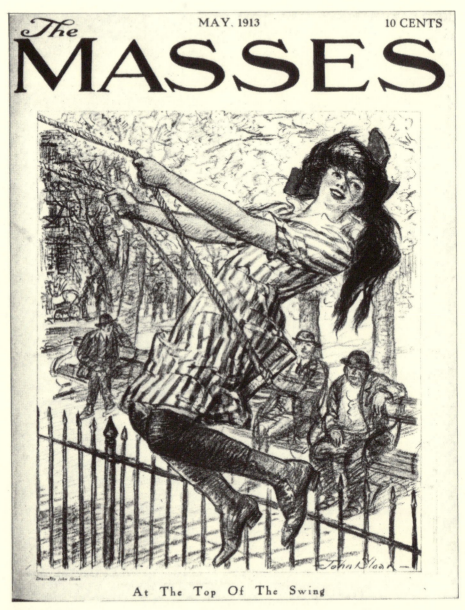

At The Top Of The Swing

John Sloan
Masses. May 1913. **Fig. 36. "At the Top of the Swing"**

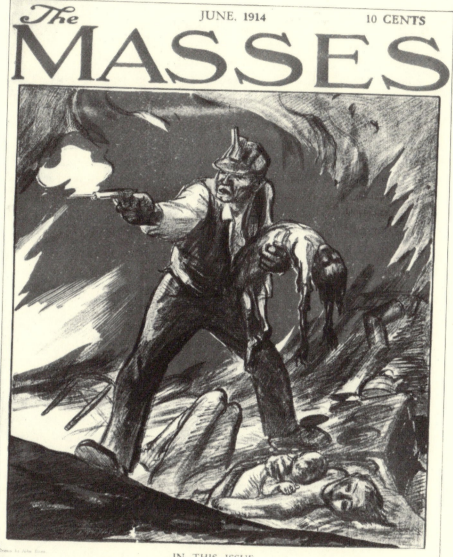

JUNE. 1914
10 CENTS

The MASSES

IN THIS ISSUE
CLASS WAR IN COLORADO——Max Eastman
WHAT ABOUT MEXICO ?——John Reed

John Sloan
Masses. June 1914.

Fig. 37

scenes that revealed certain hidden stresses, still Sloan repeated
the structure of daily life. "The Return from Toil" is doubly
objectionable for being repetitive without being indicative. In
such drawings as "The Return from Toil," Sloan's selection
process failed. To the extent that he selected and succeeded
with indicative scenes revealing latent stresses, he transcended
natural appearances because he revealed something behind the
appearances—something about the social relations of the times.
And yet, the medium that Sloan chose to achieve this, namely,
the portrayal of the surface of ordinary life and the revelation
of details pointing to something beneath the surface, left every-
thing implicit and never clearly defined or judged morally.
He did not define what those contradictions were, what
judgment was being passed about or in what respect. So,
"although [Sloan's] act of selection and representation of
the people or incidents in effect constituted a certain artistic
commentary, for the most part, the artist withheld his personal
feelings and allowed the subjects to speak for themselves."[34]
 Sloan's art could easily give way to the photograph, in a way
that Young's, Minor's, and Becker's work could never do. In
many cases photographic art could draw out scenes of daily life
and odd occurrences more sharply than Sloan could. Again, his
aim was to give the reader a glimpse of everyday life as it was,
and at the same time to find the revealing detail that pointed
behind the surface of life to something else. Sloan wanted to
avoid merely "imitating appearances," but rarely succeeded in
doing so because he seldom had a deep political point to make.
When he occasionally did, he could be an incisive cartoonist.
 When we contrast Sloan with Minor—which is the sharpest
contrast—we see that Minor immediately abandoned appearances
and tried to show political and social forces colliding dramatically
in a particular political event. Sloan, whose art was in a sense
much more empiricist than Minor's, suggested there might
be certain forces behind the appearances, forces in collision
and conflict. But he rarely tried to exhibit these forces. It might
be argued that Minor's art was too rigid, and that he tried to
depict events by preconceived ideas of what the contradictions

and forces in collision were. This might be the weakness as well
as the strength of Minor's art. In contrast, the strength of Sloan's
art was that, in trying to present indicative scenes of daily life, he
did not attempt to prejudge the case.

Thus, Sloan, the caricaturist of social manners rather than
critic of the state, in contributing to the *Masses* and in consider-
ing the nature of socialist art, had no option—not being a political
cartoonist—but to argue that socialism could best be propagated
by adhering to an open, nonideological outlook, one maintaining
a humorous perspective. As Helen Farr Sloan wrote, Sloan made
a distinction

> between cartoons (made against some wrong) and illustrations
> about the human condition which are fundamentally positive
> with good humor. . . . Sloan had hoped that the magazine could
> keep a position of good humor through the war years, feeling
> that this would have really helped the cause more than the
> emphasis on dogmatic propaganda.[35]

Underestimating the severity of wartime government repression,
Sloan felt the *Masses* would have survived the Great War if it had
not engaged in ideology. He complained that "the satire lost its
subtlety" before the editors' steady "hammering on propaganda."
In effect Sloan argued that the *Masses* should not take a political
position on the war. He felt guilty in expressing alienation except
to his diary. "When I became too exercised about problems of
social justice, losing my sense of humor and perspective on
things in general," his fatherly friend John Butler Yeats "scolded
me," and Sloan bowed to such reproaches.[36]

Sloan's attitude toward propaganda in art was best expressed
in his reaction to Emma Goldman. Impressed by her courage as
a lecturer, he would not criticize her; "her admirers, however,
like many Socialists and other followers are horridly appreciative
of the points in their creed, as they are trotted forth they smile
the 'ah! isn't that a crushing truth?' . . . at platitudes of the
propaganda. Just like Socialists, I say." Later Sloan returned for
another Goldman talk on "Art and Revolution," but concluded
she sometimes "demanded too much social consciousness from

the artist. For instance, she said that if the great painter (there-fore revolutionist) should paint a wealthy lady he would show the parasite covered with diamonds—this is too far, takes it out of art—which is simple truth as felt by [the] painter."[37]

With the outbreak of World War I, Sloan and Art Young con-stantly fought over art and politics in the *Masses*, and Sloan began losing interest in both the magazine and socialism. By August 1914 he was contributing less and attending fewer meetings. He dropped his membership in the Socialist party, though his drawings continued to appear up to the time of the so-called Greenwich Village Revolt of April 1916, when he for-mally resigned. He felt that with the war "the thing got too political to suit me."[38]

Although Young and Sloan quarreled, Sloan had drawn occasional cartoons with conscious social intent, true cartoons rather than simple observations, such as the June 1914 cover. He drew cartoons for George Kirkpatrick's *War—What For?* (1910) to help workers realize "capital and the shop keepers make use of [workers] against each other in warfare." Throughout his life he avoided military parades. Ironically, Sloan drew for the *Masses* a scene he could not possibly have observed in "'His Master: You've Done Very Well. Now What is Left of You Can Go Back to Work'" (September 1914). It showed, he recalled, "a fat man sitting in an armchair with all the symbols of capitalism, high hat, etc., and a man lying at his feet with his entrails dragging on the ground beside him."[39]

Such cartoons should not obscure the basis of Sloan's dis-agreement with Young. Sloan willingly drew antiwar cartoons because he felt the artist should only select "simple truth as felt by [the] painter," and he unequivocally hated militarism. He did not hate East Side tenements: there was too much exotic subject matter in them. "Sloan's viewpoint," explained Helen Farr Sloan, "was primarily that of finding what is fine and good. Humorful satire goes with this kind of mind. It was only on occasion that he *felt* like making a cartoon or caricature." Seldom could Sloan draw cartoons without qualms, complaining that "Art Young's idea of art was the glorified cartoon." He

refused the *Call*'s request for workers drawn "more starved and emaciated."[40]

Admitting he had done propagandistic cartoons, Sloan chose to segregate illustration from painting, with the exception of his canvasses "Grey and Brass" and "Recruiting, Union Square" (1909). The latter was inspired when Sloan, a pacifist, noticed a recruiting sergeant surrounded by unemployed men sitting passively on park benches; Sloan admired these men, who "stick to the freedom of their poverty." After completing the work, he "felt self-conscious" about it, explaining later that a sense of "injecting propaganda interfered" with the "innocent poetic feeling" he had toward city subjects. But in 1945 Sloan said, "While I am a socialist, I never allowed social propaganda to get into my work," deliberately separating "propaganda ideas" from "poetic social consciousness," the former in illustrations, the latter in painting.[41]

When Sloan resigned from the *Masses*, it was ostensibly over cooperative editing, which he insisted on, and the injection by Dell and Eastman of social consciousness into Sloan's, Coleman's, and Davis' drawings. Later Sloan also attributed his disenchantment with socialism to World War I, which had severely jolted him. "Ever since the Great War broke out in 1914," he said in 1939, "this world has been a crazy place to live in. I hate war and I put that hatred into cartoons in the (old) *Masses*. But I didn't go sentimental and paint pictures of war. I went on painting and etching the things I saw around me in the city streets and on the roof tops." Sloan had "great hopes" for the world's socialist parties until 1914. "Then I saw how they fell apart. Some of the leaders were killed; the emotional patterns of national pride set one country against another. I became disillusioned." A better explanation for his 1914 disillusionment is that the war gave Sloan, who once admitted never having committed himself to any group except "the gang around Henri," the excuse to break a tenuous relationship.[42]

When Sloan refused to write a *Coming Nation* article on the democratization of art, he told the editor "when propaganda enters into my drawings it's politics not art—art being merely

an expression of what I think of what I see." He later complained
that socialism hindered his painting, saying "this quirk may have
kept me from painting a lot more city pictures" after 1909
because his feeling for "seeing a picture" in familiar places was
inhibited by associated propaganda ideas. Sloan called the
political years 1909-1912 his "crisis of conscience" when he
seldom saw pictures and as a busy painter thought it a nusiance
to be pressured by friends for political "angles" in his painting.[43]
This raises the question of the relationship between Sloan's
interest in socialism and his creative crisis as an artist who
attempted to divorce painting from illustration.

At the time, Sloan did not attribute his crisis to socialism,
stating ingenuously in 1911, after three fruitless days painting
from the model,

> I felt dog tired and rather disheartened. I do so poorly for a
> man of forty years! . . . I went on ineffectively trying to paint.
> Before one o'clock I "dropped over" to Madison Square to
> hear Chas. [sic] Solomon talk Socialism. I'm sure my conservative
> artist friends would say that's what's the matter with Sloan. Too
> much socialism. I don't agree with this theory of my present poor
> efforts at painting.[44]

A few months later, after five hours of painting Dolly had "ended
in a dismal defeat," Sloan then judged some of his *Scribner's*
illustrations as "no better than they should be."[45]

Sloan later stated that on another level his creative crisis
developed apolitically. "At the age of forty" (1911), he ex-
plained, "a creative artist often has to find a fresh approach or
he will start to repeat himself." As a result, he did Hudson River
landscapes from 1908, and in 1909 began working with the
Maratta colors: twelve full colors, twelve bi-colors, and twelve
hues, which "opened up the palette" for him and made him
"think of branching up into the notes of higher intensity."[46]

Thus, after 1912 Sloan did fewer city paintings and more
figures, showing increasing concern with form, color, and line.
That year Sloan wrote the collector John Quinn that he had "not
been so dry a reed as to stand unbending against the breeze of
brighter color which is sweeping across the fields of art." By

1914 he felt he had passed through his "city" period. Although
he had seen modern art before the Armory Show, it was there he
concluded, from the French artists who "were *using color* to
build form and get color-surface texture," that "the ultra-modern
movement is a medicine for the disease of imitating appearances."
From 1914 on Sloan felt that he worked "from plastic motives
more than from what might erroneously be called 'story-telling'
motives."[47]

Starting in 1914, Sloan summered five years in Gloucester,
Massachusetts. He had begun landscapes in 1892, and at Gloucester
he continued to turn out numerous landscapes. He also turned to
figures, using a wider spectrum of color than the low-key earth
tones of his "grey period." Sloan had now decided never again to
paint with "propaganda content." In 1916 he began teaching
privately at Gloucester during summers and at the New York Art
Student's League during winters. From 1920 to 1950 Sloan
spent four months a year in Santa Fe, New Mexico, and wintered
in New York, where he continued at the Art Student's League.[48]

But in abandoning socialism Sloan did not abandon the urban
genre, though he no longer focused on the city scene and though
all his postwar paintings showed increased interest in color
"notes of higher intensity," transplanting previous greys and
browns. Sloan had little time during the years 1910-1914 to devote
to city scenes. No longer did he have a steady income from word-
charade puzzles, and he expended much energy on the *Masses* in
1912 and 1913. He of course believed that he continued to develop
as a painter after his socialist period. After turning to new
settings for painting in Gloucester, he went to Taos near Santa Fe.
During these relocations he developed greater interest in the
nude.[49]

On balance, however, it appears that Sloan's best painting
from around 1905 to about 1912 overlaps with his socialist
period, 1909-1914. During this period he produced some of the
best work of the "New York realist tradition" (or "Ash Can"
school): paintings such as "Wake of the Ferry No. 2" (1907)
and "McSorley's Bar" (1912), "remarkably evocative of
people, places and a way of life," most truthfully upheld

"Henri's conception of the painter who creates art out of the marrow of living." He was not then or later, despite his fascination for Maratta's color scheme, a great colorist, draftsman, or composer—just competent. Sloan's "equipment" was sufficient for painting lower class New York, but it was sadly lacking when he was concerned with esthetics. Despite his teaching to the contrary, he sought "art" (technique) over "life" (content) and "finally ended with cross-hatched nudes, a late echo of Neo-Impressionism."[50]

The difference between Sloan's pre-World War I city scenes and those of the twenties is reflected in the contrast between "McSorley's Bar" (1912) and "McSorley's Cats" (1929). His urban scenes of the 1920s, as in "The City from Greenwich Village" (1922), destroyed "the warm intimacy of mood" that marked his earlier style by focusing on "the excitement of the city, the hurly-burly of lights, noise and movement." The earlier McSorley's was a place where Sloan could have a pleasant ale, and he called it "the Old House at Home." By 1929, his striving for nostalgia to replace his old sense of mood induced him to paint McSorley's as a "historic landmark," cluttered with clever detail and artistic devices. He succeeded as a reporter depicting "a moment at a given time." When at his best before World War I, there was "a kind of uninhibited and faithful recording."[51]

There are two plausible theories to account for the relationship between Sloan's socialism and art. One is that politics did not affect his painting at all. Sloan was a painter of a historical epoch; when the epoch passed, he had no subject matter left and declined. The other is that socialism's emphasis on underlying historical causality encouraged him to look behind surface appearances in his painting. The *Masses* venture was Sloan's probing step in illustration toward nonliteral art, toward modernism. Socialism's emphasis on underlying causality suggested another style, and the modernism of the Armory Show supplied the technical equipment. But Sloan was unable to adjust to the expressionist "propaganda" of cartoons or the nonrepresentational art of Matisse, though he sensed that in "the

new movement—Matisse and the 'neo-Impressionists' and Cubists
. . . a splendid symptom, a bomb under conventions . . . the
explosive force is there—revolution it is."[52] He retreated from
active socialism, but in attempting to mesh modernism's new
mode of coloring with his previous representational conception
of form, his painting suffered.

Though Sloan gave up on active politics in 1914, he re-
mained a democratic socialist, writing in 1928: "I am still a
socialist in my ideals but have had no hope of *political* socialist
results since 1914." He had become convinced around 1914,
from an idea he got from Victor Berger in 1909, that the
Socialist party of America would become entangled in
bureaucracy and should, rather than seek power, provide
ideas to be carried out by diversified social agencies, public
and private. As a painter who refused to compromise with dealers
and patrons and who survived modestly by etching, illustrating,
and teaching, what he hoped from socialism, as he saw it, was
a better welfare state: "With the intelligence, scientific attain-
ment—machinery could do away with the poverty of the lower
strata. The lowest you could sink in such a society would be to
good clothes, food, shelter. Our differences would move to a
higher plane." With socialism "will come respect for the creative
hand-made things"; "everyone will be an artist. Art products
will be 'swapped.'"[53]

As a democratic socialist, Sloan was hostile to communism
and the Soviet Union, recalling that "in the early twenties [he
had] looked to Russia for the salvation of the world, but [had]
been disappointed." He considered American communists
"religious fanatics" who "want power, their way." After Debs
died in 1926, Sloan did not consistently vote socialist. Instead he
worked for Smith, Roosevelt, and Truman, whose programs he
liked.[54]

Sloan's attitude toward his artistic subject matter—the helpless
poor and downtrodden—is that of the social democrat desiring
more humane welfare administration. His sketches and canvasses
frequently depicted the underdog, the "poor wretch." In contrast
to the fighting workers of Becker, Minor, and even, on occasion,

Chamberlain, Sloan sketched the poor as hapless victims (like his alcoholic wife) but never as the proletariat, with rebellion and a sense of agency. Notwithstanding his denials, Sloan's perspective is analogous to that of the social worker or sociologist dealing with the effects rather than the causes of poverty, and it

> expresses the satisfaction of the Great White Hunter who has bravely risked the perils of the urban jungle to bring back an exotic specimen. It expresses the Romanticism of the zoo curator who preeningly displays his rare specimens . . . he does not want spectators to throw rocks at the animals behind the bars. But neither is he eager to tear down the bars and let the animals go. The attitude . . . is to create a comfortable and humane Indian Reservation . . . within which these colorful specimens may be exhibited, unmolested and unchanged. The very empirical sensitivity to fine detail . . . is both born of and limited by the connoisseur's fascination with the rare object.[55]

If Sloan's radicalism had been as profound as that of Minor and Becker, he would not only have taken the viewpoint of the "underdog," but would have focused it on drawings of the "overdog."[56]

Instead, Sloan concentrated on the urban poor and their "immediate bureaucratic caretakers": the police, bailiffs and petty judges in Jefferson Market Court.[57] Art Young, too, was a democratic socialist who advocated a better welfare state. But the difference between Young and Sloan is the difference between the cartoonist and the painter. Young's cartoons are negative, nihilistic, antibourgeois critiques. Nothing in his art says what is good, for the cartoon is largely destructive art. In contrast, the illustrations of Sloan the painter represent his positive vision, though limited, of the happy poor who need guidance.

As an art teacher and lecturer, Sloan expressed very specific ideas on the function of painting and the role of the artist. In the first place, he warned students to avoid direct involvement with social problems. The artist, he felt,

> cannot mingle with people as much as he would like, but he reaches them through his work. The artist is a spectator of

life. He understands it without needing to have physical
experiences. He doesn't need to participate in adventures.
The artist is interested in life the way God is interested in
the universe.[58]

Sloan was thus critical of socialist realism of the 1930s and 1940s.
"Today," he said in 1945, we have "the kind of art made to
glorify the worker—men with heaving shoulders, rippling muscles,
swinging sledges (they always have well-made shoes). . . . The
whole body composed of intervals between knuckles. That brings
out the nobility of the working people!" To those who "say we
should paint for the people," Sloan answered in 1949 that
"great art has always been made by the artist for himself. The
moment the artist makes compromises with his conscience he is
becoming a commercial artist or political propagandist . . . if he
is to be free to express himself he cannot give up his indepen-
dence."[59]

To preserve his independence of others' judgment and money,
Sloan constantly warned students to avoid commercial success,
declaring it was "a bad thing for the artist because it leads to
comfort and timidity and compromise. . . . he becomes a com-
mercial craftsman, an artisan at best." On this point Sloan was
adamant, saying,

> There is something of the mule in me. When my dealer suggested
> that I paint Coney Island, I never went back to the place again.
> Whether the same psychological quirk [that kept Sloan from re-
> turning to Coney Island] affected me when I became a Socialist,
> I could not really say. But I did state that I would never con-
> sciously put propaganda in my paintings or etchings from that
> time on.[60]

In cautioning students not to attempt a living at art, Sloan
referred to his career:

> My life has not been very eventful but my work has made it
> utterly worthwhile. The only reason I am in the profession is
> because it is fun. I have always painted for myself and made
> my living by illustrating and teaching. . . . I have never made
> a living from my painting. If what I am doing now were selling
> I would think there is something the matter with it.[61]

If necessary to maintain one's integrity, Sloan insisted, the artist "may have to teach or wash dishes on the side so he won't have to ask his wife and children to starve."[62]

Neither did Sloan sympathize with cultural democracy: "Democracy is a perfect ideal for the practical matters of life, but majority rule in cultural matters is not to be trusted." He called himself an "independent" artist, for "the moment I think of painting for anyone else, the patron or the landlord, or 'the people'—I cannot enjoy my work . . . and I do not think it is the duty of society to support the artist who is independent." Even so, Sloan supported a federal Department of Art to "dignify the profession. The government spends money on utilities, why should it not spend money on the spiritual utilities." Government patronage, however, would undoubtedly establish "standards of mediocrity" reflecting "the bad taste of the majority."[63]

Thus, the interesting and unique aspect of John Sloan is that he did not see painting as a commodity; he did not care if his painting sold and he did not think painting was a step leading to anything in particular. Nor, apparently, did he see a painting as a social product, the result of many people's (usually unintentional) efforts. All of which ties in with his concept of painting and illustration as street-impressionism: one sees surface appearances as a spectator, and understands, but without participating. Sloan's philosophy envisioned no particular function in painting and illustration. His art, unlike that of the Marxist Mexican muralists, was not addressed to the people, nor, unlike that of Art Young, was it meant for edification. Apparently, Sloan changed style not in response to social movements or his personal development, but for its own sake. Painting, he felt, was very personal, clarified one's thoughts when on canvas, and was not designed to prove any point.

Sloan's view of life and art was that life itself is a certain happening. Typical was his reaction to a little after-dinner incident along Greenwich Avenue in the Village: "Saw a fine thing: six or seven little girls dancing around electric light in front of the prison tower of Jefferson Market Police Court. Lights from the barred windows of the 'Conciergerie.'"[64] He felt the artist's

function was to capture the happening. Thus, his canvasses and illustrations catch such incidents that tell a story by themselves.

One day in 1951 (the year he died), Sloan was walking along Eighth Avenue in the Chelsea district. It had changed little since the days, forty-five years earlier, when he had painted the neighborhood from observation. He recalled,

> I liked to paint places I knew, waiting until I saw some human incident that gave me the idea for a picture. Then I could go back to study the place. But today everything goes by so fast. . . . There isn't enough time to get the information the imagination must draw on, to get a picture with fullness. . . . When I painted the life of the poor, I was not thinking about them like a social worker—but with the eye of a poet who sees with affection. . . . I wish I had another thirty years to live and paint the things I see here in the city this summer.[65]

With or without affection, both Sloan and the social worker relied on the continued existence of the poor. If he remained the social illustrator, he worked "only in the style which was his, and therein lies the complete honesty of his work."[66] He would not compromise his style of painting and illustrating, nor would he turn his art to either politics or the market.

NOTES

1. Quote from John Sloan, *Gist of Art: Principles and Practise Expounded in the Classroom and Studio* (New York: American Artists Group, 1939), p. 1. Helen Farr Sloan, Introduction to Bruce St. John, "The Life and Times of John Sloan," catalog, 1961 exhibition, "The Life and Times of John Sloan," Delaware Art Center, Wilmington, p. 6 [Hereafter H.F.S.]. Brooks, *Sloan*, pp. 2, 4, 7-8. Helen Farr Sloan, Introduction to John Sloan, *John Sloan's New York Scene: From the Diaries, Notes and Correspondence, 1906-1913* (New York: Harper & Row, Publishers, 1965), pp. xiv, xxi. St. John, "Life and Times," p. 10. Bruce St. John, "John Sloan," catalog, 1963 Smithsonian Institution Traveling Exhibition, p. 6. For a different interpretation of John Sloan from that developed in this chapter, see Helen Farr Sloan's Introduction and notations to Sloan, *Scene*.

2. St. John, "Life and Times," p. 10. Brooks, *Sloan*, p. 8. Brown, "Two John Sloans," p. 26. Quote from Helen Farr Sloan, Foreword, "John Sloan," p. 3. Sloan, *Gist*, p. 1.

3. Brooks, *Sloan*, pp. 13, 16-17, 23, 39-40, note. (Quote 1 from p. 23.) St. John, "Life and Times," pp. 10, 13. Quote 2 from Sloan, notes, 1950.

4. Quote 1 from Sloan, notes, c. 1948. Brooks, *Sloan*, pp. 6, 19-20. St. John, "John Sloan," p. 5. Sloan, *Gist*, p. 3. St. John, "Life and Times," pp. 9, 11, 13. H.F.S., "Life and Times," p. 6. Quotes 2-3 from Helen Farr Sloan to author, August 22, 1966.

5. Bruce St. John, *John Sloan* (New York, 1971), pp. 145-146. St. John, ed., *Scene*, p. xi. Merrill Clement Rueppel, "The Graphic Art of Arthur Bowen Davies and John Sloan," Ph.D. diss., University of Wisconsin, 1955, p. 191. In 1908 Sloan began lithographs. He taught in 1907 at the Pittsburgh Art Student's League. St. John, "Life and Times," pp. 10, 13. H.F.S., "Life and Times," p. 6.

6. H.F.S., Introduction, *Scene*, pp. xv, 20. Brooks, *Sloan*, pp. 34-35, 89-91. (Quote 1 from p. 35.) Quote 2 from Sloan, *Scene*, p. 33 (n.d.). Dolly Sloan died in 1943. Sloan married Helen Farr, a former pupil, in 1944. H.F.S., Introduction, *Scene*, pp. xvi-xvii.

7. Sloan, *Scene*, p. 131 (May 24, 1907) [diary entry].

8. H.F.S., Introduction, *Scene*, p. xx. Quote 3 from Sloan, *Scene*, p. 439 (June 30, 1910). Lloyd Goodrich, *John Sloan: 1871-1951* (New York: Whitney Museum of American Art, 1952), pp. 21-22. Quote 4 from Sam Hunter, *Modern American Painting and Sculpture* (New York: Dell Publishing Company, 1959), p. 36.

9. Quote 1, 1948, from Brooks, *Sloan*, p. 56, note. Quote 2 from Sloan, notes, 1944.

10. Quotes 1-3 from Brooks, *Sloan*, pp. 69, note, 121. Quote 4 from Sloan, *Scene*, p. 155 (September 16, 1907).

11. Quote 1 from A. E. Gallatin, Introduction, John Sloan, *John Sloan* (New York, 1925), p. 15. Quotes 2-3 from Sloan, *Scene*, p. 355 (November 27, 1909). Brooks, *Sloan*, p. 58. Quote 4 from Sloan, *Gist*, p. 214.

12. Quote 1 from Sloan, *Scene*, p. 13 (February 13, 1906); quote 3 from p. 304 (April 6, 1909). Guy Pène DuBois, *John Sloan* (New York, 1931), p. 11.

13. Sloan, *Scene*, p. 338 (October 2, 1909).

14. Quotes 1-2 from Brooks, *Sloan*, pp. 58, 63. Quote 3 from Sloan, *Scene*, p. 431 (June 7, 1910).

15. Brown, *Painting*. 18.

16. H.F.S., "John Sloan," p. 4.

17. Sloan, *Gist*, p. 223.

18. St. John, "Life and Times," p. 11. Brooks, *Sloan*, pp. 85-86. Quote 2 from Sloan, *Scene*, p. 580 (November 21, 1911); quote 3 from p. 318 (June 12, 1909); quote 4 from p. 364 (December 25, 1909).

19. Brooks, *Sloan*, p. 97, note, 86. Quote 1 from Sloan, *Scene*, p. 381 (February 1, 1910); quote 2 from p. 259 (November 3, 1908); p. 434 (June 15, 1910); p. 443 (July 26, 1910); p. 466 (October 19, 1910); p. 541 (May 1, 1911); p. 581 (November 26, 1911); pp. 600-601 (February 10, 1912). Young, *Young*, p. 294. Amos Pinchot, "New York Committee, International Workers Defense League," Amos Pinchot Papers.

20. Sloan, *Scene*, p. 390 (February 21, 1910); quote 1 from p. 516 (March 15, 1911); quote 2 from p. 479 (November 22, 1910); quote 3 from p. 601 (February 10, 1912); pp. 607-608 (March 8, 1912); quote 4 from p. 634 (January 20, 1913). In the 1940s Helen Farr bought Sloan a copy of *Das Capital*. "He dipped into it for an hour and said he couldn't read the stuff." Helen Farr Sloan to author September 20, 1966.

21. Ira Glackens, *William Glackens and the Ashcan Group: The Emergence of Realism in American Art* (New York: Grosset & Dunlap, 1957), pp. 135-136. Sloan, *Scene*, p. 316 (June 3, 1909); p. 432 (June 9, 1910); p. 471 (October 29, 1910); quotes 1-2 from p. 475 (November 9, 1910); quote 3 from p. 522 (March 31, 1910); quote 4 from p. 560 (August 29, 1911).

22. Quote 1 from Sloan, *Scene*, p. 244 (September 5, 1908); quote 2 from p. 110 (March 7, 1907); quotes 3-4 from p. 314 (May 25, 1909).

23. Quotes 1-2 from Sloan, *Scene*, pp. 116-117 (March 31, 1907); quote 4 from p. 382 (1950). Helen Farr Sloan to author, August 22, 1966.

24. Sloan, *Scene*, p. 382 (1950).

25. Quote 1 from Sloan, *Scene*, p. 313 (May 21, 1909). Quote 2 from Sloan, notes, 1947; quote 3 from notes, c. 1948.

26. Quote 2 from Sloan, *Scene*, p. 310 (May 5, 1909); quote 4 from p. 306 (April 15, 1909). Quote 3 from Brooks, *Sloan*, p. 93.

27. Quote 1 from Sloan, *Scene*, p. 306 (April 15, 1909); quote 2 from p. 317 (June 9, 1909).

28. Quote 1 from Sloan, *Scene*, pp. 393-394 (March 6, 1910); quote 2 from p. 443 (July 26, 1910).

29. Sloan, *Scene*, p. 43 (June 22, 1906). Helen Farr Sloan to author, August 22, 1966. Rueppel, "Graphic," p. 185. Quote 1 from Sloan, notes, c. 1948. Eastman, *Enjoyment*, 412-413, 441.

30. Quote 1, said of two story drawings for the *Call*, Sloan, *Scene*, p. 374 (January 12, 1910). Quote 2 from Brooks, *Sloan*, p. 97. Rueppel, "Graphic," pp. 255, 257. Bullard, "Illustrators," pp. 99-100, said Sloan's graphic style was set by 1903. From August 1913, many of Sloan's *Harper's Weekly* illustrations could as well have been *Masses* cartoons.

31. Sloan, *Gist*, p. 215. duBois, *Sloan*, p. 10.

32. Interview with Helen Farr Sloan, December 16, 1970. Walter Benjamin, "The Author as Producer," *New Left Review* 62 (July-August 1970): 89-96.

33. Brooks, *Sloan*, p. 78, note, from 1949 Art Student's League lecture.

34. Rueppel, "Graphic," p. 216.

35. Helen Farr Sloan to author, August 22, 1966.

36. Quotes 1-2 from Sloan, notes, interview with Sanka Knox for *New York Times*, 1950. Quote 3 from Sloan, *Scene*, p. 339 (n.d.).

37. Quote 1 from Sloan, *Scene*, p. 575 (November 5, 1911); quote 2 from p. 578 (November 12, 1911).

38. Helen Farr Sloan to author, July 20, 1965, August 22, 1966. Quote from Sloan, notes, interview with Mae Larsen.

39. Quote 1 from Sloan, *Scene*, p. 433 (June 13, 1910). George R. Kirkpatrick, *War—What For?* (West LaFayette, Ohio: The author, 1910). Brooks, *Sloan*, p. 115, note. Quote 2 from Sloan, notes, interview with Arthur deBra.

40. Helen Farr Sloan to author, July 9, 1967. Quote 3 from Sloan, notes, 1950. Quote 4 from Sloan, *Scene*, pp. 343-344 (October 22, 1909).

41. Quote 1 from Sloan, *Scene*, p. 311 (May 10, 1909). Quotes 2-4 from Helen Farr Sloan to author, July 9, 1967. Quotes 5 from Sloan, notes, interview with Arthur deBra; quotes 6-7 from notes, interview with Sanka Knox.

42. Quote 1 from Sloan, *Gist*, pp. 4-5. Quotes 2-3 from Sloan, *Scene*, p. 382 (1950). Quote 4 from Brooks, *Sloan*, p. 82.

43. Quote 1 from Sloan, *Scene*, p. 554 (August 1, 1911). Quotes 2-3 from Brooks, *Sloan*, p. 100. Quotes 4-5 from Helen Farr Sloan to author, July 9, 1967.

44. Sloan, *Scene*, pp. 556-557 (August 10, 1911).

45. Ibid., p. 581 (November 25, 1911).

46. Quote 1 from Helen Farr Sloan to author, August 22, 1966. St. John, "John Sloan," p. 5. Quotes 2-3 from Sloan, notes, 1944. Maratta's "pseudo-scientific theories of color and composition" are discussed in Homer, *Henri*, pp. 184-189.

47. St. John, "Life and Times," p. 11. John Sloan to John Quinn, November 24, 1912, John Quinn Papers, New York Public Library. Interview with Helen Farr Sloan, December 16, 1970. Quotes 2 and 4 from Brooks, *Sloan*, pp. 100, 123. Quote 3 from Sloan, notes, 1944.

48. Helen Farr Sloan to author, August 22, 1966. St. John, "John Sloan," pp. 5, 7. Quotes from Sloan, notes, 1944. St. John, "Life and Times," p. 14. Brooks, *Sloan*, p. 155. Sloan did not go to Santa Fe in 1933 and 1951, stood in for Henri at the Chase School in 1905, taught at the Art Student's League from 1916 to 1932 and 1935 to 1937, at the Ecole d'Arte during 1932-1933 and the George Luks School during 1934-1935. St. John, "John Sloan," p. 7. Morgan, *Bellows*, p. 44. St. John, "Life and Times," p. 14.

49. Quote from Sloan, notes, 1944. Helen Farr Sloan to author, August 22, 1966. Sloan painted in this period a number of portraits and figure

pieces little known today, and etched black and white genre off and on until 1949. Actually, he painted some sixty city subjects after 1910. Helen Farr Sloan to author, August 22, 1966.

50. Quotes 1-6 from Brown, "Two John Sloans," pp. 26-27, 56-57. duBois, *Sloan*, p. 8. Quote 7 from Daniel Catton Rich, intro., *Bellows*, p. 12.

51. Quotes 1-2, 4-6 from Brown, "Two John Sloans," pp. 57, 27. Quote 3 from Sloan, *Scene*, p. 619 (April 20, 1912).

52. Sloan, *Scene*, p. 633 (January 16, 1913). "Although Sloan in fact recognized the importance of the new trend toward abstraction, he never felt at ease with this style and always felt the need to express himself in terms of realism." St. John, *Sloan*, p. 39.

53. Quote 1 from Brooks, *Sloan*, p. 94, note [italics in original]. Helen Farr Sloan to author, August 22, 1966. Quote 2 from Sloan notes, lecture at University of Chicago, 1945; interview with Arthur deBra. Quote 3 from Sloan, *Gist*, p. 35.

54. Quotes from Sloan, notes, c. 1948. Helen Farr Sloan to author, August 22, 1966. Sloan refused a 1933 invitation extended to three Americans to attend, expense-free, the Soviet International Bureau of Revolutionary Artists in Moscow. Brooks, *Sloan*, p. 93, note.

55. Alvin W. Gouldner, "The Sociologist as Partisan: Sociology and the Welfare State," *American Sociologist* 3 (May 1968): 106.

56. Ibid., p. 111.

57. Ibid.

58. Sloan, *Gist*, p. 189.

59. Quote 1 from Sloan, notes, lecture at University of Chicago; quote 2 from notes, 1949.

60. Quote 1 from Sloan, notes, 1949; quote 2 from notes, c. 1948.

61. Sloan, *Gist*, pp. 190-191.

62. Sloan, notes, interview with Sanka Knox.

63. Quote 1 from Sloan, notes, 1945; quotes 2-3 from notes, 1949. Quotes 4-6 from Sloan, *Gist*, p. 28.

64. Sloan, *Scene*, p. 314 (May 27, 1909).

65. Helen Farr Sloan to author, August 22, 1966.

66. St. John, "Life and Times," p. 11.

5
K.R.Chamberlain

Kenneth Russell Chamberlain (1891–) was born in Des Moines, Iowa, "like most people were in those days," and moved to Phoenix at four because of his sister's asthma.[1] He attended an Episcopal Sunday school in this "frontier town." Financially, his father, a small jeweler, "made a living" but no more. In 1906 the Chamberlains returned to the Midwest for six years while Kenneth was a teenager, residing on a family farm in central Ohio. The family lived near Worthington, a "sweet, little New England type town," and his father carried on the jewelry business in Delaware, the nearest city. Chamberlain graduated from high school in 1909 and left the farm to attend Columbus Art School from 1911 to 1913, supporting himself and contributing to the family income by doing advertising drawings for the *Columbus Citizen.* At Columbus Art School he took drawing under a Henri pupil, Julius Golz, and then at twenty-one he "went right to New York," for "everybody from the Midwest goes to either Chicago or New York." George Bellows, Chamberlain recalled, also came from Columbus. "His background was typical middle class, prewar, American boy, like mine was." Chamberlain planned to study painting at the New York Art Student's League, but his main interest was cartooning. As it turned out he did little painting, for "I never could see color."

Julius Golz arranged that upon arriving in New York Chamber-

lain, who was "very poor for a while," could share an apartment
with four Columbus artists. Soon he secured a job on the weekly
American Art News, helping with make-up and clipping news
items. Chamberlain admired the radical *Masses* artists he met in
New York first and foremost for their great skill as illustrators.

> I went to New York not even knowing what socialism was. I
> had some rough idea that it was dividing up the wealth. But
> when I got down with these fellows whose drawings and art I
> admired so greatly, why, if they'd been cannibals I probably
> would have turned cannibal. I was sympathetic for it, through
> having had this art start in Columbus from a disciple of those
> artists, and so I just fitted in what the *Masses* did. So I went
> right down there and sure enough they liked my work enough
> to use it [1913]. And my ideas came. I was won over com-
> pletely and sympathetic for it.

After meeting the *Masses* people, he and Maurice Becker took
Bellows' apartment one summer, then shared an apartment-
studio the following year. "These names to me were like gods.
I'd heard of Bellows. I got right into it by luck." But Chamber-
lain was never asked to join the Socialist party. In fact, he said,
"None of us joined anything as far as I can remember." He soon
decided "the Art Student's League was too conservative and too
commercial," too involved in poster art; so he studied evenings
under Robert Henri at the Ferrer School. Chamberlain liked
Henri, who "did more talking than teaching," and who got him
"into this technique right away—I mean, I had never dreamed—
I thought everything had to be neat little pen drawings."

Chamberlain read the muckrakers, but was only somewhat
moved by them: "Those fellows had had their innings and they
were kind of going down at the time." But an awakening came
for Chamberlain on his discovery in New York of "those marve-
lous French artists who were all radicals, every one of them,"
especially Forain and Steinlen. He frequented bookstores to
study their cartoons, read *Simplicissimus*, and collected Forain's
"marvelous drawings on the Dreyfus case."

To Chamberlain, as to John Sloan, New York City's ethnicity
and bohemianism offered a charm which had failed to appeal to

Becker and Minor. Chamberlain had heard of those painters who
"came along and painted life as it is on the streets and backyards,"
and he connected the Ash Can school with the avant-garde illus-
tration of the *Masses.* He did not envision the *Masses* as more
than a medium for experimental drawings and for registering
social protest in the muckraking tradition by attacking seem-
ingly distinct issues, such as prostitution and tenements. Such
an outlook, he felt, was characteristic of the *Masses* artists as
a whole.

Chamberlain's loyalties and animosities were essentially
personal rather than social. It was his admiration for the *Masses'*
artists that made him a socialist, and he saw socialism simply as
the Eugene Debses against the John Rockefellers. "Debs radiated
love for his fellow man, and whether or not you agreed with his
old line socialism, you were sort of for him."

Always, Chamberlain and, to a degree, Sloan saw both the
Masses and Greenwich Village as fun, not to be taken too
seriously, as elements in their rebellion against what Chamberlain
called the "social idiocy" of American culture. His cartoon
attacks on absurdities in American life quite satisfied his radical
impulses. And Sloan whom Chamberlain pointed to with approval,
"always liked young girls. He'd always draw them just coming
home from work, laughing and jolly. They [*Masses* artists] were
all around fellows, they weren't these darn old bearded socialists
or commies that sat in an office and tried to reform the world by
indoctrination." Chamberlain recalled the Jefferson Market Night
Court in the Village as "a great sketch place for all of us." The
Court was not, to Chamberlain, an example of systematic injus-
tice. Rather, it was the purveyor of innumerable free models for
the artists' urban tableaux. Streetwalkers hauled into court were
not victims of exploitation, but colorful examples of "squalor"
to fill sketchbooks. Chamberlain, Becker, Davis, and Glinten-
kamp would also "go around to these colored saloons over in
Hoboken, sketch, and things like that. . . . Innocent . . . except
Becker, the only one that was interested in the idea of things."

Chamberlain believed most radical artists "were primarily
interested in their art, and they'd starve or anything for that,

but very few of them would get out and do much politicking, very few." And "most of these editors wouldn't get up on a soapbox and lead a strike on a bet." He distinguished levels of political consciousness among *Masses* artists by saying "some of us were fanatical and some of us were in earnest about it. I'd say I was in between there. I liked to draw and I liked to get an idea back of it."

No one could avoid the daily evidence of poverty and class conflict:

> In the city you saw it, you saw misery, you saw bums in the Bowery, which you don't see anymore, oddly enough. And if a strike ever happened, well, the police—the mounted police—would always come out and beat them down and they really didn't have a chance in those days. . . . The hop pickers would try to revolt, or in Ludlow, and the National Guard would be called out and shoot them all, they shot right in the [miners'] tents. . . . Those things were common in those days. Now it's gone the other way, too far let's say, perhaps. But in two generations the picture is completely changed. It's hard to imagine how it was then. Say Wall Street, you had no income tax, Carnegie would build a library, salve his conscience. But Frick and all those steel magnates, [felt] these people that work in any steel mills for fifty cents an hour, that's all they're worth. They [the magnates] were innocent in their way, too. They didn't know any better. It was the way they were brought up.

Chamberlain had a curious attitude: you must understand the magnates' point of view, for they were ignorant and needed education, which it was the artist's function to provide. As Chamberlain recalled, he "grew up in the Horatio Alger tradition, when making fortunes wasn't suspect, and [he] admired bankers, industrialists . . . never doubting their probity." Although the muckrakers and the *Masses* "began to open [his] eyes," this "background kept [him] from showing as much hate in cartoons as [he] sometimes felt."

To what degree was Chamberlain a socialist? He said, "I was simply a liberal who came to New York, saw the sweatshops, turned socialistic, probably still am, never was communistic." By socialism he meant social reform.

Chamberlain remarked that he "had a lot of fun" drawing a large number of cartoons on women's rights—suffrage, birth control, and prostitution. The *Masses* artists listened to the anarchists Emma Goldman and Alexander Berkman. It was

> the first time we'd ever heard any public discussion of birth control or anything that today [1966] is just taken for granted. You don't know what a puritanical world it was in those days. I did a cartoon on that. I had a woman dropping a baby into the Hudson River ["Family Limitation—Old Style," *Masses*, May, 1915]. Things like that.

Chamberlain "became quite a women's suffrage cartoonist," contributing about a cartoon a week on that subject to *Puck*.

In a cartoon on prostitution Chamberlain observed in the caption, "Why here's a story about a girl who went wrong. I thought they passed a minimum wage law or something which prevented such distressing things." He remarked on it as follows: "That sort of comment is much better than a thing like Young's, which puts it all on greed, commercial greed. Girls don't go wrong," Chamberlain felt, "because of being exploited for greed. There are some who want to—why not?" But "then, of course, we always attributed prostitution to commercial greed," but "we didn't have to come out bang! You could always kid the thing along." This is consistent with Chamberlain's conception of the artist's role. He seems to say art should not be too serious; for in order to educate, it must entertain, and in order to entertain, it must be acceptable.

But paradoxically Chamberlain felt his objective in radical illustrating "was to attack. If you'd ask me what I would do about it, I wouldn't be able to answer. But I'd want to attack the injustice as I saw it, whether it was fiscal or social or whatever. I mean if there is something wrong, why, you want to attack and the more meat axe kind of attack the better."

When Chamberlain's free lance drawings "began to earn a little" in 1914, he quit the clipping job. At the same time that he was a socialist, *Masses* artist, and free lancer, in 1915-1916 he also worked for the *New York Evening Sun*. Socialists Art Young, Robert Minor, and John Sloan also drew for popular

magazines and newspapers (though Sloan's drawings generally
were nonpolitical magazine story illustrations). Young and
Minor, when faced with a moral dilemma in being asked to do
cartoons they did not believe in, consistently refused. Chamber-
lain, however, complied. Young was fired by *Metropolitan* maga-
zine in 1917, Minor by the *New York Evening World* in 1915.
But Chamberlain supported the *Masses'* anti-preparedness, then
its anti-intervention campaign and simultaneously drew cartoons
such as the double-page *Harper's Weekly* spread backing military
readiness, "Why Not a Fourth 'R'?" (November 20, 1915).

In 1916 Frank Munsey purchased the *Evening Sun* and fired
all cartoonists; so in early 1917 Chamberlain went to the *Phila-
delphia Evening Telegraph* and *Public Ledger*.[2] There he drew
anti-German and Liberty Loan cartoons. "But," he added, "I
refused to draw anti-Bolshevik stuff" from Philadelphia. From
Cleveland, where he illustrated for the *Press* during 1918-1920,
he mailed antiwar cartoons to the *Liberator* and Art Young's
Good Morning. Chamberlain explained, "I just went along after
we were in the war. I wanted to hold my job as a cartoonist
although I wasn't for the war."

Chamberlain drew on every subject for the *Masses* and *Libera-
tor.* He supported the labor movement and women's liberation and
attacked the war. His drawings are marked by their unevenness.
Moreover, the humor of his drawings is opaque until combined with
their captions. Chamberlain attempted to depict a certain kind of
social hypocrisy quite different from that expressed by Young's
exposés of the ruling class. He was against general human foibles
rather than against those of a particular class. In "'Here I've
Started Four Revolutions'" (Figure 38), he expressed the
hypocrisy of either the drifter or workingman. "'Socialism is
the Menace to Our Civilization!'" (Figure 39) hit at the vanity of
the ruling class. In "Colorado Mine Owner" (Figure 40), the two
faces are pedestrian, certainly not cruel. This is all the more
curious when we realize, as the small-print paragraph below the
caption indicates, that the man to the left is one of the mine
owners responsible for the death of many persons. Thus, there
is nothing special in Chamberlain's depiction of the ruling class.

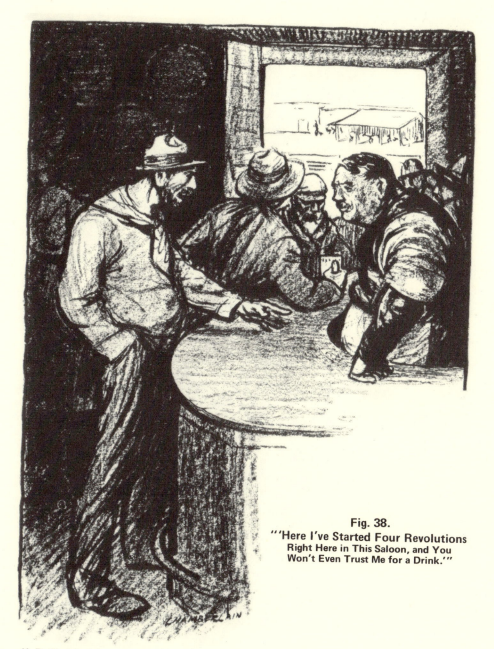

Fig. 38.
"'Here I've Started Four Revolutions
Right Here in This Saloon, and You
Won't Even Trust Me for a Drink.'"

K. R. Chamberlain
Masses. Jan. 1914.

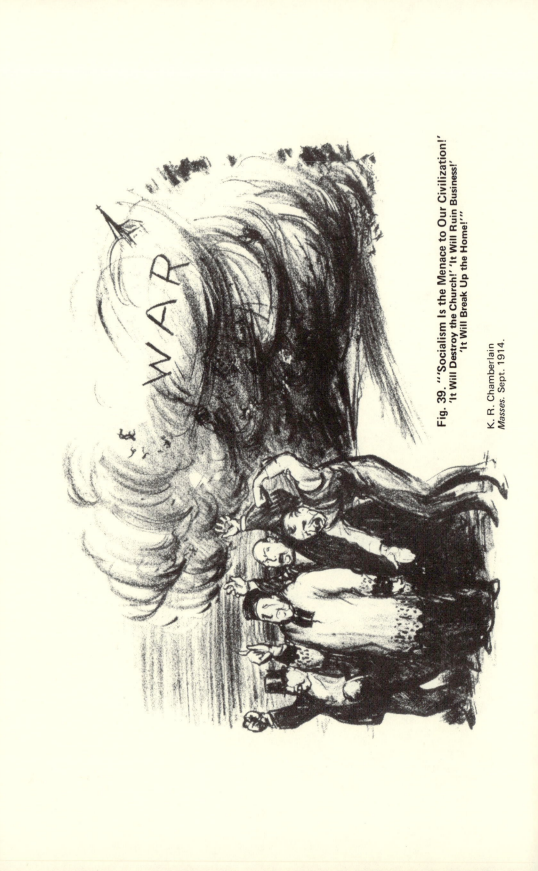

Fig. 39. "'Socialism Is the Menace to Our Civilization!' 'It Will Destroy the Church!' 'It Will Ruin Business!' 'It Will Break Up the Home!'"

K. R. Chamberlain
Masses. Sept. 1914.

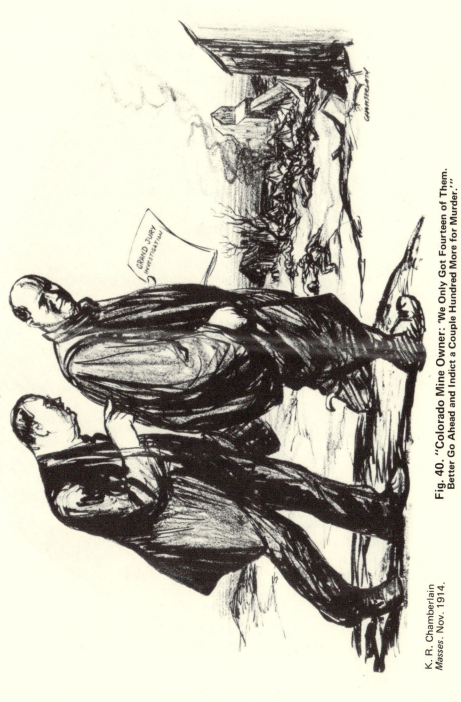

K. R. Chamberlain
Masses. Nov. 1914.

Fig. 40. "Colorado Mine Owner: 'We Only Got Fourteen of Them. Better Go Ahead and Indict a Couple Hundred More for Murder.'"

They were not vicious men, as they were to Minor and Becker;
unscrupulous, as to Young; or crude, as to Sloan. To Chamberlain
they were misinformed and obtuse more than exploitive.

There is no essential difference between Chamberlain's bosses
and workers, for unlike Young, Minor, Sloan, and Becker, he
made fun of the vanity and hypocrisy of all classes and groups
equally and on the same plane. His capitalist figures look like
people he drew in other classes except that they are a little
fatter, as in "Colorado Mine Owner." With Becker and Minor
there is a feeling for good versus evil, victim and victimizer, but
with Chamberlain there is no dramatic conflict between the
magnates and other classes. Thus, in providing only mild tension
and contrast in his pictures, Chamberlain relied heavily on his
captions. His great failing was that he attached dramatic captions
to prosaic drawings.

"At Petrograd" (Figure 41) is mediocre, in the sense that
Chamberlain had or was given a good idea foreshadowing the
Russian Revolution, but his tranquil illustration could not equal
the idea. Dramatic quality is suggested in the caption, but the
drawing is just a sketch. The two figures look almost identical,
and against them in an unimpressive background he tried to make
the big, black granite wall represent the total gloomy mood of
the picture. The wall does create dourness, but the picture was
intended to express humor, not gloom. By itself, as a drawing
conceived by Chamberlain, it is merely two people in a gloomy
atmosphere with depressing thoughts. The caption then seems
merely tacked on. The two conceptions, drawing and caption,
are not integrated.

"'Teuton Against Slav'" (Figure 42), on the other hand, is
Chamberlain's best drawing, jibing at colonial troops in the
European conflict. It is well composed: the soldiers are alive,
real, moving, and fighting. More important, "'Teuton'," is
successful in a way that most of Chamberlain's drawings are not:
it focuses on the total hypocrisy, absurdity, and irrationality of
the established political-social system.

It can be argued that Chamberlain's limited social vision
followed from his belief in the improvability of the ruling class.

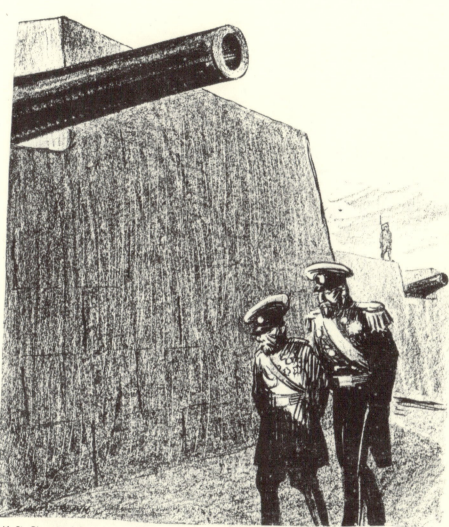

K. R. Chamberlain
Masses. Jan. 1915.

Fig. 41. "At Petrograd.
Russian Officer: 'Why These Fortifications, Your Majesty?
Surely the Germans Will Not Get This Far!'
The Czar: 'But When our Own Army Returns—?'"

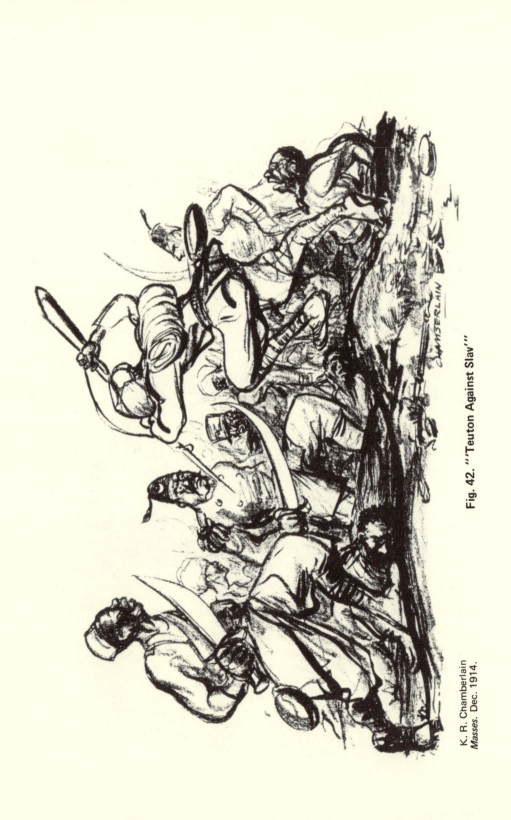

Fig. 42. "'Teuton Against Slav'"

K. R. Chamberlain
Masses. Dec. 1914.

Why does his work have this narrow social vision? Probably
one major reason for this failure is that Chamberlain was not
able to make sharp, simple points very often. When he did he
was effective. But most often it seems that Chamberlain's work
had no central focus, and that he was unable to use his resources
to concentrate a number of different factors in one sharp
political or social point or comment. The fact that his work is
usually diffuse and unfocused follows from the vagueness of
his political vision. This is not to say that a left wing artist will
necessarily produce great art, or that a conservative artist will
produce mediocre art. But being a good political artist of any
sort requires a clarity and depth of vision that Chamberlain
lacked.

There was no marked change in Chamberlain's work on the
Liberator. Fascinated as he was by the new, freer *Masses* style,
all of his drawings were a conscious attempt to be sloppy and
careless, to create an aura. He need not have been careless, but
he tried to establish a mood, as with his use of shading in
"Recruiting Officer" (Figure 43), where, combining the slums
and the military, he created a pretentiously dismal cartoon.
Chamberlain's primary drawing technique, that of expressive
crudeness, was somewhat successful. In "Contempt of Court"
(Figure 44), drawn to illustrate Frank Tannenbaum's attitude
when he was tried for leading the unemployed into churches,
he used his crude, overly dark technique on the background,
whereas in "'It Checks the Growth of the Undesirable Clawsses,"
(Figure 45) his technique was the opposite—the figures are dark
and the background light, to make the figures nondescript
people.

Chamberlain liked reform issues such as the undemocratic
nature of the church, illustrated in "Contempt of Court". This
illustration, however, is uneconomical. Minor would have drawn
fewer elements in it, having only a big judge and small Tannen-
baum. Though the drawing is in crayon and/or graphite,
Chamberlain had to ink the judge's and Tannenbaum's faces
to draw attention from the distracting overall picture.

The only original expressive device Chamberlain used to

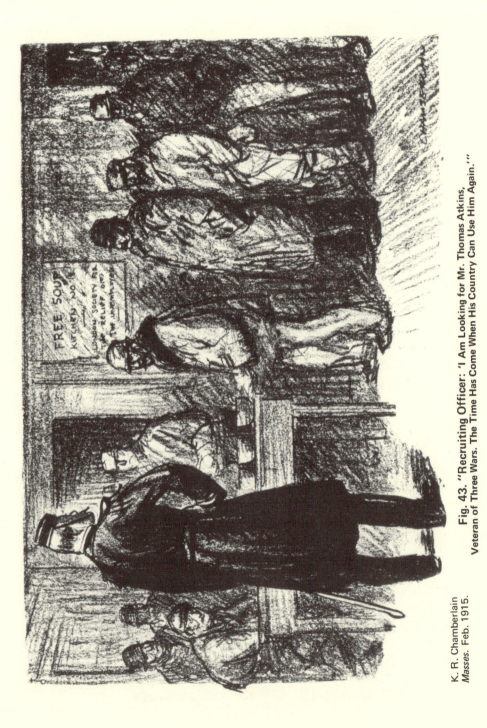

K. R. Chamberlain
Masses. Feb. 1915.

Fig. 43. "Recruiting Officer: 'I Am Looking for Mr. Thomas Atkins,
Veteran of Three Wars. The Time Has Come When His Country Can Use Him Again.'"

K. R. Chamberlain
Masses. May 1914.

Fig. 44. "Contempt of Court,
"You Can Arrest Me But You Can't Arrest My Contempt.""

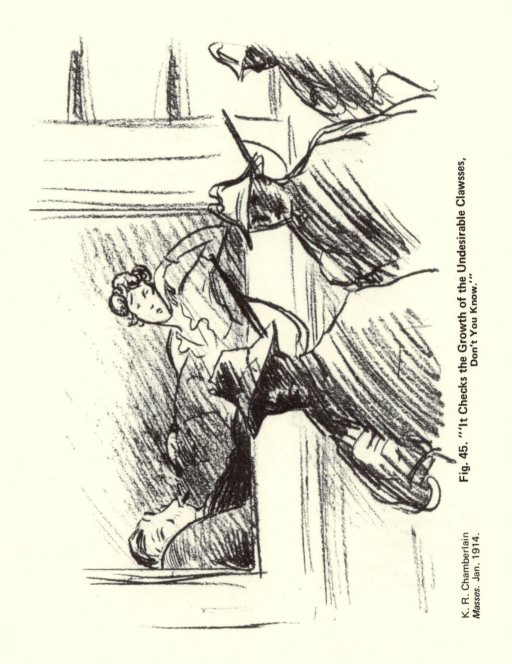

K. R. Chamberlain
Masses. Jan. 1914.

Fig. 45. "'It Checks the Growth of the Undesirable Clawsses,
Don't You Know.'"

depict character in figures is his use of posture. In "Colorado
Mine Owner" both men are clumsily awkward rather than
straight and vicious. The woman in "Afterwards" (Figure 46)
is straight in minor contrast to her gangly, dumbfounded
husband. In "At Petrograd" Chamberlain used both the straight
and sagging slant of the two military caps and the contrast of
the posture of the officer and the Czar in order to portray
Nicholas II's weakness and dejection. The worker in "'Here I've
Started Four Revolutions'" is also sagging. Likewise, the stance
of the four capitalists in "'Socialism Is the Menace'" is that of
lumbering, stupid types. Through these figures Chamberlain
wanted to say that the ruling class should develop knowledge
and kindness and should grant decent wages and working condi-
tions. This followed from a limited social vision and accordingly
produced a limited art.

Following from his narrow, muckraking social perspective is
his curious depiction—as a socialist cartoonist—of workers. As
portrayed in "War?—Not on Your Life!" (Figure 47) and
"Socialist Investigators" (Figure 48), his parody of American
socialists for their reaction to the Soviet Union, the workers
represent neither victims nor underdogs nor rebels, but just
individuals, real people. There is no conflict between oppressor
and oppressed, and even on the soup line in "Recruiting Officer"
the figures are sketched naturalistically. That is, Chamberlain
felt no acute sense of the oppression of the worker: they are
portrayed as sound, healthy, bluff people. No relationship is
expressed between worker and exploiter, only the solidarity
of worker toward worker, or the antagonism of worker toward
worker, as their ridiculous fighting of each other shows in
"'Teuton Against Slav.'"

Artistically, then, Chamberlain was a liberal individualist
rather than a welfare liberal like Sloan. Young concentrated
on the ruling class; Sloan on the poor as victims needing care
and guidance; Minor and Becker on the poor and workers as,
respectively, strong or weak rebels against the established order.
But Chamberlain rarely portrayed workers as men oppressed;
they are simply drawn as fat, skinny, straight and round

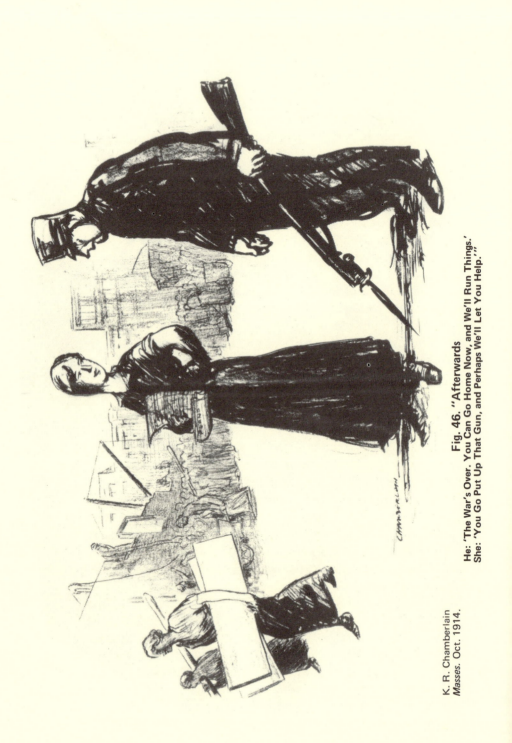

K. R. Chamberlain
Masses. Oct. 1914.

Fig. 46. "Afterwards
He: 'The War's Over. You Can Go Home Now, and We'll Run Things.'
She: 'You Go Put Up That Gun, and Perhaps We'll Let You Help.'"

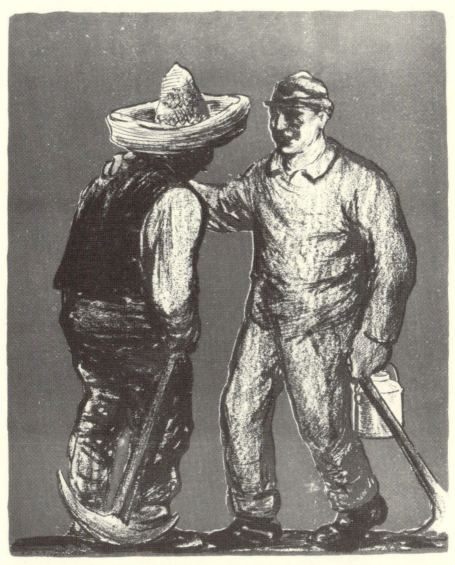

K. R. Chamberlain
Masses. June 1914 **Fig. 47. "War?—Not on Your Life!"**

K. R. Chamberlain
Liberator. Dec. 1920.

**Fig. 48. "Socialist Investigators: 'Horrors! How Crude!
It's Much Nicer Just to Dream About It!'"**

shouldered, just regular guys. The historical situation is
definitely one of class conflict, but neither struggle nor real
oppression is observable in the pictures. Chamberlain did por-
tray oppression in a small way on the question of women's
rights, where, as in "Afterwards," he was interested in that
question and was rather successful.

The weakness of Chamberlain's art, then, is that it is politically
unconvincing. Not enough is expressed in the drawings. He
tended merely to illustrate stories. If one were to eliminate the
caption, not necessarily Chamberlain's to begin with, the picture
would not speak for itself. In contrast, a considerable number of
Becker's and Minor's drawings stand on their own, the caption
not being essential to an understanding of the picture.
Chamberlain seemed to model his style on a number of persons,
attempting to synthesize social types and individuals. Though
he was a competent artist, he illustrated anything for anyone.
As a result, he was detached from his art, the idea dominated
the art. He was virtually a pure craftsman, who knew skillful
drawing techniques and used them but lacked personal conviction
and imagination. He lacked both Art Young's excellent sense of
humor and Robert Minor's dramatic flair.

Young's political cartoons also depended heavily on their
captions (at which he was a master). But the similarity ends
there. After 1910 Young only worked with those ideas he
believed in, and he would not sell himself cheap as Chamberlain
did. Young's work shows conviction, and compared with
Chamberlain's it is much more personally stylized. One
recognizes a Young cartoon in an instant, with its inimitable
and strong use of contrast and distortion and with the
caption integrally related to the picture, not merely pasted
on.

Chamberlain did not restructure reality as much as Young.
He kept too much to the correct human scale in drawing
figures, whereas Young offered varied sizes. The Russian worker
in Chamberlain's "Socialist Investigators" is an exception, but
is a typical figure in that he was drawn like a model posing on
stage—he lacks movement and force. Chamberlain's lack of

strong political convictions was reflected not only in his art
but in his attitudes toward the artist's role in society.

The only option Chamberlain saw for the radical artist was to
contribute pseudonymously to socialist illustrations. The editor
of the *Cleveland Press* recognized his work in the *Liberator*
"and said either you'll have to quit working for us or not sign
your name." Chamberlain then contributed under the name
Russell, but this was as far as he would go, for "you can
compromise to a certain extent and excuse it, but it's foolish
to stay on a paper and earn a living, support yourself and maybe
your family and try to buck the paper's policy. It just doesn't
make sense." He considered unsigned cartoons "an unhappy
subterfuge" that "went against the grain." But his *Press* job was
"the daily grind at the only trade [he] ever knew." As for the
conflict of anarchist Robert Minor with Pulitzer's *Evening World*,
Chamberlain's comment was pithy: "He was finally fired on it."
Chamberlain was totally unpretentious about his artistic role.
He said, in effect, that he was a hired hand and would have
deceived himself to think otherwise.

Chamberlain is representative of the many radical American
artists who were revolutionary artistically but not socially and
politically. He had doubts about socialism as early as 1917, with
the first discussion in the United States of the meaning of the
Bolshevik Revolution. Before 1917,

> I.W.W. was the only, or socialism was the only 'ism we knew
> about, and none of us subscribed to that. We'd vote for Morris
> Hillquit or Gene Debs, but you wouldn't be in a party, wouldn't
> have the label. I would always, always have voted for anybody I
> thought was the best guy. . . . But when the Russian Revolution
> came along then, in 1917, things changed there a bit. They got on
> one side or the other and entered party fights, inter-editor fights,
> and everything.

Nevertheless, the Russian Revolution, though confusing, was
greeted enthusiastically by Chamberlain in the *Liberator:*

> I had [an unsigned] cartoon ["Socialist Investigators"] I did
> when I was in Cleveland. The socialists sent a delegation over

to Russia to see how it was working out, and they came back
quite disillusioned. They thought it was too rough. So I had a
cartoon of these little fancy pants socialists coming home, a
big worker in the back with a gun, and they were saying, "Oh
heavens! it's so crude!"

But rather quickly the new Soviet regime disappointed him:

When the Russian Revolution came along we thought that was
the end of the struggle, that was the new hope for the world
and everything. And I think Art [Young] never got over that
hope. But Eastman was one of the first to become disillusioned.
He went over there, and he could see that the dictatorship of
the proletariat was just about as unpleasant as any other dic-
tatorship.

Though his radicalism waned in 1917 after he moved to Philadel-
phia, he continued to visit old colleagues on the *Liberator*. But
he drifted from social involvement and he stopped contributing
to socialist publications. His last *Liberator* cartoon (by "Russell")
was in August 1923. As for the post-*Masses* radical movement, he
said, "I don't know anything that happened after 1918." Even
so, Chamberlain asserted that "I never dropped my radicalism. It
goes through phases. It was simple radicalism then—pretty girls
on magazine covers."

After leaving the *Cleveland Press*, Chamberlain worked in
Chicago "and all around," and in 1920, after the death of his
sister, joined his mother in Los Angeles. There he cartooned for
the *Record*. He was employed seven years in Los Angeles, where
he also "did movie publicity and magazine work and anything I
could." The *Record*, too, "died in the 1920's, but it was a labor
paper originally and that's when I could rip municipal, [or] local
injustice or theory, the council, or prohibition, or anything like
that."

Chamberlain continued his support for piecemeal social
criticism and personal liberty. He evaluated Robert Minor's
attack on Comstock and censorship in "'Your Honor, This
Woman Gave Birth to a Naked Child!'" (*Masses*, September
1915) as "a beautiful cartoon. Just the sort of thing, any social

thing, it doesn't have to be radical, but social idiocy, like that, we could pick on in the *Masses.*"

In 1927 Chamberlain returned to New York and was hired by the *Sunday World;* to work there had been one of his ambitions. Unfortunately, the *World* died three days after he started work when it was sold to the *Telegram.* Other things disappointed him. Though rents had risen in Greenwich Village before he left New York in 1917, Chamberlain found on returning that "night clubs and honky tonk sort of things, and lots of gift shops [had] moved in. Rents had skyrocketed. The artists had to move out. They didn't have any money."

In 1928, though he had to pay his way over, Chamberlain traveled through Europe, studying and sketching for the *New York Herald-Tribune.* After he returned to the Village in 1930, he married Henrietta Morton, who worked in advertising on the *New Yorker.* She was the daughter of American Baptist missionaries in Brazil, and he had met her in 1928. Eventually they had two sons and a daughter.

In 1933, Chamberlain went to work for the Topics Publishing Company, with which he remained for nearly twenty years. But during and after the war he also did cartoons for Hearst's King Features. Hearst's opposition to the war was, as Chamberlain said, "one of the few times I agreed with [him]." In 1949 King Features dropped his contract: "I wasn't losing money, but I wasn't making much for him. I had 120 papers, but they were probably paying a dollar or two a week. So I was included in a basket deal where they got all kinds of features." For the next ten years, living in semi-retirement in Riverside, California, Chamberlain worked for the National Association of Manufacturers (NAM). "I was free lancing. I didn't care by that time who paid me. You're either going to pay rent or collect it."

It seems that only during Chamberlain's socialist phase did he generate enthusiasm for his art, though he never completely empathized with the intense, hostile illustrations of Minor and Becker. He described Minor's drawings as "big, black brutal things," and Becker as "a Jewish boy, born in Russia [who] never got over it in a sense. There's something grim about those people." Still he conceded "there's something about Art Young's cartoons

and Robert Minor's. They had a knack—I don't know, I can't
describe it—but even though they were bitter they met it in
sharp, they had a saving grace, either humor or an angle to it
that you always liked. Other cartoonists were just plain
blah-bitter."

Chamberlain considered *New Masses* cartooning particularly
"blah-bitter": "so doctrinarian, so boring to read, it defeated
itself." He believed that at some point American radicalism had
turned off in strange directions. He had no quarrel with the
Liberator. But even before he joined the *Liberator*, he sensed
"the things that would come. It wasn't the age of innocence
any more. You had to watch your step, this was when the new
factions came in." Chamberlain noted that the *New Masses*
"died, [as] all those bitter-end papers die." Compared with the
old *Masses*, its namesake "was a very indoctrinating thing. It
just didn't have at all what this thing had, a spirit of fun and
impudence."

Chamberlain was asked "several times to do something" for
the *New Masses*, but he declined.

> I don't mean to make it sound futile saying it wasn't fun, but
> it wasn't the way we believed that the approach should be.
> It would just antagonize readers. You just couldn't wade
> through it. And if you saw a cartoon, it was always a bloody
> thing that antagonized more. . . . And the new crop of blood-
> hounds came along to work, but they were mostly this Jewish
> bitter-end school again—that had to be blood.

The gap between Chamberlain's avant-garde graphics and Robert
Minor's political communism was unbridgeable. Nor did
Chamberlain care for the socially conscious Mexican muralists
of the 1930s; he criticized their "vicious cartoons on the walls
against the Catholic church, in a very Catholic country."

As a cultural radical Chamberlain appreciated the technique
but not the subjects of William Gropper, who "always painted
these bitter social comments, always." Even worse, Gropper

> wasn't fun. The only time or two I met him he wouldn't
> communicate at all. . . . And yet Art Young didn't get bitter
> over that [Chamberlain's defection from radicalism]. We didn't

have rows over that. But I think Gropper was one of those that wouldn't speak to us because we weren't still one hundred per cent communists.

Chamberlain expressed similar feelings toward Robert Minor as a communist: "I think he was altogether an organizer. Strike official of some kind. But I know he used to get beat up by cops and go to jail. He was really a bitter-ender."

How did Chamberlain explain his own defection? "As you get older you get more gentle, you try to get more humor in it, or you try to see a little of the other side sometimes. Everybody goes through that. I think Art Young was one of the few that stayed [socialist], and Bob Minor."

Chamberlain, who had once ridiculed American socialists as "fancy pants" for criticizing Soviet Russia, later had different recollections:

> Max Eastman got over there and saw what was happening. And the hard core, like Maurice Becker and Bob Minor and those fellows, they wouldn't speak to Eastman. If they saw him they'd cross the street to get away from him. And yet, now he's been proven correct. He had the intelligence to see it.

Many persons criticized Max Eastman for taking a position in 1941 as a roving editor for the *Reader's Digest*, but Chamberlain saw no harm in taking a job paying "fifteen thousand a year whether he did anything or not." The point, said Chamberlain, was that this "regular income" allowed Eastman to "write for himself." Eastman and most former radicals, he said, had "just outgrown their youthful enthusiasm."

Ultimately, Chamberlain's interpretation of artistic radicalism in the United States must be described as cyclical. In his later years he said that radical artists wearied because of—

> Well, just age. As you get older you lose that flash of youthful enthusiasm. I used to get so mad at some of the things I'd want to scream about it, but I wasn't the courageous type to go down and get beaten up by a cop. But nor would Eastman. He would skirt these things. He would organize meetings and speak, but he

> was never in any forefront of any struggle, physical violence. But
> as you get older you lose that and you see both sides a little more.

In 1948 Chamberlain voted for Henry Wallace because "we were
all sympathetic yet, but not actively working for a revolution in
the sense that we thought the Russian Revolution would reform
the world anymore. You just know better." He preferred Wallace
as "the only candidate with something new to offer," and at-
tended a Wallace rally in Madison Square Garden, where Maurice
Becker waved to Chamberlain from the balcony.

The cold war years perplexed and confused Chamberlain:
"You don't know where to turn hardly, any more. The artists
were just as affected as anybody else. . . . Norman Thomas can
still be on a program and in his weak old voice he can still put
over some thoughts. Upton Sinclair can still mumble a few
things yet, but artists don't do it." Yet, he remained "all for
organized labor, heaven there has to be. I know what it was in
the old days. Oh boy!"

Chamberlain denigrated the "op" and "pop" trends of the
1960s as "all of this op and pop stuff, nothing to do with any
social comment at all that I can see. I don't mean to condemn it,
but it's way out of my ken." But he looked back with some
bitterness at the more committed of the *Masses* crowd. He
remembered Dolly Sloan, for example, who arranged socialist
meetings and handed out literature, as a "rabid socialist who
liked to get out and soap box."

In an interview in 1966 Chamberlain said that socialism
"went down like all liberal or radical movements" and was
"pretty moribund now." Through the confusing fabric of his
personality emerged an artist who, he said, did not care for the
"social thing." He just wanted to spoof "human foibles" and
was never drawn to socialism as more than a revolt against
conservative art. So he left the movement when the discussion
of soviet communism in the United States "got way over
[his] head."

It seems that Chamberlain has remained politically uncertain

to the present day. As superficially as he was drawn to socialism,
it had been a deeper commitment than any subsequent interest.
As for electoral politics, in 1966, as a half century ago,
Chamberlain would

> vote for the best man. That old cliché, but what else can he do?
> I'm not registered in any party at all, I wouldn't know who I'd
> vote for. I can't understand being compelled to sell my house
> to a Negro . . . even though I would be just as indignant if I
> was ever told I couldn't sell to a Negro, if I wanted to.

Thus, it appears that Chamberlain changed very little from his
pre-World War I days in Greenwich Village. He was "all for
the Negro having the best schools he can have and voting and all
that, but when it comes down to my personal liberty" Chamber-
lain's *weltansicht* was simply the libertarian live and let live,
the same motive force which impelled him to the Village and
the *Masses* in 1913. He always remained a Village radical—no
more—believing in tolerance rather than acceptance. He believed
in the right of different cultures and traditions to co-exist, but
he never accepted the responsibility to attempt to create one
community from diverse class and ethnic strains.

The problem one encounters in evaluating Chamberlain is that
he was no mere hack illustrator. He was a craftsman and wanted
to participate in new graphic styles. He could make a living on
the regular newspapers but he could not fill his need as an illus-
trator, so he joined the *Masses.* But he also found no role for
himself as a radical artist, and made his compromises, especially
as he grew older. Chamberlain might not have wearied of social
protest if he had been offered a real vision of a socialist alterna-
tive. But he never had the faith of a Robert Minor or a Maurice
Becker. In terms of his art and politics Chamberlain was a
soldier of fortune. As a cultural avant-gardist, he did not deceive
himself, as had Max Eastman, that he was a great Marxist.[3]
Unfortunately, the commercial world completely broke his
spirit as an artist.

NOTES

1. This chapter is based on interviews with K. R. Chamberlain August 10, 1966, December 19, 1966, July 10, 1968, July 25, 1968 and correspondence December 22, 1970, January 23, 1971, March 22, 1971, May 15, 1971.

2. Chamberlain also did sketch assignments for the *Public Ledger* which "may have been among the last in the field." When the *Ledger* fired its sketch artists, they looked for work in magazine and advertisement illustration.

3. Max Eastman wrote his publisher, W. W. Norton, requesting that the circular for Eastman's *Stalin's Russia and the Crisis in Socialism* (New York: W. W. Norton & Company, 1940) and *Marxism: Is It Science?* (New York: W. W. Norton & Company, 1940) include this blurb from the *New Republic* review of the books: "'The most intelligent and searching, as well as the best informed discussion of the implications of the Marxist movement . . . that has yet appeared in English . . . an intellectual edge, which would be hard to match elsewhere today in the American literature of ideas.'" February 16, 1941. W. W. Norton, Papers, Butler Library, New York.

6
Maurice Becker

Maurice Becker (1889—) was born in Nijni Novgorod, Russia
(now called Gorky) on the Volga. His father served the minimum
term of nine years in the Imperial Army as a uniform tailor, as
had Becker's grandfather before him, who served twenty-five
years.[1] Not wanting "his sons to suffer a similar fate," their
father moved to New York's East Side in 1892, where he became
a "sweat-shop tailor of police uniforms," but with the satisfaction
at least of seeing "no more Beckers in the Czar's army."

At the age of three in 1892 Becker "became an East Side New
Yorker," growing up on Hester St. (the center of the Jewish
push-cart trade) near the Bowery, on the West Side of which
was an Italian section, and on Cherry Street. The Beckers
"always observed the Sabbath and the Big Holidays" when
his father took him to the synagogue, but "there was little
conservatism in the Jewish family" as Becker knew it, his parents'
politics being not uncommon among immigrant Russian Jews.[2]

Becker attended public schools, entered Commercial High
School to study bookkeeping, but later transferred to Evening
High School on the East Side in order to work during the day
in a garment factory and for a Wall Street newsstand. Out of
boredom he dropped bookkeeping after the first term. In high
school he found "the drawing class next door was too tempting."
The students worked in pencil and charcoal from plaster casts,
and once a week from live models. There Becker learned of

Robert Henri's evening classes from a high school instructor
who was a Henri pupil. In 1908 Becker, too, became a Henri
student, but always as an evening pupil while holding down a
variety of daily jobs: newsboy, advertising agency office boy, Wall
Street lawyers' telephone operator, then clerk in a large broker-
age, Wasserman Brothers. Next, he switched to a theatrical
poster shop, hoping "in [his] innocence to learn fine commer-
cial art." In Henri's evening class were two able artists whose
"daily jobs were painting signs from scaffolds on 15-story city
walls and along R. R. [railroad] tracks." Becker too decided
to become a sign painter, taking an assistant's job at $3 a day,
but after a year he was doing figures and lettering from copies
supplied by the poster studio.

 Becker soon tired of reading Hearst's *Evening Journal* and
took the *Call* in which "Eugene V. Debs, Bill Haywood and
Morris Hillquit were [praised as] outstanding fighters for
working class rights." As for the influence of literature on his
radicalism, Becker said

> I've read considerable literature and Marx and historical work.
> But as a tenement kid who read Horatio Alger's success stories
> and sold newspapers and made his way into a large brokerage
> firm in Wall St. only to end up drawing and painting under
> Robert Henri. So I became an addict of Rembrandt and
> Daumier. So you see I didn't choose to become a radical—did
> only what came naturally.

 While still a Henri pupil in 1912 Becker met Rockwell Kent,
already well known as an artist, who dropped in on Henri's
class several times a week to draw the model. Kent, who worked
as an architect during the day, acquainted Becker with the
Masses. Both walked home from the Henri school on 66th Street,
"even tho'," Becker recalled, "it meant to the 30's for him and
the lower East Side for me to whom a nickel was worth saving.
'A man who draws as well as you do,' he said to me one evening,
'ought to be drawing for the *Masses.*' So before the year was
over [December 1912] my name was on the list of Contributing
Art Editors." To Becker, who at this time also drew for the *Call*,
it was as simple as that. On the *Masses* he was steady in his work.

Louis Untermeyer remembered "Maurice Becker, whose work was sternly proletarian long before 'proletarian art' became a Marxist slogan."[3]

Since socialism "came naturally" to Becker, "it never occurred" to him to "quarrel over policy" on the *Masses*. He would work with any editor or magazine fighting for the cause. As he recalled, "I think Eastman and Dell's interpretations of American society are what made the *Masses* and *Liberator*. The Russian Revolution was too young for critical appraisal." It was not the artist's function, in Becker's view, to develop socialist theory: "Certainly we Leftist Americans didn't have to suggest to Debs how to build a revolutionary movement."

Becker thought socialism would inevitably come, and possibly legally, through the ballot, but unlike Sloan and Young, who ran for office on the socialist ticket, and Minor, who worked in the Communist party hierarchy, Becker never ran for office or engaged in overt political activity, such as speaking or leafletting. He would, however, contribute money to causes such as the Sacco and Vanzetti and Scottsboro cases. He was never asked to and never did join the Socialist or Communist party. Becker was very much an "inner-directed" man, who wanted to be an artist— perhaps nothing more—in order to get out of the ghetto physically and spiritually, but the difficulties encountered in simply surviving made him a socialist nevertheless.[4]

In 1914 and 1915 Becker was on the art staff of the *New York Tribune*.

> The photograph hadn't yet monopolized the field so I sketched Morgans and Rockefellers at hearings in City Hall when Frank Walsh's Capital and Labor representatives were the jury [the Commission on Industrial Relations]. The Rockefellers' Massacre of Ludlow Colorado copper-miners had occurred some time before. Another type of big shot that was in the news at the time was Harry K. Thaw—a killer in a love affair. But even characters of lesser status made news and were unconscious models.

Becker liked sketching "Morgans and Rockefellers," but did not mention that his sketches of magnates and society dinners, at

first glance innocuous, were of people whom in fact he hated
and so depicted in the *Masses* (Figure 49). In addition, Becker
did a few *Tribune* illustrations that were politically objection-
able. He drew "'We Shall All Come Back Here as Members Some
Day'" (December 6, 1914), for a story about New York Univer-
sity School of Business seminars for bankers and stockbrokers.
The drawing depicted a broker and Mr. Average America speak-
ing to his son. The caption (as well as the story) indicated that
enlightened American finance was ready to give all Americans a
fair share of its largesse.

In addition Becker said nothing about the anti-immigrant
cartoons by one of the *Tribune*'s regular cartoonists, Clive Weed.
Becker compromised his political feelings by working for a
newspaper that was against what he, as the son of an immigrant,
was for. Obviously, he did not support the *Tribune*'s immigration
policy and was working purely for money. The odd thing is that
he did not attempt to rationalize this compromise politically.

It could be objected that Art Young drew for *Life* in the
Masses period, even when *Life* continued its anti-Semitic cartoons
against Jewish theater owners. But the important difference be-
tween the two artists is that Becker's drawings for a politically
objectionable publication were at least innocuous, whereas
Young's were not. Young used his art as a weapon, while Becker,
to say the least, was pulling his punches. Becker was frank in
responding to issues, yet seldom admitted that working for pub-
lications such as the *Tribune* was the price of economic survival.

Becker and other *Masses* artists lived largely from free lance
sales to magazines such as the *Metropolitan*, which was editorial-
ly pro-socialist until American intervention in World War I, but
markedly conservative or tame in its cover art, featuring coy
lasses with "cherry lips and waving curls." At a magazine
"Evening" in Mabel Dodge Luhan's Village salon, Carl Hovey and
Will Bradley, the *Metropolitan*'s editor and art editor, met the
Masses artists, who were hostile but none so much as Becker.
Although not a *Metropolitan* contributor, Becker expressed the
feeling of the *Masses* cartoonists toward the conventions of com-
mercial illustration. Mabel Luhan wrote of the incident:

Maurice Becker
Masses. May 1914.

Fig. 49. "Unlawful Assembly"

> Young Maurice Becker, hair on end, shook his trembling finger
> at the quaking Art Editor. . . . "We give you every chance,"
> Bradley murmured, when he had an opportunity. "Chance?
> What chance? We never get a chance to *see* you and show you
> our stuff. We hardly know whether or not it reaches you, for
> often we can't even get it back. . . . *You* are far away inside
> somewhere behind your mahogany, surrounded with Spanish
> leather screens—and you send us your cold replies. . . .
> 'We are considering your drawings. If we find them acceptable
> you will receive $20 upon publication.'" . . . "You must
> understand we publish a great many drawings and we cannot
> afford to be too generous to *one* and less to others. Many,
> we find, are satisfied with what we pay." "How do you *know*
> they're satisfied? . . . Do you know anything about what any
> of us think about you and your prostitute of a magazine?
> Have you any idea *at all* what *we* think of your 'pretty girl'
> . . . covers? My God!"[5]

Becker finished "with a gasp at his own surprising passion and
eloquence." Afterward at lunch Hovey told Luhan the artist's
attack on Bradley "quite knocked him out."[6]

What Becker was saying was that the magazine editors were
paying the artist as little as they could get away with. It was
very simple: they were paying too little for a man to live on
decently. And the fact that an artist had to get his own materials
and supplies was not taken into account, nor were the humiliat-
ing hours waiting in editors' offices to sell one's drawings ever
considered.

Becker was at most one generation removed from eastern
European Jewry, his politics intertwined with that culture's
transplantation to the East Side where he was raised. A rebel
politically and socially, as well as culturally and personally,
Becker was disinterested in mere Village bohemianism and
artistic revolt as ends in themselves. Many of his drawings have
abstract, intellectual qualities, which served as his artistic means
of escaping his traditional background. Politically, Becker lived
in a limbo. That is, he was a consistent and lifelong pacifist
socialist who was reluctant to explain his convictions (which
resulted in a jail term during World War I), but he also com-
promised with the art market when necessary. But he did so in a

way different from Chamberlain. Becker was able to produce
political drawings expressing ideas antithetical to his own without
losing his ideals. He lived in a subterranean world, always cogni-
zant of the realities of the art market, sure of his beliefs, yet
only dimly aware of the compromises he made.

In arguing that Becker was a product of, and a rebel against,
his cultural background, two points should be made. First,
there was a characteristic traditional culture that fairly uniform-
ly pervaded the Jewish communities of Poland and Russia,
though it differed slightly from area to area. In terms of this
traditional culture, Jews saw themselves as both oppressed and
culturally, intellectually, and morally superior to their oppres-
sors. That fact was always a very strong element in Jewish
resistance. Their sense of alienation as ghetto dwellers was
different from that felt, for example, by poor workers. There
was little sense of cultural deprivation among Jews. This culture
did not sanction what may be considered Western Enlightenment
values, such as individual liberties and the unalienable rights:
liberty of religion, freedom of press and education, women's
rights, and tolerance. It did not define individual rights outside
the social context of the Jewish community.[7]

Second, as a result of their own experience, certain Russian
and Polish Jews were highly influenced by the "Haskallah" or
Hebrew Enlightenment values in the nineteenth century. They
seemed particularly affected by the Hebrew Enlightenment
emphasis on spiritual values. This emphasis was compatible with
the rational determination of society and with the search for a
rational, nonmystical, scientific-religious world view. For such
Jews these values were seen as a way of breaking away from the
rigidity of ghetto life and culture.[8]

Becker seems to have been deeply touched by Hebrew
Enlightenment values. For this reason (although he was immersed
in traditional Jewish ethnic community life, as transplanted to
New York), his art and politics should be understood as a revolt
against what he felt to be the narrowness of the ethnic communi-
ty from which he came. Thus, Becker identified with the IWW
and he was a conscientious objector, but he did not identify in

the same way with the Communist party. Many of his themes
emphasize individual rights, such as his defense of Sacco and
Vanzetti in "America" (Figure 50) and rights for women in
"'They Ain't Our Equals Yet!'" (Figure 51). Of course the
Masses in general was concerned with libertarian issues. But
libertarianism for Becker was completely different from what it
was for Chamberlain, for example. Libertarianism was a conver-
sion for Becker, a break with the repression of his community,
not individual liberation.

"Americanizing the Alien" (Figure 52) and "Whom the Gods
Would Destroy They First Make Mad" (Figure 53) express
sophisticated cartoon ideas. They indicate that Becker's humor
was considerably more abstract and intellectualized than that of
the other artists discussed here. At first glance, the capitalist in
"Whom the Gods Would Destroy" is to be feared, for he has a
bomb and a torch. But the deeper idea is that the warring Western
powers are to be feared tactically and despised strategically, or
that their show of strength in World War I is a sign of their
deeper madness or weakness.

In "Americanizing the Alien" the immigrant's head is like an
open pot and Uncle Sam—who has the stereotypical chiseled
Anglo-Saxon features of people Becker hates—is pouring in
American ideas. Indeed, much of Becker's humor, such as that
in "America," was conditioned by the fact that he was an immi-
grant; he never believed in America in the way Art Young once
did. But the idea behind "Americanizing the Alien" is very
theoretical. That is, the point the cartoon explicitly illustrates
is not some contradiction or dramatic conflict, as in Robert
Minor's drawings. Becker is making a kind of abstract representa-
tion: the failure of the "melting pot" to assimilate immigrants
to dominant American cultural values. He is making fun of the
idea that the United States is a melting pot.

In "Whom the Gods Would Destroy," Becker is mocking the
contradictions inherent in capitalism. The cartoon depicts the
bestial power of capitalism unleashed against a hapless world; yet
this power will be the very cause of capitalism's own annihilation.
Becker makes the abstract point that the reality of a situation is

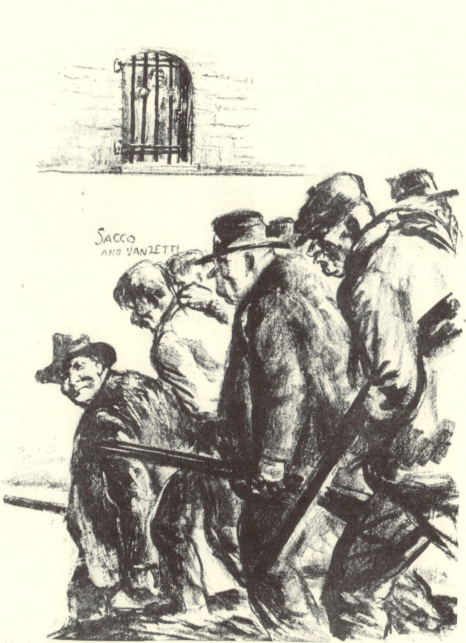

Maurice Becker
Liberator. Nov. 1921. Fig. 50. "America. We Still Offer an
'Asylum' to Liberty-Loving Europeans."

WOMAN SUFFRAGE LOSES in W. VIRGINIA & So. DAKOTA

Maurice Becker
Masses. Jan. 1917. **Fig. 51. "'They Ain't Our Equals Yet!'"**

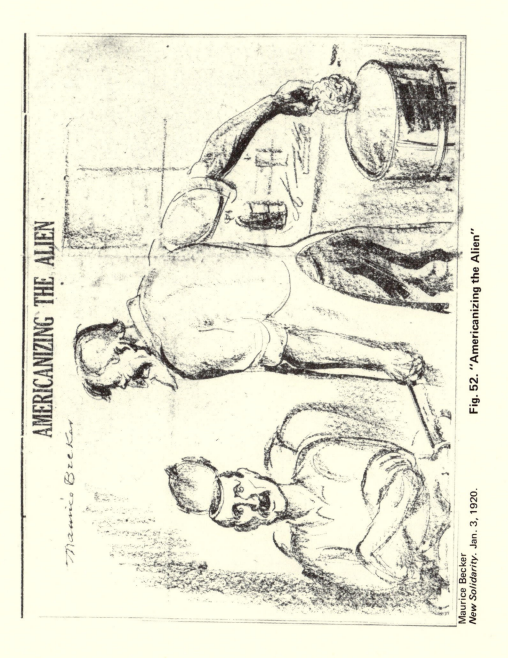

Maurice Becker
New Solidarity. Jan. 3, 1920.

Fig. 52. "Americanizing the Alien"

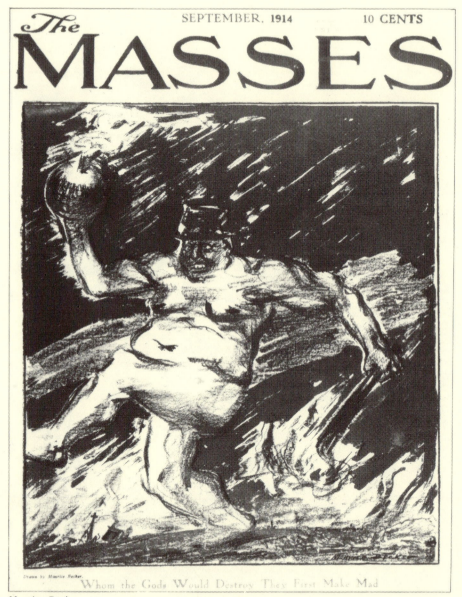

SEPTEMBER, 1914 10 CENTS

The MASSES

Whom the Gods Would Destroy They First Make Mad

Maurice Becker
Masses. Sept. 1914. **Fig. 53.** "Whom the Gods Would Destroy They First Make Mad"

different from its appearances. Not until much later in his career
did Art Young make a similar point, but in a different way, with
"The Big Shots" (*Direction*, Summer 1941). In drawing "Wilson's
Last and Best Joke" (*Good Morning*, February 15, 1921), Young
was still making fun of Wilson's pretensions as opposed to what
Wilson the man was. Young had not yet begun to depict the
nature of the social-economic system in an abstract way.

Of "Harbinger of Spring" (Figure 54), Becker recalled that he
"did not invent the drawing. The man had a push-cart of flowers
at the sidewalk. He took 2 of those flower pots and went shout-
ing they were for sale." And at first glance, "Harbinger" seems
merely a lighthearted rendition of this little moment in the
workaday world. Yet, the drawing conveys a certain irony (and
appears to be a satire of a similar illustration by another artist
in the May 30, 1908 *Collier*'s cover). Having grown up in a
sweatshop family and having worked all day to go to school at
night, his perception of the rigors of working life was acute. He
therefore gave the peddler a distinctly pained expression. Indeed,
Becker added that his hawker "is still a peddler concerned with
sales, especially since his product has a temporary existence.
Naturally his face couldn't reflect the joy that the 'romantic
blossoming of flowers' brings to the face of a well-to-do pur-
chaser." Spring means something very different to the vendor
than to his customers. To him, it is work; to them, it is romance
and beauty.

Had Minor drawn "Solidarity at Youngstown" (Figure 55),
he would have matched massive overwhelming capitalists with
delicate workers. Compared with the working class as depicted
by Chamberlain, Minor, Sloan, and Young, Becker's workers
are by far the most physically rebellious agents against capitalists.

Becker's work on the *Masses, Liberator,* and *New Masses*
demonstrated his ability to mix art styles, and while he did not
go through artistic phases, he drew on a whole repertoire of
styles. Sometimes, as in "Absolute Justice" (Figure 56), his
lines were calligraphic. In "'They Ain't Our Equals Yet!'" where
facial expressions are not stereotypical, he relied on light and
shade, as did Sloan and Chamberlain. But Becker's drawings

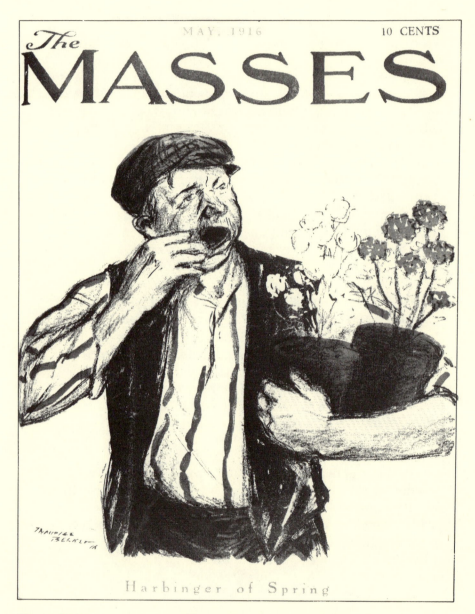

MAY, 1916 10 CENTS

The MASSES

Harbinger of Spring

Maurice Becker
Masses. May 1916. **Fig. 54. "Harbinger of Spring"**

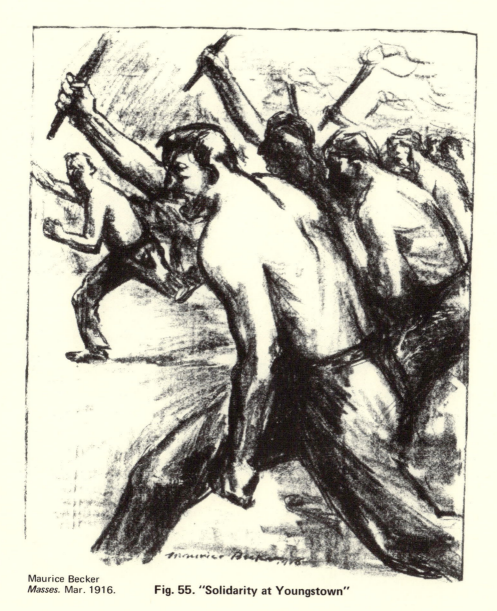

Maurice Becker
Masses. Mar. 1916. **Fig. 55. "Solidarity at Youngstown"**

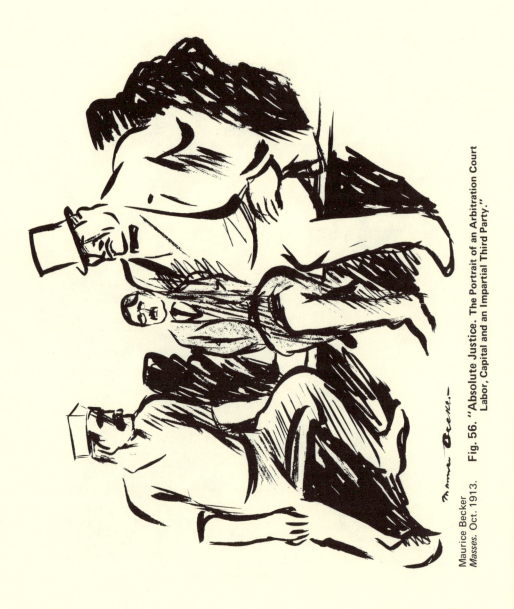

Maurice Becker
Masses. Oct. 1913.

Fig. 56. "Absolute Justice. The Portrait of an Arbitration Court
Labor, Capital and an Impartial Third Party."

often combined calligraphic elements with light and shade, and sometimes, like Chamberlain's, which have expressive crudity of materials, Becker's crayon strokes were sloppy in order to capture mood as a form of expressionism. Two elements, calligraphy and light and shade, create an impression; expressive crudity goes deeper. All three are combined in "Whom the Gods Would Destroy They First Make Mad." But in "Christmas Cheer" (Figure 57) there is no calligraphy.

Becker had a greater variety of styles than any other *Masses-Liberator* cartoonist. In "September 12—Morgan Uber Alles" (Figure 58) Becker, not trapped by American artistic traditions, adopted Cubism. Of all the *Masses* and *Liberator* artists, Becker most fully assimilated art trends. In "May Day Parade" (Figure 59), drawn at the age of forty-eight, Becker created fragile lines in the linear style of satirist George Grosz, who was popularized on the *Liberator* and *New Masses* by Adolph Dehn. Becker achieved this style as an eastern European Jew one generation out of Europe, who retained a great cultural affinity to modernism in art, a movement which originated in Europe. In his *Masses* work Becker merged the social satirist's caricature of individual facial expressions—development of psychological nuances—with the specifically political point made by the cartoonist. In short, Becker drew exploitive capitalists like Young, but drew them with expressive distortion and individualized, nonstereotyped faces like Sloan.

Becker thus offered more artistic resources and techniques than the other artists in this study, although he was not always able to achieve the same striking effects as Minor and Young. Becker's many resources were clearly the result of his work as a painter. The techniques common in Becker's drawings would probably not have been attempted by a cartoonist who did not paint. It is clear that John Sloan's graphics and canvasses were not much influenced by the many Post-Impressionist or modernist trends in art, while Becker's were. Some of the techniques common to Post-Impressionism were adopted by Becker. In his painting "Near Tehuantepec" (1923 and 1962), he utilized bright colors and planes and volumes—in this canvas, Cubist simplifications. While Sloan was not particularly experimental in his

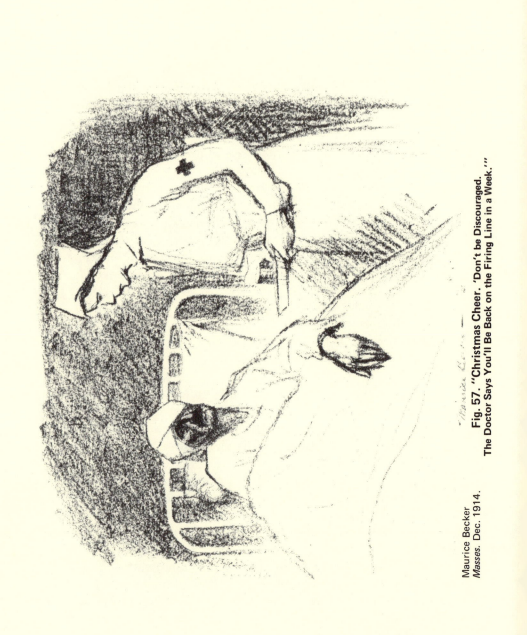

Maurice Becker
Masses. Dec. 1914.

Fig. 57. "Christmas Cheer. 'Don't be Discouraged. The Doctor Says You'll Be Back on the Firing Line in a Week.'"

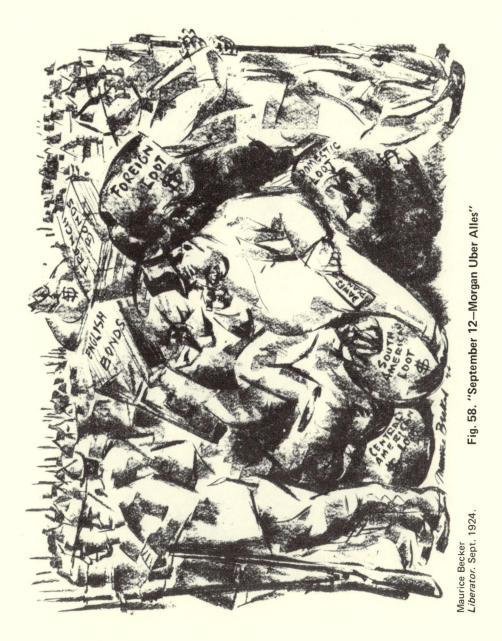

Maurice Becker
Liberator. Sept. 1924.

Fig. 58. "September 12—Morgan Uber Alles"

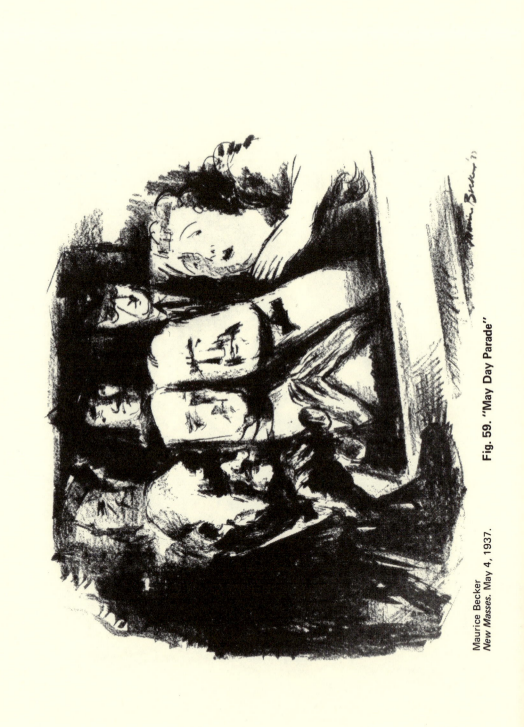

Maurice Becker
New Masses. May 4, 1937.

Fig. 59. "May Day Parade"

approach to art, Becker was continually trying new techniques. Much of his experimentation as a painter was reflected in his work as an illustrator and cartoonist.

But if Becker was richer in artistic resources than the other artists discussed, he was not as successful as Young and Minor in achieving his aims: this very richness made his works too complicated and too subtle for his audience. Becker seemed much more interested in artistic experimentation, in the problems of the artist per se, than the other artists, and almost accidentally he produced journalistic art. In a way, while his artistic interests were responsible for the best qualities in his work, they at the same time undermined his commercial success.

Becker was much more influenced by the modern works shown at the Armory Show in 1913 than John Sloan. Becker was a bright young man who wanted to escape the narrow, confined life of the ghetto, to come out and participate in new art trends, in the exciting events of the time, intellectually and esthetically. So Becker's mind seems to have been particularly open. He need not have developed an interest in modernism, but chose that option as a means of breaking out of his traditional culture.

Illustrating never interfered with Becker's painting. He exhibited at the Armory Show of 1913, had his first one-man show in 1916, and regularly exhibited well into the 1960s. His conception of political illustration was fraught with none of the qualms John Sloan faced in attempting to reconcile his painting with his cartooning. He made no distinction, as Sloan did, between political cartooning and humorous satires of actual incidents. Becker believed that good drawings and paintings deal with people, and that as a consequence the question of propaganda versus art is a false issue.

Having simultaneously cartooned and painted since he worked on the *Masses*, Becker faced the difficulty that every radical artist had to resolve: how to embody a positive socialist vision in art. While the positive vision failed Becker, the socialist critique of capitalist society occasionally carried over from his cartoons to his paintings. In 1932, he was "inspired by an utterance of Einstein's": "'If 2 percent of the conscripts in every country

said "NO" there would be no war.' Well who was I," he claimed,
"to dispute Einstein's calculation." Thus he painted "Tribute to
Einstein," shown at a 1932 mural exhibition at the Museum of
Modern Art in New York. This large painting, done in "uneasy
days all over the world," shows "the central figure, Einstein,
with his left hand resting on a globe, rais[ing] 2 fingers of his
right [hand] as he addresses a group of 4 military officers.
Behind him are a group of unclothed war-objectors. At Einstein's
left a Wall Street figure, somewhat distressed, pokes his head
into the composition." The exhibition was housed in the base-
ment of a temporary museum building, reached by descending
a rounded staircase. "Of course," added Becker, "the Rockefellers
would stick my anti-war painting under the staircase. But Orozco
. . . told me before he returned to Mexico 'Becker, yours is the
best work in the show.'"

Maurice Becker, painter and illustrator, merged art and politics
more fully and more successfully than any other *Masses-Liberator*
artist. Young and Minor were cartoonists, Sloan was almost a
pure illustrator, and Chamberlain tried to be both and failed to
be either. Becker's dominant style, expressive distortion, is within
the medium of art per se, yet he succeeded in using expressive
distortion to make a cartoonist's, as contrasted with a mere
illustrator's, point. For example, in "'Unlawful Assembly'" he
shows the true inner nature of the capitalist soul as he perceived
it. This explains how Becker kept his political commitment, yet
remained a true artist. He found a way of reconciling both his
particular form of art, expressive distortion, and his painting
resources with politics. In contrast, Sloan was limited by his
narrow style of street impressionism to illustrating satirical
incidents, and was therefore constantly forced to look to varied
settings for subject matter for his political sketches.

Though Becker was not as flashy a cartoonist as Minor and
Young, his contribution in the merging of artistic styles was
substantial. Through his use of expressive distortion, he was the
only *Masses* artist to integrate all the lessons of the Armory
Show with politics. The illustrator or social artist, such as Sloan,
catches the small effects, the social manners exposing the corrupt

nature of social relations. But the cartoonist or political artist, such as Young and Minor, captures the actions of the state and its relationships to social classes and groups—for instance, labor fighting the militia. Becker managed to combine both: essentially the social artist, he used his social critique for a political purpose. That is, like Young, Becker drew greedy magnates, but unlike Young, to whom facial expressions were unimportant, Becker developed facial expressions, psychological grimaces, and contortions, the emotional nuances which Sloan tried to catch as snapshots.

During Becker's *Masses* period, in the summer of 1916, friends lent him a shack in Tioga, Pennsylvania, where for two months he and his friend Mike Gold, future *Liberator* and *New Masses* editor, worked as section hands. In addition to working for the *Tribune* and *Harper's Weekly,* Becker found employment with the Scripps Newspaper Enterprise Association, where he was commissioned, among other duties, to the newly purchased Danish West Indies in 1917 as artist-correspondent. The result was a dozen drawings with commentaries.

In 1916 a double-page Becker cartoon, "President Wilson" (*Masses,* January 1916), was published by the pacifist organization, the American Union Against Militarism, and sent around the country.[9] Becker went to the Union's Fifth Avenue office to procure additional reprints and there met Dorothy Baldwin, whom he later married. Her father was a lawyer, and she, despite her quiet appearance, had been an active socialist and a Socialist party member at Vassar. "She was," recalled Becker, "one of several who gave anti-war talks when groups assembled in temporarily rented stores in N.Y.C. [New York City] and Brooklyn to pick up posters and literature."

When the United States intervened in the Great War, the *Masses* was, as Becker said, "singled out for trouble by the warmakers," and so was he. In 1918 Becker was "one of a mere 250 from all over the country who were conscientious objectors." Becker, who had been married only a short while, was sentenced to twenty-five years at hard labor in Fort Leavenworth Disciplinary Barracks because "I won't carry a gun to kill my fellow-

man." His statement before his court-martial at Camp Travis
in October 1918 best explains his political convictions. After
describing his early background and financial difficulties while
studying art, he explained that

> the question of bread finally asserted itself so forcefully that
> I was compelled to secure work at outdoor advertising. . . .
> Life at this time was very hard and I read and thought much about
> its problems. . . . Rockwell Kent, a painter, saw some of my
> drawings and told me of a magazine which he thought could
> use them. These sketches were some I had made while travelling
> in cars and subways in going about my advertising work. The
> magazine was "The Masses" . . . whose ideals were such that
> artists could express themselves in it unhampered by considera-
> tions which control commercial magazines. . . . Ever since I
> could reason and think I have had a horror of war. I do not
> believe it is right to kill a human being under any circumstances.
> . . . I do not belong to any religious sect or any church . . . but
> my own conscience leads me to this position. . . . Much of my
> artistic work and many of my sketches and cartoons done since
> the war began . . . bear me out in this statement.[10]

Becker went on to state that when war was declared he had
registered for the draft claiming exemption as a conscientious
objector, believing that by objecting he would receive noncom-
batant service. However, having noted the military's prosecution
and imprisonment of conscientious objectors and hoping the
United States policy toward conscientious objectors would
change as England's had, to allow them to perform nonmilitary
service, Becker departed for Mexico in November 1917. (Six
Masses editors and the business manager, but not Becker, were
indicted in October.)[11]

Becker intended to return for noncombatant service when
the country's policy changed. On reading President Wilson's
March 21, 1918, statement on conscientious objectors in the
Liberator (May 1918), which he interpreted as the government's
willingness to defer conscientious objectors from combat duty,
Becker returned and presented himself to his draft board. He
was arrested after crossing the border and imprisoned until
September 1918, when he began recruit training as a noncom-

batant. He was charged in October with desertion, however,
and sentenced to twenty-five years imprisonment.[12] At the Fort
Leavenworth Barracks, Becker joined the prisoners who went on
strike shouting "There ain't no more [war]."

It came as "the surprise of their lives" to the Beckers when
he was freed from prison in 1919, after serving only four months.
"President Wilson," Becker explained, "did not declare amnesty,
but it was the first time any of us heard of psychiatrists. Here
was a body of them in uniforms to study us and our individual
cases. They reduced all sentences—they ran from 10, 15 and 25
year terms and 5 years was made maximum." Only after their
release was it learned that Wilson had made a policy decision to
free all conscientious objectors from prison and to allow non-
combatant service for conscientious objectors in the military.[13]

Soon after departing Leavenworth, Becker received offers of
employment as cartoonist for two IWW newspapers in Chicago,
New Solidarity (1918-1920) and *New Majority* (1919-1924) and
for the Wobbly Kansas City paper, *Workers World* (1919).
"The aim of the I.W.W. of course was 'One Big Union.' Certainly
I was all for that." "Bill Haywood [head of the IWW] of course
knew my *'Masses'* work," so he returned "to cartooning again
until the Palmer raids [of January 1920] descended on us."
Becker said he "was forewarned, of course, and made for New
York," having worked only a few months "with those fine pro-
union people" and having had his plans for an evening class in
life drawing cut short by his abrupt departure. Though conflict
between left and right wing socialists, and later between socialists
and communists, was endemic, Becker, who simply opposed wars
and wanted power given to the toiling masses, stated laconically
that his "cartoons were published in the Socialist, I.W.W. and
Communist press."

After the Red Scare, Becker contributed to the *Liberator* from
1919 until its demise, though after 1921 he concentrated more
on painting, living in Mexico from 1921 to 1923, but sending
drawings, political cartoons, and local sketches to the *Liberator.*
In 1921 and 1922 Becker illustrated for "El Pulso de México,"
an English language business magazine owned by the wealthy

son of an American banker in Tampico. For the "Yucatan
Number" (April 1922) Becker covered the inauguration of the
governor of the state of Yucatan, Felipe Carrillo Puerto, a
socialist. "The recent Mexican revolution brought wonderful
people like Felipe into power." Becker wrote to the *Liberator*
about "gentle, sunny peaceful Zapataland" and his five-week
inaugural tour with Carrillo Puerto. "The people throughout
the state are henequen workers, and are solidly organized . . .
in fighting Socialist locals, where every man has, in addition
to his red card, a Mauser and a machete that he uses when the
bosses get too fresh." He was enthusiastic when land was con-
fiscated and redistributed. "They are going to do here all that
is possible to do now to make a real worker's republic. What
more can you ask of any one?"[14]

Did Maurice Becker the conscientious objector have difficulty
approving the revolutionary violence of the "Ligas de Resistencia"
in Mexico? Apparently not. Becker's feeling was that "countries
wishing to progress and shed the restrictions of the capitalist
system are bound to encounter other difficulties for a time." But
he would not personally, as a revolutionary, attempt to over-
throw capitalism by force. "This C. O. of World War I refused to
carry a gun to kill his fellow-man. This is still his religion."

Becker painted a great deal in Cuernavaca in 1922, exhibiting
with Rivera and Orozco at the San Carlos Academy. But in 1923
the Beckers returned to the Village. After 1924 and the end of
the *Liberator*, Becker cartooned less and was able to continue
painting because his wife Dorothy had steady employment with
the New York Welfare Department "even before the Depression
of 1929."[15]

Becker contributed cartoons during the 1920s and 1930s to
the *Daily Worker* and *New Masses*, and was on the *New Masses'*
original executive board. Though he had no quarrel with Max
Eastman as editor of the *Masses* and *Liberator*, it was too much
for Becker when Eastman became anticommunist in the 1930s.
"Quite often we find," Becker explained, "that people who
espouse a cause while it's on paper become critical when they
face the reality or desert and become reactionary as do the Max

Eastmans . . . those who continued with the *New Masses* were
not Eastmanites." Becker discontinued his friendship with
Eastman.

The crash and the depression, Becker felt, "only convinced"
the left of "the validity of their belief that the world rests on
the shoulders of the working class and [that] Big Biz to sustain
itself will make its biggest profits in war." Fortunately, during
the 1930s, a landlord friend let the Beckers live rent-free on
upper Broadway. In 1931 the Russian head of the Amtorg
Trading Corporation, the official USSR trade agency head-
quartered in New York, to whom Becker had recently sold some
works, invited him to visit Moscow. Becker went over with a
New York labor group and sold several cartoons to a Soviet
newspaper.

He was among the nearly fifty artists and writers who signed
a 1932 presidential campaign statement supporting the Com-
munist party candidates, William Z. Foster and James W. Ford.
The statement read in part that "the only effective way to
protest against the chaos . . . in the present economic system
is to vote for the Communist candidates." Becker was in the
Works Progress Administration (WPA) Artists' Union, and in 1935
signed the call in its magazine, *Art Front* (1934-1937), for an
American Artists' Congress. The call was to discuss the preserva-
tion of "our cultural heritage," warning that "the cultural crisis
is but a reflection of the world economic crisis." In 1936, at
the call of the Artists' Congress for an "Exhibition in Support of
Democracy in Spain" at the ACA Gallery to raise money for the
Spanish People's Front, Becker was among the 202 contributors.[16]

Becker's painting was unaffected by his WPA experience. He
continued painting his own way, while many artists, such as
Willem de Kooning and Jackson Pollock, from about 1936
reacted against Communist party influence on the WPA Art
Project by turning to "abstract expressionism" or "action painting"
in the 1940s.[17] Becker considered socialist realism neither good
nor bad, for "art which does not denigrate everyday people
might have been called Socialist realism in the 30's." The atroci-
ties of the Moscow trials of 1936 and 1937 did not shake

Becker's commitment: "Because a Stalin for a short while intruded as dictator[,] Russian Socialism was not destroyed."

In fact, Becker faced little conflict, at least consciously, between art and politics. He explained, "Since I am not an 'aloofer' my art never said 'To Hell with Man.'" "So Man and Nature always had priority as subject matter and even when I experimented with Cubism the 2 subjects were never subjugated to the style." That is,

> despite the cubistic patterning, figures were never subordinated or obliterated. . . . When I say subordinating to style I think of a work like [Duchamp's] "Nude Descending the Stairs" ["Nude Descending a Staircase"] where the figure is practically obliterated by the maze of fractions and cubes. Man and Nature may find a place in a cartoon but that doesn't mean that by painting Man and Nature the result is a cartoon.

Becker's "short experience in Wall Street early in life only confirmed [his] belief that one who loves to paint everyday people and who has ability as [a] cartoonist should speak up for them in his cartoons." This is Becker's simple but perpetual theme, a theme reiterated in his statement for the catalogue of the fiftieth anniversary of the Armory Show. After referring to the "Eight" of the 1913 show as "these strong individualists," "the rebels acquainting us with non-academic work," he pointed out that in the Armory Show,

> whatever influences prevailed, the modernists . . . were linked to Man and Nature and in these found their inspiration. However, as we approached the boundaries of the Nuclear Age it became fashionable and profitable to produce canvases that shouted "to hell with man." . . . Still, man as subject matter is not forever banished, as an apologetic minority of these artists permit a few lines called "figurative" to intrude in their "free work." I wonder whether fifty years hence we will witness an exhibition honoring "Ninguna de Nada" [Nothing from Nothing]?[18]

From 1935 to 1939 and from 1941 to 1945 the Communist party advocated violent resistance to fascism. But Becker, whose last *New Masses* drawing was "Where Planes Accumulate and Men

Decay" (February 18, 1941), was a consistent pacifist.[19] Although
a Jew, he did not draw pro-intervention cartoons; of World War II
he said, "I have no sympathy for those who engineer wars and
give them appealing names only to slaughter and make fortunes,
and will never call such atrocities by the label 'Patriotism.'"

Becker thus considered all international wars, as opposed to
civil wars of national liberation, the result of market competition.
His socialist precepts having remained unchanged since youth,
Becker insisted that the agency of social change was the prole-
tariat. He was critical of anarchists and direct violence until
(quoting with approval a *Worker* article criticizing the anarchist
Peter Kropotkin) "the ultimate social revolution when force may
be unavoidable."[20] Becker admitted that the American working
class had been opportunistic, but he continued to have faith in
their revolutionary role. He conceded "difficulties that face the
Working Class in today's world" (1968), but "violent resistance"
would compound them. As for the failure of American socialist
artists to develop a viable Marxist culture in the United States,
Becker, who never engaged in editorial bickering while contribut-
ing to socialist publications, attributed weaknesses in the socialist
esthetic not to internal flaws but to external government repres-
sion: "Haven't you heard of H.U.A.C. [House Un-American
Activities Committee]?" What the United States presently
needed, in Becker's estimation, "more than it did in 1918-19
and the 20's [was] a *Liberator* magazine with a Max Eastman of
those days and that group of Contributing Editors."

In recent correspondence with the author, Becker reminisced
fondly in retirement at Tioga, particularly of his Mexican
experience. He quoted *El Pulso de México* (April 1922) that his
Mexican illustrations caught "the tang of the country, rich with
that much talked of but rarely captured virtue called 'local color,'"
exclaiming "Gosh, it's wonderful to recall those 'Good Old
Days!'" Becker spoke concisely of his experiences in Mexico;
all the same, it seems that his years in Mexico, traveling, painting,
and illustrating in what then seemed a promising socialist state,
were the happiest days of his life and that he wanted nothing
more but to continue in this role.

Why did Becker remain steadfast and unchanging in both his art and radicalism? Becker was always more than an avant-gardist cultural radical, who, as a group, tended to be socialist only while the movement was ideologically loose and popular and identified with new art trends. Culturally, Becker is between the traditional Russian ghetto and Greenwich Village. He did not merely rebel esthetically against American middle class mores, as did Sloan and Chamberlain, because he was not a product of American culture. But it can be said that Becker, as a member of a traditional ethnic community who was drawn to the fringes of intellectual life, revolted against traditional ethnic group life. In doing so he also adopted some libertarian ideas. If he did not become a bohemian, he certainly associated himself with bohemian revolt. It is interesting that he was influenced both by Debs and the Armory Show. Becker, the son of working class Jews, identified with Debs; Becker the artist assimilated the Armory Show. In both cases it was Becker the Jew in revolt against the stultifying effects of orthodox Jewish community life. Thus, Maurice Becker remained a political socialist and artist in his own right, whereas Robert Minor, in refusing to compromise with the art market, eventually felt it necessary to give up art for a totally political role in the Communist party.

Of course, Becker faced the demands of the art market. Though in his summary way Becker spoke little of his work for the *New York Tribune* and *Harper's Weekly,* it is clear that in order to survive he had to do work he disliked. When he attacked the *Metropolitan*'s art editor, Will Bradley, at Mabel Dodge Luhan's salon, he rhetorically asked Bradley "Have you any idea *at all* what *we* think of your 'pretty girl' [covers] and how we loathe ourselves for selling drawings to go inside your covers? My God!"[21] But this outburst was exceptional. After he got married in 1918, his wife's employment alleviated the economic problem, so that he was free to paint as he liked and continue to contribute cartoons, without pay, to socialist and communist publications. To Becker, it did not have to be a question of choosing "between the 'art market' and doing cartoons for *The Masses.* . . . Both are undependable if you desire a steady income."

That he rarely perceived conflict between the demands of the market and his political sensibilities does not mean that the dilemma was nonexistent. Living in a kind of nether world, seldom consciously working out his deeply held convictions at length, Becker simply refused to admit the conflict.

NOTES

1. This chapter is based on correspondence with Maurice Becker on January 2, 1968, January 17, 1968, January 24, 1968, January 26, 1968, February 7, 1968, February 16, 1968, March 20, 1968, June 17, 1968, July 2, 1968, July 3, 1968, July 19, 1968, July 23, 1968, July 31, 1968, October 20, 1969, October 27, 1969, February 23, 1971, March 27, 1971; and an interview on May 1, 1971. "In the Czar's army any Jew who served 25 years was permitted to settle in any part of Russia he preferred. My grandfather did, so he took his family out of the remote southern settlement and moved to the much more desireable Nijni Novgorod on the Volga River."

2. Moses Rischin, *The Promised City: New York's Jews, 1870-1914* (New York: Harper & Row, Publishers, 1970), pp. 55, 162-168, 224-228. Melech Epstein, *Jewish Labor in U.S.A.: An Industrial, Political and Cultural History of the Jewish Labor Movement,* vol. 1 (New York: Trade Union Sponsoring Committee, 1950), pp. 168-297. Hutchins Hapgood, *The Spirit of the Ghetto: Studies of the Jewish Quarter in New York* (New York: Funk & Wagnalls Company, 1902), pp. 18, 33-34.

3. Untermeyer, *World*, p. 44.

4. David Riesman et al., *The Lonely Crowd: A Study of the Changing American Character* (New Haven: Yale University Press, 1950).

5. Luhan, *Shakers*, pp. 85-86. [Italics in original.]

6. Ibid., pp. 86-87.

7. J. H. Adeney, *The Jews of Eastern Europe* (New York: Macmillan, 1921), pp. 48-55. S. M. Dubnow, *History of the Jews in Russia and Poland: From the Earliest Times Until the Present Day,* vols. 1 and 2 (Philadelphia: Jewish Publication Society of America, 1916 and 1918), pp. 111-113, 379-380. Rischin, *Promised*, pp. 34-38. Louis Greenberg, *The Jews in Russia*, vol. 1 (New Haven: Yale University Press, 1944), pp. 188-189. Francis H. E. Palmer, *Russian Life in Town and Country* (London: G. P. Putnam's Sons, 1901), pp. 127-128.

8. Greenberg, *Jews*, vol. 1, pp. 12-28, 101-129. Jacob S. Raisin, *The*

Haskalah Movement in Russia (Philadelphia: Jewish Publication Society of America, 1913), pp. 110-303.

9. The American Union Against Militarism changed the title to "Do You Want to Buy a War?" and replaced "Morgan, Schwab & Co.," with "The Men Behind the Guns."

10. "Statement of Maurice Becker before Court Martial at Camp Travis," October 18, 1918, Amos Pinchot Papers.

11. Ibid.

12. Ibid. Becker drew two April 1919 *Liberator* illustrations based on his prison experience: "The Ft. Leavenworth Soviet" and "Psychological Test in Ft. Leavenworth."

13. Dorothy Baldwin Becker wrote Amos Pinchot, noting Maurice Becker's twenty-five year hard labor sentence at Fort Leavenworth, and requesting Pinchot to ask Frank P. Walsh, co-chairman of the National War Labor Board, to intercede with Secretary of War Newton D. Baker to "get him out," November 28, 1918, Amos Pinchot Papers.

14. Maurice Becker, "A Letter from Mexico," *Liberator* 5 (April 1922): 12.

15. "Maurice Becker Watercolors," catalog to exhibition, Art of Today Gallery (New York, 1955). *Who's Who in American Art, 1970*, vol. 24 (New York: R. R. Bowker, 1970), p. 26. Becker was never able to live from the sale of his paintings.

16. Egbert, *Socialism*, p. 100. "Call for an American Artists' Congress," *Art Front* 1 (November 1935): 6. Among the signers were *Masses* and/or *Liberator* illustrators Peggy Bacon, Stuart Davis, Adolph Dehn, Hugo Gellert, Lydia Gibson, H. J. Glintenkamp, William Gropper, Louis Lozowick, Boardman Robinson, and Art Young. Herman Baron, "Exhibition in Support of Democracy in Spain," *Art Front* 2 (November 1936): 14.

17. Harold Anton, head of Artists' Union Grievance Committee, 1936-1938, to author, August 1, 1968. Interview with Harold Anton, December 23, 1970. Harold Rosenberg, "From Pollock to Pop: Twenty Years of Painting and Sculpture," *Holiday* 39 (March 1966): 99; Harold Rosenberg, "The Search for Jackson Pollock," *Art News* 59 (February 1961): 58.

18. "Armory Show 50th Anniversary Exhibition, 1913-1963," catalogue, Henry Street Settlement and Munson-Williams-Proctor Institute (New York and Utica, 1963), p. 96.

19. Becker drew a few cartoons for *Masses and Mainstream* and for *Mainstream*, his last in July 1961.

20. William Weinstone, "The National Guardian and the Anarchist Peter Kropotkin," *Worker*, January 14, 1968, p. 8.

21. Luhan, *Shakers*, p. 87. [Italics in original.]

Epilogue

As artists producing for a mass audience, Art Young, Robert Minor, John Sloan, K. R. Chamberlain, and Maurice Becker had to relate to the structure of the art market and to the work process in that market as affected by modes of production. Before the printed medium or the manufacture of mass-circulation newspapers and magazines, art production was analogous to a "cottage industry" or craft. It was a craft in the sense that the artists produced the commodity (their art), which they sold to a middle man, who in turn sold to the market. Thus, they were not only producers but they were involved in the marketing process, and to this degree they were small business-men. Marketing was frequently controlled by middlemen—agents and dealers. This remained true of painting.

With the development of the newsprint medium, illustrators disliked the manufacturing method and especially the hurried tempo of production. The salaried illustrators produced and created their art, but were not involved in the marketing process. Their art was mass-duplicated by the publications. Rather suddenly they became proletarianized, if not in ideology, then in fact. This proletarianization extended to the free lancers, who did piece work, and like the salaried illustrators they did it the way the publisher or editor wanted it. They had to alienate their skills as artists to an employer for a salary or wage. The free lancers got piece rates, the others a regular salary.

225

Each of the five illustrators discussed had to adjust to the new
method. Each also wrestled, in varying degrees, with his desire
to create art in accordance with the feelings and aspirations of
his audience, and in opposition to what the editors wanted. And
so the dimensions of the illustrator's art market were profoundly
shaped by the development of the printed medium.

Artists, not all of whom were socialists, were drawn to the
Masses and *Liberator* or to some form of social radicalism because
of their artistic revolt against academic art and their support of
some form of modernism in art. For this reason the two maga-
zines provided a vehicle of expression. Conservative art was
identified with capitalism, and since the artists had "come to
believe that most American art ha[d] lost touch with the everyday
realities of American life," the traditional strain of Marxist
thought, with its emphasis on the common people as subject
matter and on personal liberty as the outcome of the class
struggle, appealed more strongly to most socialist artists (except
the mature Robert Minor) than its "scientific" methodology.
Thus the *Masses* and *Liberator* attracted artists with

> strong equalitarian, humanitarian, or collectivistic inclinations
> . . . which have made them sympathetic to some aspects of
> Marxism. . . . Many have been artists stirred to social protest
> against capitalism partly, at least, by their first-hand knowledge
> of the difficulties and injustices which beset the artist within a
> business and industrial civilization.[1]

Every artist had to face the reality of a "business and industrial
civilization," specifically the art market. The rebellion of the
Masses and *Liberator* artists was derived from and impelled by
the same social conditions facing all graphic artists in the United
States. Each illustrator was forced to recognize the limited social
role or avenue for expression provided the artist in America. The
magazine and newspaper illustrator's market was dominated by
publishers and editors who dictated the style of illustrations and
could fire the artist at will.

The graphic artist faced the hard choices of supporting the
existing structure of society by promoting conventional art and

politics; of revolting personally, like Gauguin, who escaped to the South Seas and into allusive symbolism; or of revolting socially with canvas social art or radical illustration. A few artists, such as Ben Shahn and Philip Evergood, attempted social painting, often aided in their endeavor by WPA funds, but most survived by having their wives work, taking various jobs themselves (Sloan, to paint as he wished, taught many years at the New York Art Student's League), and by selling occasional paintings. *Masses* and *Liberator* illustrators received no compensation for contributions, partly because the magazines had limited circulation and always had difficulties meeting regular deficits.

Though institutional support for social art was and remains common in socialist countries, in the United States it was generally limited to the federal government's WPA and Treasury Department programs (1935-1943), or to support through the publications of pressure groups and political parties, such as the National Association of Manufacturers' *Industrial Press Service* and the Communist party's *New Masses.* The high artistic quality of the privately owned *Masses* and *Liberator* relative to the lower esthetic caliber of the *New Masses* suggests that the best socialist art emanates from journals independent of party control.

Thus, the significance of the *Masses* is not only that it introduced "an art of social satire" produced by many of our most talented artists, but that it encouraged a spirit of "critical realism" which simply could not flourish elsewhere. This "critically outspoken art" of the *Masses* was to become the socialist realism of the 1930s.[2]

Within the American context each artist faced three problems: being an artist; selling his art on the market; and being a political being. How were all three to be solved simultaneously? None could escape the dilemma. The art market presented limited options for such artists. Most, but not all, were from poor families and worked at odd jobs while attending art school. Instead of graduating as academy stars with careers as portrait painters for wealthy patrons, most worked at newspaper and magazine illustration for established periodicals. They were in effect hired hands. Some made a little money on the side drawing

newspaper puzzles, painting signs, and selling a few paintings or
etchings. None earned much, and of course none expected pay
for contributions to the *Masses* and *Liberator.* Usually they
were not reimbursed for work submitted to other socialist
publications, such as the *Call.*

In response to their economic insecurity, restrictions on
artistic freedom, and the avant-garde graphics in the *Masses,*
they were drawn to socialism. For a time these artists saw
politics as a substitute for market art. But it was not a substitute,
and with time the cooperative commonwealth, which would
provide for each according to his needs, seemed as distant as ever.

A bohemian opposition to conventional art and their experience
in the art market compelled the rebellious artists to form a
peculiarly artistic conception of socialism. As artists, *Masses* and
Liberator cartoonists had nowhere to go in society. All but Minor
and Becker wanted as the goal of their socialist vision minimal
welfare for all and freedom to do their work. "Most of all they
wanted freedom: free verse, free art, free love, free milk for
babies." Forging socialism was to them, as Waldo Frank told the
first American Writers' Congress in 1935, primarily a cultural,
not an economic problem: "the cause of the socialist society is
not, finally, a political-economic problem: it is a cultural
problem."[3]

The decay of the old Village, World War I, and the Bolshevik
Revolution ended the best fusion of the strongest tendencies
within Bohemia and socialism that had marked the *Masses.* The
Liberator carried over much of the same spirit, but not enough
to set the overall tone and style of the magazine as had the
Masses. Frederick Hoffman considers the years 1904-1917 a
"progressive" period of radical exposure with varying degrees of
ire; 1917-1930 an "aggressive" period with issues sharply
delineated, Marxist commentators devising principles and
venturing all-out assaults on capitalism; the 1930s an "active"
period with socialist concepts assumed by intellectuals and
advocated in preference to capitalist ideas. Put in other terms,
the *Masses* was more definitely artistic than the *Liberator* and
the *New Masses.* It stressed politics but could not synthesize

art and politics. It focused on war, poverty, and other interests
of socialists and communists but not on the essence of Marxism.
The *Liberator* on·the other hand concentrated on the develop-
ment of communist ideology, with an American flavor, and
from its inception it paraphrased Marx's and Lenin's writings.
Following the Russian Revolution, *Liberator* associate editor
Floyd Dell said: "There was true revolutionary leadership now
in the world—if we could only understand it. . . . Socialism that
meant what it said, took back its old name—Communism."
Nevertheless, since artists on the *Liberator* were faced with the
example of socialist Russia, the tensions between artistic
sensibility and social reconstruction were far greater than on
the *Masses.* As John Reed, back from the Soviet Union, said
when Eastman asked how his political work was going, "It's
all right. . . . It's going all right. . . . You know this class
struggle plays hell with your poetry!"[4]

By 1918 when the Russian Revolution seemed to prove "the
workability of the political tenets of Communism," the tension
between artistic and political outlooks, always present in the
Masses, sharpened into intense conflict. The *Liberator* "show[ed]
a more specific interest in the actual problems of American
communism" than the *Masses,* its policies coming close to the
aims of the Communist movement of the early twenties. There
was conflict at *Masses* and *Liberator* editorial meetings over
art versus propaganda, but on the *Liberator,* recalled Art Young,
"as the echoes of the war receded and the splits in the radical
movement grew wider, battles in editorial conferences more
often centered upon the matter of tactics to forward the cause
of social revolution throughout the world."[5]

Daniel Aaron claimed that by the end of 1922 "the rebel
could no longer encompass all varieties of intransigence";
he had to choose between his "personal compulsions or serving
'the party of humanity.'" The *Liberator*'s radical artists made
their decision early in the 1920s. Joseph Freeman's notebook at
the time concluded that "if one wishes to voice his private
opinions all the time . . . even after a majority has adopted a
policy, one should stay out of politics." Eastman had appointed

Mike Gold and Claude McKay joint executive editors of the
Liberator in March 1921. By the fall of 1922 the *Liberator* was
"beginning to lose its momentum and to reflect the uncertainties
and divisions in the minds of its editors," and in the minds of
American intellectuals in general, over the imminence of world-
wide socialism and the old question of art versus propaganda.[6]

Gold and McKay, for example, quarreled violently over
standards of proletarian art. In a sense the fight over politics
and esthetics was resolved in favor of politics when in October
1922 the *Liberator* staff voted to turn the magazine over to the
Workers party, and the journal, under Robert Minor and Joseph
Freeman, moved to party headquarters, out of the Village, to
East 11th Street, a neighborhood of unionized workers. This
change, Freeman felt, was "a turning point of the utmost
importance in the history of the radical and liberal writer in
America." For the first time a socialist journal of art and politics
was owned and run by a party, not by the artists; a party pledged
to the International.[7]

In 1936 Freeman wrote that when the *Liberator* was taken
over by the Workers party "we felt that one period in American
radical literature had closed, and another had opened. The
Masses and *Liberator* as we had known it since 1913 had died."
In one sense he was correct. The party now controlled editorial
policy through the *Liberator*'s political editors. Art, considered
less important, was left to the art editors, mostly the old *Masses*
and *Liberator* group. Beginning with the December 1922 issue,
executive editors Minor and Freeman "combined politics and
poetry in one publication *mechanically* while separating them
functionally." The artists went off in one direction, the
revolutionaries in another. Now both, as *Liberator* poet Genevieve
Taggard recalled, were suspicious of each other.[8]

The present generation's interest in the *Masses* can be
attributed to its awareness that the problems and the solutions
of today are the same as in the 1910s and 1920s. But the Com-
munist party left of the 1930s which controlled the *New
Masses* failed so miserably to deal with these questions that
students of radicalism must turn to the decades before the

crash for solutions. The solutions are not evident. Compared
with the intense singlemindedness of the *New Masses'* attacks
on the established social-economic system, the *Masses'* ideology,
insofar as it had any, was uncalcified, much of it late muck-
raking in the reform tradition, much of it bohemian-libertarian
flaunts. Some saw the *Masses* as too individualistic, so egotistic
that, by tacit comparison with the *Liberator* and *New Masses,* it
"consistently lacked an objective revolutionary quality."[9]

The *Liberator* showed less concern, and the *New Masses* almost
none, with the libertarian issues which the *Masses* devoted great
attention to, such as prostitution and censorship. The *Masses*
even parodied the socialist movement's foibles as well as the
very class struggle. This indicated an outlook at least capable of
self-criticism. There was little of this in the *Liberator,* and under
the canons of socialist realism the *New Masses* criticized neither
the communist movement nor what was conceived of as the
proletariat or "the working people." The *New Masses* developed
a political line tied so closely to the Communist party that its
illustrations attacked President Roosevelt one month and praised
him the next. If Maurice Becker's "Solidarity at Youngstown"
personified the spontaneous worker of the 1910s, William
Gropper's cover drawing (Figure 60) depicted, "with simply an
overpowering, unsubtle grossness," the stylized wooden
proletarian of 1930s left cartooning. There was competent
illustration in the *New Masses,* but in general, especially as the
thirties wore on, the *"New Masses* said essentially the same
things it had been saying since 1926, about the links between
capital, religion, and politics."[10]

Many *Masses* and *Liberator* illustrators drifted from radicalism
in the 1920s. Such transience was due partly to continual
factional splitting among socialist and communist groups in the
twenties, the lack of party leadership concern with the artist
per se, and Marx's and Lenin's (not Trotsky's) interest in, but
failure to develop, a Marxist esthetic.[11] An equally important
cause of their transience was the tendency among American
radical artists to evaluate socialism and Marxist parties
culturally but not socially and politically.

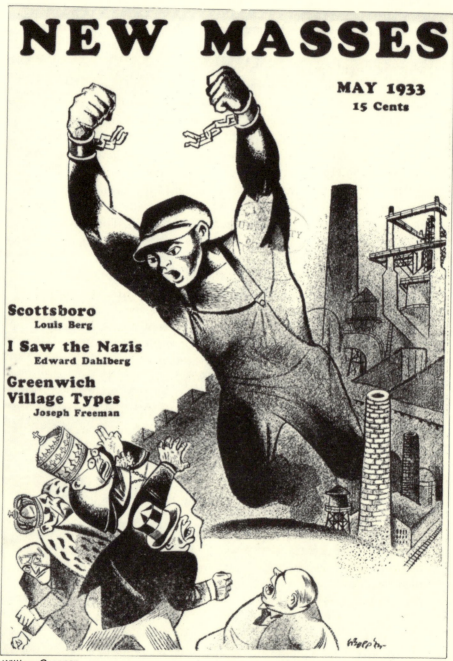

William Gropper
New Masses. May 1933. **Fig. 60**

On the other hand, there is little evidence that either the Socialist or Communist party made serious efforts to bring radical artists into the movement. This was a weakness of American radicalism. Socialist friends told Becker, Chamberlain, Minor, Sloan, and Young to produce drawings and to come to parties and lectures, but never approached them with a Marxist conception of what socialist painting and illustration should be. Obviously, a simple form of socialist realism would not work. The theory would somehow have to take these artists from jibes against capitalist foibles to a deeper and more lasting level of analysis. The problem is very deep and rarely satisfactorily solved.

NOTES

1. Egbert, *Socialism*, pp. 95, 97, 109.

2. Brown, *Painting*, pp. 32, 190. Theodore Draper wrote as follows: "A list of the *Masses* contributors reads like a Who's Who of artistic and literary America for the next two or more decades" (*Roots*, p. 49).

3. William L. O'Neill, ed., *Echoes*, p. 19. Waldo Frank, "Values of the Revolutionary Writer," in *American Writers' Congress*, ed. Henry Hart (New York: International Publishers, 1935), p. 71.

4. Hoffman, *Magazine*, pp. 30, 149-150. Dell, *Homecoming*, p. 310. Max Eastman, *Heroes I Have Known: Twelve Who Lived Great Lives* (New York: Simon & Schuster, 1942), p. 223.

5. Hoffman, *Magazine*, pp. 152, 254. Young, *Young*, p. 386.

6. Quotes from Aaron, *Writers*, pp. 91, 93, 95, note. Freeman, *Testament*, p. 308.

7. Claude McKay, *A Long Way from Home* (New York: L. Furman, 1937), pp. 138-140. Eastman, *Love*, pp. 269-270. Quoted in Aaron, *Writers*, p. 96.

8. Freeman, *Testament*, p. 310. Genevieve Taggard, ed., *May Days: An Anthology of Verse from Masses-Liberator* (New York: Boni & Liveright, 1925), p. 13.

9. Hutchins Hapgood, *A Victorian in the Modern World* (New York: Harcourt, Brace and Company, 1939), p. 313.

10. Quote 1 from Gahn, "Gropper," p. 185. Quote 2 from Don Hausdorff, "Magazine Humor and the Depression Years," *New York Folklore Quarterly* 20 (September 1964): 211.

11. Both Marx and Lenin were interested in esthetics. Marx wrote
poetry in his youth, read both the Greek tragedies and Shakespeare, and
modeled his writing on them. He planned (but never wrote) a long book on
Balzac as the nineteenth century's greatest social analyst. Isaiah Berlin,
Karl Marx: His Life and Environment, 2d ed. with corrections (London:
Oxford University Press, 1960), pp. 269-270. Lenin, who was moved by
Beethoven, wrote a pamphlet on Tolstoy in which he praised Tolstoy for
capturing all the conflicts and contradictions in Russian civilization, in
spite of the fact that he did not solely represent the working class.
Vladimir Ilich Lenin, *Articles on Tolstoy* (Moscow: Foreign Languages
Pub. House, 1951). Through praise of Balzac and Tolstoy, the esthetic
hinted at but not developed by either Marx or Lenin seems to be com-
mitted to the accurate portrayal of social tensions and conflicts. But
the theory is not socialist realism.

Bibliography

BOOKS

Aaron, Daniel. *Writers on the Left: Episodes in American Literary Communism.* New York, 1961.

Adeney, J. H. *The Jews of Eastern Europe.* New York, 1921.

Adoratsky, V. *Dialectical Materialism: The Theoretical Foundation of Marxism-Leninism.* New York, 1934.

Berlin, Isaiah. *Karl Marx: His Life and Environment.* 2d ed. with corrections. London, 1960.

Brooks, Van Wyck. *John Sloan: A Painter's Life.* New York, 1955.

Brown, Milton W. *American Painting: From the Armory Show to the Depression.* Princeton, 1955.

——. *The Story of the Armory Show.* Greenwich, Conn., 1963.

Chamberlain, John. *Farewell to Reform: The Rise, Life and Decay of the Progressive Mind in America.* 2d ed. Chicago, 1965.

Christ-Janer, Albert. *Boardman Robinson.* Chicago, 1946.

David, Henry. *The History of the Haymarket Affair: A Study in the American Social-Revolutionary and Labor Movements.* 2d ed. New York, 1958.

Dell, Floyd. *Homecoming: An Autobiography.* New York, 1933.

——. *Intellectual Vagabondage: An Apology for the Intelligentsia.* New York, 1926.

Draper, Theodore. *American Communism and Soviet Russia: The Formative Period.* New York, 1963.

——. *The Roots of American Communism.* New York, 1963.

Drinnon, Richard. *Rebel in Paradise: A Biography of Emma Goldman.* Chicago, 1961.

Dubnow, S. M. *History of the Jews in Russia and Poland: From the Earliest Times Until the Present Day.* 3 vols. Philadelphia, 1916, 1918, 1920.

duBois, Guy Pène. *John Sloan.* New York, 1931.

Dulles, Foster Rhea. *Labor in America: A History.* 3d ed. New York, 1966.

Eastman, Max. *Enjoyment of Living.* New York, 1948.

———. *Heroes I Have Known: Twelve Who Lived Great Lives.* New York, 1942.

———. *Love and Revolution: My Journey through an Epoch.* New York, 1964.

———. *Marxism: Is It Science?* New York, 1940.

———. *Reflections on the Failure of Socialism.* New York, 1962.

———. *Stalin's Russia and the Crisis in Socialism.* New York, 1940.

Egbert, Donald Drew. *Socialism and American Art: In the Light of European Utopianism, Marxism, and Anarchism.* Princeton, 1967.

Epstein, Melech. *The Jew and Communism: The Story of Early Communist Victories and Ultimate Defeats in the Jewish Community, U. S. A., 1919-1941.* New York, 1959.

———. *Jewish Labor in U. S. A.: An Industrial, Political and Cultural History of the Jewish Labor Movement.* 2 vols. New York, 1950, 1953.

Frank, Waldo. "Values of the Revolutionary Writer." In *American Writers' Congress.* Ed. Henry Hart. New York, 1935, pp. 71-78.

Freeman, Joseph. *An American Testament: A Narrative of Rebels and Romantics.* New York, 1936.

Gilbert, James Burkhart. *Writers and Partisans: A History of Literary Radicalism in America.* New York, 1968.

Gitlow, Benjamin. *I Confess: The Truth about American Communism.* New York, 1940.

Glackens, Ira. *William Glackens and the Ashcan Group: The Emergence of Realism in American Art.* New York, 1957.

Goldman, Emma. *Living My Life.* One vol. ed. New York, 1934.

Goldwater, Walter. *Radical Periodicals in America, 1890-1950.* 2d ed. New Haven, 1966.

Goodrich, Lloyd. *John Sloan: 1871-1951.* New York, 1952.

Greenberg, Louis. *The Jews in Russia.* 2 vols. New Haven, 1944, 1951.

Hapgood, Hutchins. *The Spirit of the Ghetto: Studies of the Jewish Quarter in New York.* New York, 1902.

———. *A Victorian in the Modern World.* New York, 1939.

Hoffman, Frederick J. *The Twenties: American Writing in the Postwar Decade.* Rev. ed. New York, 1965.

———, et al. *The Little Magazine: A History and Bibliography.* Princeton, 1946.

Homer, William Innes. *Robert Henri and His Circle.* Ithaca, 1969.

Howe, Irving and Lewis Coser. *The American Communist Party: A Critical History, 1919-1957.* New York, 1962.

Hunter, Sam. *Modern American Painting and Sculpture.* New York, 1959.

Keller, Morton. *The Art and Politics of Thomas Nast.* New York, 1968.

Kirkpatrick, George R. *War—What For?* West LaFayette, Ohio, 1910.

LaFollette, Belle Case and Fola LaFollette. *Robert M. LaFollette.* 2 vols. New York, 1953.

Larkin, Oliver W. *Art and Life in America.* Rev. ed. New York, 1960.

Lasch, Christopher. *The American Liberals and the Russian Revolution.* New York, 1962.

————. *The New Radicalism in America, 1889-1963: The Intellectual as a Social Type.* New York, 1965.

Lenin, Vladimir Ilich. *Articles on Tolstoy.* Moscow, 1951.

Luhan, Mabel Dodge. *Movers and Shakers.* Vol. III. *Intimate Memories.* New York, 1936.

Marcuse, Herbert. *One-Dimensional Man: Studies in the Ideology of Advanced Industrial Society.* Boston, 1964.

McKay, Claude. *A Long Way from Home.* New York, 1937.

Morel, Jean-Pierre. "A 'Revolutionary' Poetics?" In *Yale French Studies.* Edited by Jacques Ehrmann. Vol. XXXIX. New Haven, 1967, pp. 160-179.

Morgan, Charles H. *George Bellows: Painter of America.* New York, 1965.

Mott, Frank Luther. *American Journalism: A History, 1690-1960.* 3d ed. New York, 1962.

————. *A History of American Magazines.* 5 vols. Cambridge, Mass., 1930, 1938, 1948, 1957, 1968.

Myers, Jerome. *Artist in Manhattan.* New York, 1940.

Nelson, Steve. *The Volunteers: A Personal Narrative of the Fight Against Fascism in Spain.* New York, 1953.

North, Joseph. *Robert Minor: Artist and Crusader.* New York, 1956.

O'Neill, William L., ed. *Echoes of Revolt: "The Masses," 1911-1917.* Chicago, 1966.

Palmer, Francis, H. E. *Russian Life in Town and Country.* London, 1901.

Perlman, Bennard B. *The Immortal Fight: American Painting from Eakins to the Armory Show, 1870-1913.* New York, 1962.

Raisin, Jacob S. *The Haskalah Movement in Russia.* Philadelphia, 1913.

Riesman, David, et al. *The Lonely Crowd: A Study of the Changing American Character.* New Haven, 1950.

Rischin, Moses. *The Promised City: New York's Jews, 1870-1914.* New York, 1970.

St. John, Bruce. *John Sloan.* New York, 1971.

Samson, Leon. *Toward a United Front: A Philosophy for American Workers.* New York, 1933.

Shannon, David A. *The Socialist Party of America: A History.* Chicago, 1967.

Sloan, John. *Gist of Art: Principles and Practise Expounded in the Classroom and Studio.* New York, 1939.

——. *John Sloan.* New York, 1925.

——. *John Sloan's New York Scene: From the Diaries, Notes and Correspondence, 1906-1913.* New York, 1965.

Symes, Lillian and Travers Clement. *Rebel America: The Story of Social Revolt in the United States.* New York, 1934.

Taggard, Genevieve, ed. *May Days: An Anthology of Verse from "Masses-Liberator."* New York, 1925.

Untermeyer, Louis. *From Another World: The Autobiography of Louis Untermeyer.* New York, 1939.

Vorse, Mary Heaton. *A Footnote to Folly: Reminiscences of Mary Heaton Vorse.* New York, 1935.

Ware, Caroline F. *Greenwich Village, 1920-1930.* Boston, 1935.

Weinstein, James. *The Decline of Socialism in America, 1912-1925.* New York, 1967.

Who's Who in American Art, 1970. Vol. 24. New York, 1970.

Wilson, Edmund. *The Shores of Light: A Literary Chronicle of the Twenties and Thirties.* New York, 1952.

Young, Art. *Art Young: His Life and Times.* New York, 1939.

——. *Art Young's Inferno: A Journey through Hell Six Hundred Years after Dante.* New York, 1934.

——. *Hell up to Date: The Reckless Journey of R. Palasco Drant, Newspaper Correspondent, Through the Infernal Regions, as Reported by Himself.* Chicago, 1893.

——. *On My Way: Being the Book of Art Young in Text and Picture.* New York, 1928.

ARTICLES

Baron, Herman. "Exhibition in Support of Democracy in Spain." *Art Front* 2 (November 1936): 14.

Benjamin, Walter. "The Author as Producer." *New Left Review* 62 (July-August 1970): 83-96.

Brown, Milton W. "The Two John Sloans." *Art News* 50 (January 1952): 24-27, 56-57.

"Call for an American Artists' Congress." *Art Front* 1 (November 1935): 6.

Conlin, Joseph R. "Wobblies and Syndicalists." *Studies on the Left* 6 (March-April 1966): 81-91.

Eastman, Max. "Bunk about Bohemia." *Modern Monthly* 8 (May 1934): 200-208.

——. "New Masses for Old." *Modern Monthly* 8 (June 1934): 292-300.

Gouldner, Alvin W. "The Sociologist as Partisan: Sociology and the Welfare State." *American Sociologist* 3 (May 1968): 103-116.

Hausdorff, Don. "Magazine Humor and the Depression Years." *New York Folklore Quarterly* 20 (September 1964): 199-214.

Hirschfield, Charles. "'Ash Can' Versus 'Modern' Art in America." *Western Humanities Review* 10 (Autumn 1956): 353-373.

Howe, Irving. "The Force of Innocence." *Washington Post Book Week Supplement*, June 5, 1966, pp. 6, 13.

Leinenweber, Charles. "Is American Socialism Unviable?" *International Socialist Journal* 5 (February 1968): 140-151.

Liberator, 1918-1924.

Masses, 1911-1917.

Minor, Robert. "After Garvey—What?" *Workers Monthly* 5 (June 1926): 362-365.

———. "Art As a Weapon in the Class Struggle." *Daily Worker*, September 22, 1925, p. 5.

———. "Death or a Program!" *Workers Monthly* 5 (April 1926): 270-273, 281.

———. "The First Negro Workers' Congress." *Workers Monthly* 5 (December 1925): 68-73.

———. "How I Became a Rebel." *Labor Herald* 1 (July 1922): 25-26.

———. "Lenine Is Eager for Peace, He Tells *World* Man; Asks 'When Will Revolt Reach U. S.?'" *New York World*, February 4, 1919, pp. 1-2.

———. "Lenine Overthrew Soviets by a Masked Dictatorship; Bourgeoisie Gain Power." *New York World*, February 6, 1919, pp. 1-2.

———. "The Negro and His Judases." *Communist: A Magazine of the Theory and Practice of Marxism-Leninism* 10 (July 1931): 632-639.

Morris, George. "Spanish Republic Gains Strength, Minor Tells Communist Convention." *Daily Worker*, May 23, 1938, pp. 1, 4.

New Masses, 1926-1948.

Perlman, Bennard B. "The Years Before." *Art in America* 51 (February 1963): 38-43.

Phillips, William. "Old Flames." *New York Review of Books* 8 (March 9, 1967): 7-8.

Riley, Maude. "Art Young, Famous Cartoonist, Dies at 77." *Art Digest* 18 (January 15, 1944): 21.

Rosenberg, Harold. "From Pollock to Pop: Twenty Years of Painting and Sculpture." *Holiday* 39 (March 1966): 96-105, 136-138, 140.

———. "The Search for Jackson Pollock." *Art News* 59 (February 1961): 35, 58-60.

Sterling, Philip. "Robert Minor: The Life Story of New York's Communist Candidate for Mayor." *Daily Worker*, September 11, 12, and 15, 1933, p. 5.

Weinstone, William. "The National Guardian and the Anarchist Peter Kropotkin." *Worker*, January 14, 1968, p. 8.

Young, Art. "Theory of Design, Technique, and Materials." Under "Cartoon," *Encyclopaedia Britannica: A New Survey of Universal Knowledge.* 14th ed. Vol. IV. London, 1929, pp. 950-952.

CATALOGS AND PAMPHLETS

Altgeld, John P. "Reasons for Pardoning Fielden, Neebe, and Schwab." Chicago, 1893.
"Armory Show 50th Anniversary Exhibition, 1913-1963." Henry Street Settlement and Munson-Williams-Proctor Institute. New York and Utica, 1963.
"Maurice Becker Watercolors." Art of Today Gallery Exhibition. New York, 1955.
Minor, Robert. "Free Earl Browder!" New York, 1941.
———. "The Heritage of the Communist Political Association." New York, 1944.
———. "Invitation to Join the Communist Party." New York, 1943.
———. "Lynching and Frame-up in Tennessee." New York, 1946.
———. "One War: To Defeat Hitler." New York, 1941.
———. "Our Ally: The Soviet Union." New York, 1942.
———. "Tell the People How Ben Davis Was Elected." New York, 1946.
———. "The Year of Great Decision, 1942." New York, 1942.
St. John, Bruce. "John Sloan." Smithsonian Institution Traveling Exhibition. 1963.
———. "The Life and Times of John Sloan." Exhibition, "The Life and Times of John Sloan," Delaware Art Center, Wilmington, Delaware, 1961.
Young, Art. "The Campaign Primer." Chicago, 1920.
———. "The Socialist Primer." New York, 1930.

CORRESPONDENCE, INTERVIEWS AND MANUSCRIPTS

Allen, James S. Interview, December 22, 1970.
Anton, Harold, to author, August 1, 1968.
Anton, Harold. Interview, December 23, 1970.
Becker, Maurice, to author, January 2, 1968, January 17, 1968, January 24, 1968, January 26, 1968, February 7, 1968, February 16, 1968, March 20, 1968, June 17, 1968, July 2, 1968, July 3, 1968, July 19, 1968, July 23, 1968, July 31, 1968, October 20, 1969, October 27, 1969, February 23, 1971, March 27, 1971.
Becker, Maurice. Interview, May 1, 1971.

Bullard, Edgar John III. "John Sloan and the Philadelphia Realists As
 Illustrators, 1890-1920." Unpublished master's thesis, University of
 California at Los Angeles, 1968.
Chamberlain, K. R., to author, December 22, 1970, January 23, 1971,
 March 22, 1971, May 15, 1971.
Chamberlain, K. R. Interviews, August 10, 1966, December 19, 1966,
 July 10, 1968, July 25, 1968.
Eastman, Max. Max Eastman Papers, Lilly Library, Bloomington,
 Indiana.
Gahn, Joseph Anthony. "The America of William Gropper, Radical
 Cartoonist." Unpublished doctoral dissertation, Syracuse University,
 1966.
Gellert, Lawrence, to author, July 11, 1968, August 2, 1968, September
 7, 1971.
Minor, Robert. Robert Minor Papers, Butler Library, New York.
Mooney, Tom. Thomas Mooney Papers, Bancroft Library, Berkeley.
North, Joseph. Interview, December 23, 1970.
Norton, W. W. W. W. Norton Papers, Butler Library, New York.
Pinchot, Amos. Amos Pinchot Papers, Library of Congress, Washington,
 D. C.
Quinn, John. John Quinn Papers, New York Public Library, New York.
Rueppel, Merrill Clement. "The Graphic Art of Arthur Bowen Davies and
 John Sloan." Unpublished doctoral dissertation, University of Wiscon-
 sin, 1955.
Sloan, Helen Farr, to author, July 20, 1965, August 22, 1966, September
 20, 1966. July 9, 1967.
Sloan, Helen Farr. Interview, December 16, 1970.
Sloan, Helen Farr. Unpublished verbatim notes, 1944-1950, of John
 Sloan's conversations, interviews and lectures, Delaware Art Center,
 Wilmington.
Sloan, John. John Sloan File, Whitney Museum Records, Archives of
 American Art, Detroit.
Sonnenberg, Martha Rose. "A Contradiction within a Contradiction: The
 Experience of Radical Writers and Artists in America, 1912 to the
 1930s." Unpublished master's thesis, University of Wisconsin, 1970.
Waite, John A. "*Masses*, 1911-17: A Study in American Rebellion."
 Unpublished doctoral dissertation, University of Maryland, 1951.
Wilson, Gil, to author, May 4, 1970, June 10, 1970, June 14, 1970.
Wilson, Gil. Gilbert Wilson Papers, Woodrow Wilson Junior High School,
 Terre Haute, Indiana.

Index

Numbers in italics refer to the illustrations.